All Available Light

All Available Light

The Life and Legacy
of Photographer Ted Polumbaum

JUDY POLUMBAUM

McFarland & Company, Inc., Publishers

Jefferson, North Carolina

ISBN (print) 978-1-4766-8660-8
ISBN (ebook) 978-1-4766-4407-3

LIBRARY OF CONGRESS AND BRITISH LIBRARY
CATALOGUING DATA ARE AVAILABLE

Library of Congress Control Number 2021022369

On the cover: photographer Ted Polumbaum at 37, trusty Weston light meter
on his belt, with daughter Judy, age 8, on a boat in Greece during the homeward leg
of a 1961 round-the-world journey (photograph by Nyna Polumbaum, family collection);
background the Reverend Martin Luther King, Jr., in Boston to lead a march for equal jobs
and housing, April 1965 (photograph © Ted Polumbaum / Newseum collection)

Printed in the United States of America

*McFarland & Company, Inc., Publishers
Box 611, Jefferson, North Carolina 28640
www.mcfarlandpub.com*

To those little geysers of interspecies affection and solace:
Simone, Holiday, Yogi, & Maple

And to truth, justice, and the American way of our dreams

Table of Contents

Acknowledgments

At one level, writing for others is an act of faith. The author hopes that others will understand, and care.

At another level, even writing for others is writing for oneself. I am glad and relieved to have set down these words.

To proffer the biography of a beloved father, with recollections of a not particularly distinguished daughter, might be especially self-indulgent. This is about *my* dad. Through *my* eyes.

I am fortunate that many people indulged, encouraged, and improved this account. All remaining flaws and foibles, of course, are my responsibility alone.

My first debt of gratitude goes to Ted Polumbaum's life partner, my mother Nyna Brael Polumbaum. If not for her remarkable, if sometimes selective, memory, this book could not exist. If not for her formidable spirit, Dad might not have become a photographer.

I'm thankful that my sister Miki allowed me to share some of her story. Her unique perspective and uncanny memory provided details that exist in no other mind. My brother Ian read every draft, and contributed some of his own tales. He is a brutally fine copy editor.

Conversations with my parents' friends and associates taught me a great deal: the beloved and much missed Bert and Louise Lown, Sid Herman, China Altman, Richard Wood, and the now departed Ted Kazanoff and Pat Vecchione. My father's cousins Phil and Mickey Weiner and Dick Epstein and my cousin Susy Schaflander Rothschild filled in some blanks.

Photographers Lou Jones, Steve Schapiro, Stanley Forman, and the late Ivan Masser were generous with recollections, as was Dad's former photo assistant Tom Nemcik. *LIFE* photo editors John Loengard and Dick Anthony welcomed me into their New York City apartments to converse about the magazine's weighty days. The late Edgar M. Cullman, Sr., shared thoughts on the tobacco industry. Dr. Chuck Keevil, Harvard Medical School graduate, half of the longtime physician partnership serving Lincoln, Massachusetts, and avid tennis player, reminisced at length about doctoring in my hometown. Ruth Wales shared her knowledge of Browns Wood. Alaric Naiman shed additional light on our neighborhood and town.

During the time they owned and lived in my father's former home in Harrison, New York, Bruce and Elizabeth Kaminer graciously gave me a tour, and supplied me with a copy of the original floor plans. Their then-teenaged son Riley, an able photographer, documented the house for me, inside and out. Astrid (Gronlund) Lenzel and John Lenzel, Harrison High schoolmates of Ted's, extended help from South Carolina. Gene

D'Imperio, sports editor of the Harrison High newspaper when Ted was editor, provided some wonderful insights via his daughter, Gogi LaRusso.

I am grateful to childhood friends Becky Fernald and Sara Meyer for clarifying some details, and even more grateful for our enduring ties.

As undergraduates at the University of Iowa, Kirsten Riggs (now Newmaster), Lindsey Moon, and Jennifer Earl helped greatly in early phases of research.

Thanks again, Matt Cecil, for extracting Ted's stupefying FBI dossier.

My most faithful early readers, Dan Campion and David Holzman, caught many a typo, syntactical error, and stylistic glitch. Both cheered on my compositional efforts, often with far more enthusiasm than the material deserved.

Two of my most talented former students, Nick Compton and Danielle Wilde, reassured me that young people not related to me could find this story engrossing. Nick suggested the kinship guide. Danielle made very specific, and very wise, recommendations related to both content and style.

Astute friend and accomplished writer Mary Helen Stefaniak, besides flagging a bunch of little things, extricated me from several big dilemmas of my own making.

And I'm indebted to my wonderful writing partners, Sarah Phillips and Patty Martin, for their fortitude, frank critiques, and assistance unraveling tangled prose.

I am honored that historians Andrew Bacevich and Linda Kerber took time to read my manuscript and found it worthy. Juliet Schor bolstered my courage. Tom Lutz reinforced my verbal arsenal. Osha Gray Davidson buoyed my hopes. Paul Basken lifted my spirits and detected a particularly cagey typo.

Thanks to the Newseum staff, past and present, for serving as excellent custodians of my father's archives; and particularly to original visual curator Karen Wyatt, who immediately recognized the value of Ted's legacy, and Indira Williams Babic, her indomitable colleague and successor.

Special gratitude to the current curator of Newseum collections, Freedom Forum Vice President Carrie Christofferson, for her continuing support and advocacy. For those who may wonder, we are assured that the Newseum remains a valued part of the Freedom Forum and its mission of supporting the First Amendment, and that its collections remain intact and secure, despite the shuttering of the great DC museum at the end of 2019. For information on use/permissions/licensing of images in the Ted Polumbaum photo collection, contact *collections@newseum.org* or *visualresources@newseum.org*

At McFarland, my utmost appreciation to Layla Milholen for recognizing the merits of this book (and for wanting more photos!); and to Rhonda Herman, Beth Cox, David Alff, Lori Tedder, Kristal Hamby, Dylan Lightfoot, Dré Person, Lisa Camp, and others who labored through the pandemic.

Hurrah for the American Society of Media Photographers, the Authors Guild, Biographers International, and Prairie Lights Bookstore.

Thanks to the many scholars and authors who informed my research, furthered my thinking, and helped animate my writing. Thanks to the friends who keep me going.

As always, boundless love to my comrade-in-arms Karl and our sons Nathaniel and Gabriel for putting up with my foolishness.

Note to the Reader

This book about my father's life and livelihood, and about the times in which he lived and worked, has been my on-again off-again preoccupation for two decades. Now, as the project reaches its culmination, it cannot quite find a conclusion. The story seems ever more resonant with new developments in the ongoing quest for social justice, ever more connected with current campaigns for change that shapeshift with each passing day.

As a photojournalist, my father bore witness to movements for peace and justice over nearly half a century. As a citizen-dissident, he acted upon his conscience and beliefs. As a man both of and ahead of his times, he saw much progress, but never enough. He is missing out on the latest tidal waves of activism, outrage, connectedness and transformation. He's been dead twenty years, and we are still conversing.

Here is his biography, and more; history, journalism, visual testimony and collective memoir are woven throughout. I say collective memoir because the text relies on memories beyond my own, incorporating information from extensive (some might deem them excessive) family files.

Writing was, and remains, endemic among my kin. Although my father took notes in an illegible scrawl, he typed up much that he considered worthy of report and reflection. He also wrote letters, poetry, and the occasional imaginative sketch. My mother's penmanship is elegant, as befits an artist; her correspondence and essays, handwritten and typed, along with her recounted memories, are a treasure trove. My older sister and I often kept journals; my younger brother wrote a lot of silly stuff, illustrated with cartoons. We've preserved a good deal of our written reveries and repartee, including printouts from the early days of email. An assortment of older letters from some of my father's relatives and friends also survives.

My account draws on such personal materials, along with interviews, visits to key spots, historical research, and the extraordinary bonus of my father's photographic legacy. The vast archive of images he left behind, both professional and personal, serves to complement, bolster, amplify, and sometimes correct the written record. Each interlinked chapter may be read as an essay in itself. The ones labeled "assignments" go behind and beyond some of my father's more intriguing photographs. To the best of my ability, I have hewed to nonfiction; however, in occasional ventures beyond what the record definitively shows, I offer a modicum of conjecture about what my father might have thought, said, or done.

I believe that this human story, set in a larger context, helps illuminate how political and social struggles of the past bear upon the present and shape the future. And I hope my father's personal journey, as both documentarian and activist for social change, can inform and inspire those who continue to strive for a better world.

Kinship Guide

Philip/Phil Polumbaum (1892–1974): Ted's father, eldest of six children of immigrants from Tsarist Russia.

Minnie (Posen) Polumbaum (1894–1946): Ted's mother.

Alvah/Al Posen (1895–1960): Ted's favorite uncle.

Mildred (Herbert) Polumbaum (1897–1971): Phil's second wife, Ted's stepmother.

Marjorie/Peggy (Polumbaum) Schaflander (1922–2001): Ted's older sister.

Theodore/Ted Polumbaum (1924–2001): Phil's middle child, Judy's father.

Robert/Bobby Polumbaum (1929–1963): Ted's younger brother.

Gerald/Gerry Schaflander (1920–1996): Peggy's husband, Ted's brother-in-law.

Lazer/Louis Israel (1895–1957): Nyna's father, immigrant from Ukraine.

Ruth/Ruthy (Amdur) Zweiban (1901–1986): Nyna's mother, immigrant from Belarus.

Morris/Murray Zweiban (1907–1991): Ruthy's husband, Nyna's stepfather, immigrant from Romania.

Nyna Brael Polumbaum (b. 1924, Nina Israel): Ted's wife, Judy's mother.

Mini Ann/Miki Polumbaum (b. 1950): Ted and Nyna's daughter, eldest of three children.

Judy Polumbaum (b. 1953): the author, the middle child; married KARL, two sons.

Ian Polumbaum (b. 1963): the little brother; married NALINA, one son, one daughter.

1

The Decisive Moment

You must be on the alert with the brain, the eye, the heart, and have a
suppleness of body.
— Henri Cartier-Bresson, *Writings on Photography*

My father never planned to be a photographer; this destiny was thrust upon him.
Men who claimed to be public servants, in the name of trawling for traitors, were perse-
cuting loyal citizens. My father foolishly stood up to them.

It was the height of the period we have come to call McCarthyism. In truth, we ought
to call it the age of Un-Americanism, after the House Committee on Un-American Activ-
ities, or HUAC.

Joe McCarthy, the blustering, alcoholic Republican US senator from Wisconsin,
had risen to national prominence in the early 1950s with his outsized allegations of com-
munist infiltration in government. By then, HUAC's much more widespread inquisi-
tions were well underway. The outlandish campaign McCarthy pursued as chair of the
Senate Subcommittee on Investigations lasted only two years. HUAC's no less prepos-
terous rampage went on much longer, from the eve of the Second World War into the
early 1960s. By mid–1954, McCarthy would make a fool of himself in nationally tele-
vised hearings into purported subversion in the US Army; by the end of that year, his
uncivil behavior would earn him censure from the entire Senate. HUAC's indiscrimi-
nate mandate formally ended only when the renamed Internal Security Committee shut
down in 1975.

In the spring of 1953, when McCarthy was still riding high, it was HUAC that sum-
moned my father to spill his secrets before a tribunal in Washington, D.C. At the time,
Ted Polumbaum wrote the late-night television newscast for United Press in Boston. He
and his wife Nyna had one daughter, with a second in the womb. That would be me.

Ted had been a well-behaved suburban kid who leaned Republican and admired
his conservative businessman father. Then he went to war, drafted out of his freshman
year at Yale. By the time he returned to campus from the jungles of New Guinea and the
Philippines, rejoining the same interrupted class as George H.W. Bush, his outlook had
changed dramatically. Bush was in Skull and Bones, the society for bluebloods. Ted, a
secular Jew, joined the John Reed Club, an organization of little consequence that batted
around progressive ideas.

Now HUAC was holding hearings into "Communist subversion in education." My
newsman father challenged the committee's right to inquire into his personal or politi-
cal beliefs or associations. Taking the Fifth Amendment, proven to be a much better legal
shield than the First, he spurned any questions beyond basic biography, rebuffed efforts

to get him to implicate others, and accused the congressmen of shredding the Bill of Rights.

Ted was threatened with contempt charges, and speedily fired. United Press management deemed his refusal to cooperate with HUAC "incompatible with the best interests of journalism." The American Newspaper Guild took up his case, a brave gesture for those times, and won in arbitration, but lost on a technicality after UP appealed to the courts and got the case assigned to a friendly judge.

Unemployed, blacklisted, needing to support a wife and two kids, the FBI following close on the heels of any job interviews, my father returned to a childhood hobby. Long before everyone took pictures and the world was awash in imagery, he became a freelance photographer.

The policies of another Yale alumnus, publishing magnate Henry Luce, made a successful career possible. Luce, who in the lead-up to World War II had called on the country to exercise world leadership in an era he forecast to be "the American Century," remained a staunch anticommunist and cold warrior. Yet he empowered his editors to hire the best talent money could buy for his Time Inc. publications, foremost among them *LIFE*, then the most popular picture magazine in the world.

As a Boston-based lensman, Ted would complete hundreds of assignments for *LIFE* and hundreds more for other publications, as well as work for books and exhibitions. In time, the general interest photo magazines succumbed to television's growing supremacy in the fight over advertising dollars. *The Saturday Evening Post* closed in 1969 (to be relaunched some years later as a very different nostalgia vehicle), *Look* magazine shuttered in 1971 (its archives scattered to the winds, with some of Ted's pictures ending up at the Library of Congress), and *LIFE* ended weekly publication in 1972, resurfacing as a monthly in 1978, finally ceasing in 2000 (to be briefly resuscitated as a newspaper supplement, and continued as an Internet "brand"). Adapting to this changing climate for photography, my father turned increasingly to commercial work for his livelihood. But he never abandoned his true passion, documentary photography.

It might be said, therefore, that Ted Polumbaum experienced his paramount decisive moment as he faced those congressional interrogators back in April 1953. In that confrontation, he showed his mettle. In standing on principle, a stance heroic in retrospect but foolhardy at the time, he emerged with conscience and integrity intact. The aftermath set the subsequent course of his life, bringing unanticipated professional and personal rewards. It also set the course for his immediate family—my artist mother Nyna, always his best picture editor, not to mention a provocateur who encouraged him to take chances; and my big sister Miki and little brother Ian and I, who grew up surrounded by the fixtures, forays, exigencies, and stories of our father's trade.

From then on, my father would be in pursuit of a different sort of critical instant in his work, what the great French photographer Henri Cartier-Bresson termed "the decisive moment" in picture taking. Cameras were still finicky, film speeds slow, printing technologies tedious, the whole process expensive and laborious. "You wait and wait, and then finally you press the button—and you depart with the feeling (though you don't know why) that you've really got something," Cartier-Bresson wrote. That something was the coming together of subject and composition in the viewfinder, light and shadow captured on celluloid, to be conjured up as imagery in the darkroom and possibly shared in print with the world.

Dad wasn't after masterpieces; he didn't even consider what he did "art." But he took

a deeply humanistic approach to photography, mindful that his vantage from behind the camera often put him in a position of power. "The profession depends so much upon the relations the photographer establishes with the people he's photographing, that a false relationship, a wrong word or attitude, can ruin everything," Cartier-Bresson also wrote.

More to the point was W. Eugene Smith, whose work Dad saw as the epitome of humanitarian photography: "I cannot accept a habit of scavenging among the human frailties and the tragic, when this is done for the sole purpose of exploitation and serves no other purpose," Smith told an interviewer in 1959. "I cannot accept an essay, a photographic essay, that is done superficially, because to me superficiality is a form of untruth, for it commits an untruth by omission, by lack of depth, by lack of understanding, and by lack of full presentation."

Dad viewed the very language of photography as ignominious. We "shoot" photos, after all. "Shooting" is a pretty good description of the physical pose. It's also an act of destruction. The camera is a surrogate gun; the subject, even an inanimate one like a tree or a building, the target.

Not that we discussed these things while my father was raising me in a wet darkroom, teaching me to develop film and print pictures amidst swirls of chemical fumes. But his thinking was implicit in his work, and in just about everything else he did. Only much later, when he was in his 70s and I was in my 40s, and I asked him to reflect on how we talk about photography, did he make his misgivings explicit. I preserve the results in a printout from the early days of email.

The very act of "taking" a picture involves using, exploiting or seizing the subject matter, Dad wrote. To "take" a photo is to appropriate the image—or, as so-called primitive people are supposed to fear, to photograph is to capture the soul, he pointed out. "Through the lens," he said, "for better or for worse, the item, person, animal, hill, flower, landscape becomes the object of manipulation, occupation, abduction, maybe even demolition."

Nevertheless, that's what he did for a living, and I think his efforts to resist the temptations of power are evident in the images he left behind. Even if, up against the realities of the business, the most noble of intentions sometimes broke down.

2

Assignment: Escuminac

Everywhere Canadian children were the most eager to see the queen and
they infected the adult crowds with their delight at the royal sight.
— "Queen's storybook tour of Canada,"
LIFE magazine, July 6, 1959

My sixth birthday was a month away when calamity hit Canada's eastern shore. My
father was several years into building his new career as a photojournalist. His encounter
with the anguish of the people of a small fishing hamlet would be one of his most agoniz-
ing lessons in the stealing of souls.

The storm came up without warning, a tropical cyclone-turned-hurricane racing up
the Atlantic coast and then veering toward Canada's maritime provinces, winds up to 75
miles per hour raising 50-foot waves.

The regional weather office had forecast breezes for the day. Even with the growing
competition from industrial trawlers, cod was plentiful, salmon prospects were good,
and basket traps could be checked for lobsters. About 45 fishing boats had set sail from
three small coastal communities in the province of New Brunswick, including the village
of Escuminac. The basic wooden craft, with a hold for the catch, carried men and boys,
fishing gear and nets, and little else. No radios aboard, no channels for weather updates,
no way to be reached.

Dispatched by *LIFE* editors in New York, Boston bureau correspondent Paul Welch
and freelance photographer Ted Polumbaum took a plane, rented a car, and came upon a
lone hitchhiker at dawn. The man was headed to join relatives in the search for survivors.

The shoreline was littered with remnants of demolished cottages and wreckage
of boats. The dock was lined with people standing shoulder to shoulder watching the
horizon. Some who tried to come in during the storm had been smashed up. Some who
decided to ride it out were making it back.

Ted and Paul followed their hitchhiker along the beach to a stunning reunion with
kinfolk the man feared he might never see again—a father and two sons, one boy hardly
in his teens, their boat just hauled in. An uncle lay dead in the hold below, his skull
crushed in the fury of the elements by a fall or collision or flying debris.

With some kind of acceptance, or perhaps desire to get the story out, or maybe
because the visitors had picked up the relative, the rescued father beckoned Paul and Ted
to accompany him. They arrived at his one-room house, where his wife and other chil-
dren and neighbors sat in silence. With a quiet Leica—no whirring motor drives yet—
Ted recorded a sequence of disbelief, amazement, and rebirth.

Bleak faces turned toward the doorway as the father entered, in his familiar overalls

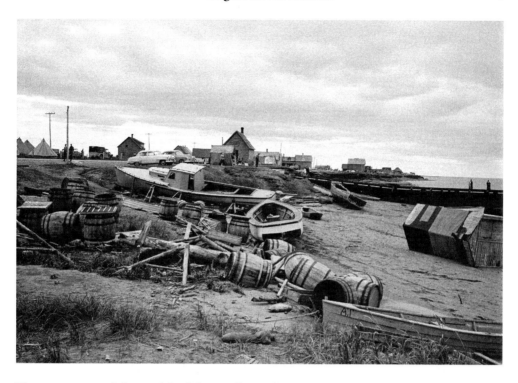

The storm-ravaged shore of the fishing village of Escuminac, New Brunswick, Canada, 1959 (©Ted Polumbaum / Newseum collection).

and plaid wool shirt and crumpled bucket hat, a ghost turned back into a man. He bent down to pull off his boots and, without a word, walked the few steps to the crib in the center of the floor, picked up his baby, and brought the infant's cheek to his lips.

Then the ice broke, and everybody started talking.

Thirty-five husbands, fathers, uncles, cousins, sons, brothers never came home. Just about every family in Escuminac lost someone. Some of the bodies were never recovered. Over the next few days, Paul and Ted documented the vigils and wakes and funerals. Ted's cameras found the same young teen he'd seen rescued, now smiling, a kid again among his friends, not the haggard boy who'd had his brush with death. His cameras found the father, whom Ted had thought was at least 50, maybe 60; now he looked his age, 40.

Ted would have no memory of where he stayed or how and what he ate, but he would never forget how the gentle people of this community invited strangers into their darkest sorrows and unlikeliest joys.

It had all the makings of a typical *LIFE* picture story: life and death in a remote village. In this deeply religious Lutheran hamlet, there was a sense that the slow rhythms of traditional ways were breaking down. The young people wanted to go to the cities. For the moment, though, they were unified in the terrible poignant beauty of tragedy, portrayed with the noble composition, ethereal light, sublime shadow, and arresting contrast of Ted's black-and-white photographs.

The raw materials, Paul's copy and Ted's images, were in the hands of the editors in New York. The photos were selected, sequenced, sized, laid out, a spread planned over multiple pages.

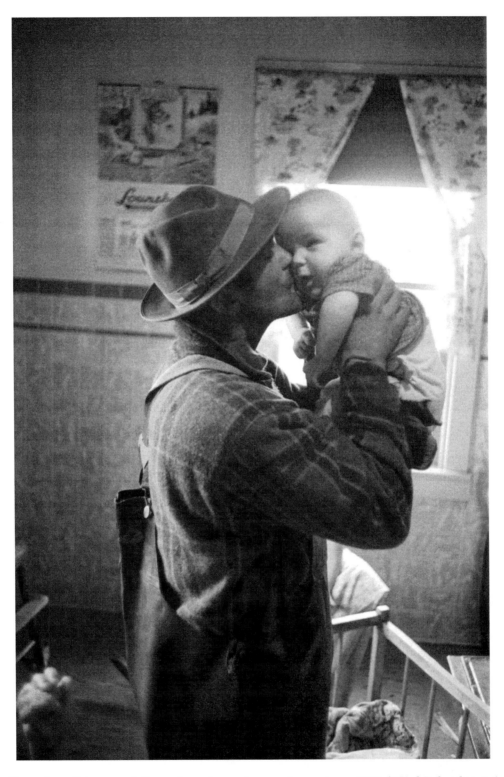

Escuminac fisherman-father returns home from a storm at sea, 1959 (©Ted Polumbaum / Newseum collection).

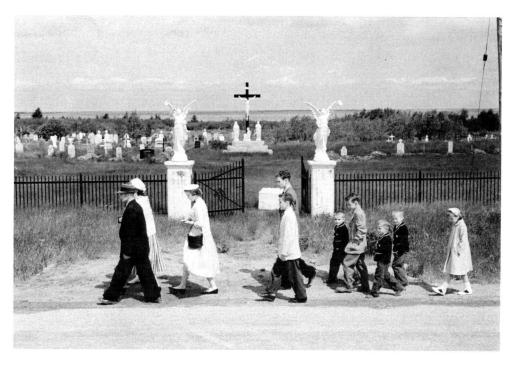

Nearly every Escuminac household lost someone; funeral procession, 1959 (©Ted Polumbaum / Newseum collection).

Canada remembers: A monumental sculpture commemorating the lives lost at sea, commissioned ten years later and depicting three stolid fishermen, overlooks Escuminac's harbor. But the episode did not surface in the most popular picture magazine of the times.

For another sort of storm had transpired: That same week, England's Queen Elizabeth swept through Canada with pomp and parades, speeches and ceremonies, dignitaries and gleeful crowds, Prince Philip in Royal Air Force uniform, even President Eisenhower coming north to help dedicate the St. Lawrence Seaway.

That issue of *LIFE* contained nothing about the disaster; neither, once it was old news, did any other issue. Those were the magazine's profligate days, when perhaps one story would run for every five or six assigned. The editors could not entertain more than one Canada piece at a time. Royalty obviously trumped the folks from an obscure fishing village. The Queen's visit was splashed across eight pages, six in color. The story of Escuminac stayed in the archives.

3

The Birthplace of the Fifties

> Everybody had to find a mold to fit into. Doctor, lawyer, soldier—it didn't
> matter what it was. Once in the mold you had to push forward.
> —Charles Bukowski, *Ham on Rye*

My father loved to banter, but seldom reminisced. Mainly he talked about ideas and events, philosophical notions and abstractions, human behavior and transactions, politics, economics, religion, the meaning or meaninglessness of life, just about anything in the realms of thought and action. His one occasionally repeated story from growing up was about taking a girl to the movies in high school and afterward telling his father he'd put an arm around her, whereupon his father gave him a lecture on venereal disease.

Getting a grip on Ted's story requires understanding the great rift between him and his father, Philip Polumbaum, which requires understanding Phil, which is difficult because the gulf was so great and we saw him so seldom.

After a long period of estrangement, my parents finally started taking my sister and me to New York for the annual family Thanksgiving dinner, customarily held in a banquet room over an otherwise deserted Manhattan restaurant, the turkey dry and tasteless. My grandfather, whom adults called Pop and kids called Poppy, presided over the event in a glad-handing manner. He was pale, slightly puffy, with a liver-spotted bald pate, a stogie wedged in his mouth, the smell of cigar smoke always hanging around him.

Phil and most of the elders were interlopers in my personal space, people whose identities I couldn't keep straight from year to year, greeting me with gushing comments, annoying pinches and sloppy kisses. The next generation, my father's cousins, were more reasonable. Their offspring, my peers, naturally were the most tolerable of all. The times we dined at Schrafft's, I would gravitate toward my seasonal chum Nancy, daughter of Dad's cousin Dick, and we would pirouette downstairs to coax candy from the ladies behind the counter.

Even with the advantages of time and further inquiry, Phil remains an elusive figure. Yet, as an influence on Ted, both example and counterexample, for both actions and inactions, I know he looms large. So I have searched for clues, anything that finds resonance in my father's character and abilities, as well as the many things my father resisted or rejected.

Judging by his schooling, advancement, and achievements, Phil must have been brainy, as my father certainly was; but their intellects came to serve very different values and goals. Ted and Phil were both self-made, each crafting a career he found fulfilling, although the nature of their occupations—Phil a tobacco executive, Ted an image-maker—could hardly have been less similar, and their definitions of fulfillment

were at odds. Phil's drive to distance himself from his humble roots has a kind of inverted counterpart in Ted's determination to leave behind the very privileges that Phil had toiled to attain. As a father, from all I can gather, Ted was Phil's antithesis. Whereas Phil was daunting, remote, imperious and impervious toward his own, Ted was attentive, affectionate, beguiled if not always enchanted by his children. Work often took each away from home, but Phil was absent even when present, whereas Ted was available.

Phil was born in 1892, the year Ellis Island opened; more than eight million immigrants, including Phil's parents, already had arrived in New York through Castle Garden, a processing center attached by landfill to the southern tip of Manhattan. He grew up in the Bronx, the borough across the Harlem River from Manhattan. Once largely farmland, undergoing a residential boom as the nineteenth century yielded to the twentieth, the district had become home to immigrants from all over Europe, with plenty of Jews and synagogues, as well as bootleggers and speakeasies. Phil was the eldest of six children, all first-generation Americans. The age span between him and his youngest siblings was large; after three sisters came two brothers, the last arriving as Phil neared the end of high school. Along with his seniority, he had high ambitions and a sense of destiny that, over time, gained him seldom-disputed status as the family patriarch.

He attended New York's High School of Commerce on Manhattan's Upper West Side, a daily commute that undoubtedly familiarized him with the larger universe of the big city as well as with the business world. Commerce was an early example of a specialized high school designed for "the masses" that also would serve the nation's expanding industrial economy. At the laying of the cornerstone in 1901, business magnate Andrew Carnegie declared it a place where "the son of the laborer enters upon exactly the same terms as the son of the millionaire." The school aimed, according to its leaders, "to provide a training which shall be broad and liberal in its character, and at the same time acquaint the students with the principles and technique of commercial transactions." Required courses included a good bit of history (Greek and Roman, medieval and modern, English and US), foreign language (German, French, or Spanish), drawing and penmanship, algebra, geometry, chemistry, logic, and "physical training." An impressive range of electives included classes in banking and finance, transportation and communication, accounting and auditing, and business organization and management. The school lasted until 1965, when it was demolished to make way for urban renewal and the expansion of Lincoln Center, a pet project of planning czar Robert Moses.

At age 17, while at Commerce, Philip Polumbaum made a transitory splash as one of the top ten winners of a *New York Times* essay contest on the life of Abraham Lincoln. The *Times* of February 28, 1909, published his essay, a slightly overwrought recitation of Lincoln's career. "He was absolutely fearless in upholding the principles he thought were right, even to the detriment of his political career," Phil wrote. "No man was more fit to pilot the Union through the civil war than he. Calm and calculating, he knew just what to do at the proper time. His hand was on the helm of the Union, with an iron grip." The essay ended, "Sometimes, when he laid off the mantle of care for a moment and joked, people called him a fool. God grant this country many more such fools!"

After high school, Phil availed himself of a new evening program at the College of the City of New York, working toward his accounting certification. City College, free for residents, was the poor boy's alternative to Columbia University. In the working world, meanwhile, he began his ascent from the low rung of the ladder, starting as an office boy at American Sumatra Tobacco. The company was the country's largest grower of shade

tobacco, with fields in the Connecticut River Valley and more properties in the south. By the Depression, Phil would be high in the executive ranks, insulating his family from the economic hardships afflicting the country, since tobacco did even better in those unhappy times. World War I and the draft briefly intervened; marriage to the former Minnie Posen and job promotions ensued.

By then, Phil's parents had moved from the Bronx to Brooklyn, and about the time their eldest son was leaving home, a new son-in-law was moving in—second sister Lennie's beau Morris Leff. On a Friday in late September of 1918, when Phil and Minnie headed to city offices in Brooklyn for their marriage license, Morris and Lennie went along to do the same. The 1920 census found Phil and Minnie living in a rooming house in Florida, one of the southern states where American Sumatra did business. Over the years, work often took Phil to Florida, and Minnie sometimes joined him there. But their main home would be back in the expanding suburbs of Westchester County, just north of New York City.

During the first quarter of the twentieth century, as upwardly mobile New Yorkers pushed farther outside the city, Westchester County grew apace. By my father's childhood, in a greater metro area of some nine million people, Westchester's population approached half a million. The county was famed for its comprehensive park system, reaching from its southern border at the top of the Bronx to its lake-dotted northern reaches, and from the Hudson River along its western edge to Long Island Sound on the east. The county also owned Playland, a public amusement park with modern rides and games, indoor skating rink, pool, beach, and boardwalk, opened in 1927 in the seaside town of Rye to replace two commercial theme parks said to be attracting unsavory crowds.

Theodore Samuel Polumbaum was born on June 4, 1924, at Brooklyn Jewish Hospital, five years before the stock market crash that introduced the Great Depression. He was the middle child of three, between elder sister Marjorie and younger brother Robert. The children spent their early years in the town of Mamaroneck as Phil planned their dream house, a custom-built manse that took shape by their adolescence in the tonier town of Harrison. The architectural drawings included bedrooms labeled for Peggy, Teddy, and Bobby. Not quite an hour's ride on the New York, New Haven and Hartford Railroad from Grand Central Terminal in midtown Manhattan, Harrison had about 12,000 residents spread over 18 square miles when the Polumbaum family arrived and my dad entered high school there.

Dad always said he grew up in the birthplace of the fifties, by which he meant Westchester County. On the face of it, the claim didn't make much sense, because by the 1950s he was long gone from there, having moved on to college, war, marriage, work, and dwellings elsewhere. What he really meant was that he knew the wellsprings of the era's conservatism and suspicion. To the adult Ted Polumbaum, the affluent suburbia where he'd spent his youth was a bastion of antediluvian attitudes and pompous affectations. Looking back, he found much in his upbringing repellent; in his own father's attitudes, associates, and pecuniary pursuits, he saw bigotry, paternalism, and profiteering incarnate.

The Harrison house and grounds, much as he loved the place at the time, would exemplify the sort of material striving Ted later came to associate with the fifties. While not especially ostentatious by today's big-house standards, the handsome brick dwelling at the end of Valley Ridge Road was positively opulent for its day. It sat on a spacious lot bordering a ravine, with brick walks winding through elegant landscaping of lawns,

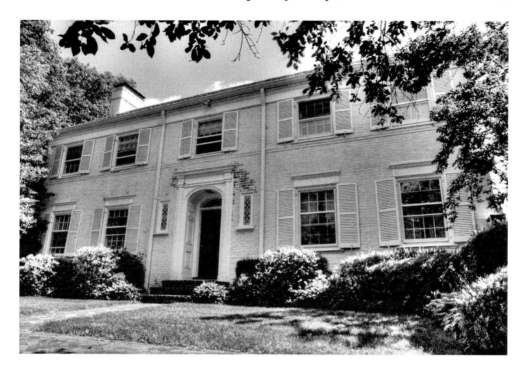

The Polumbaum family manse in Harrison, New York, as it appears today (Riley Kaminer).

large shade trees, a brick barbeque pit, and a Japanese garden with exquisitely contorted miniature species. The drive led to a three-car garage with servants' quarters above and a toolshed at the rear. The solid wood front door, with a big brass lock, was flanked by twin rectangles of leaded glass and topped by a half-round in stained glass. Shutters framing casement windows were adorned with cutout scrolls inscribing a double letter P, backward and forward in mirror image.

On the first floor, to the left of the entryway, was the big living room with dark oak flooring. A "hot bed" for plants at the far end, mounded with soil and enclosed by greenhouse panels, admitted light from the side yard. A passage opened to a veranda with a brick floor. Toward the back of the house was a spacious library, to the right the open dining room, cramped kitchen, and ample pantry. A mechanical buzzer system, with buttons in each bedroom to summon the hired help, converged at a panel in the kitchen.

The front stairs, with a beautifully carved wood banister, swooped upwards in a graceful curve. The large master bedroom upstairs had a fireplace faced with Japanese hand-painted tiles. A narrow rear staircase off the kitchen ascended more directly to the children's bedrooms, with quarters for the help just beyond. Rear steps also descended to the basement. Throughout the house were built-in shelves and cabinets, commodious closets, and fine detail work. The abundance of lavatories, unremarkable now, was regal then: There were six, from the big bathroom off the master bedroom to a tiny water closet in the basement.

Below ground was a large, finished playroom with pine board walls, with another greenhouse potting bed at foundation level jutting into the side yard. Around a corner, in a specially designed nook with a sink and grooved wood counter, Ted's mother, an avid gardener, assembled bouquets of fresh flowers to place around the house.

A doorway at the foot of the stairs led to a succession of utility and storage rooms harboring some novel household contraptions. First came the laundry area, where an enclosed metal closet with a rod and hangers heated by gas jets underneath served as a clothes dryer before the modern form of that appliance existed. Beyond was a boiler room, and beyond that a soundproofed room where two giant compressors, placed on concrete footing, powered a central air-conditioning system, a luxury practically unheard of in private homes at the time. An industrial-strength 300-amp electrical connection was required to support it—the modern standard for even the most demanding residential use being 200 amps.

My sense of lord-of-the-manor Phil, hazy and incomplete as it may be, nevertheless has heft, some sort of commanding force and density. My mental portrait of Ted's mother Minnie, on the other hand, is gossamer thin. She died not long after my parents met; my mother Nyna saw her but once, spending a few minutes at her sickbed.

As a parent, Minnie seems to have counterbalanced Phil; perhaps my father's gentler, more accepting propensities came from her. Her character might help explain my father's affinity for the underdog and willingness to stand up to bullies. And I suspect she was a source of his bemused, witty way of looking at the world. But I cannot say for sure.

In the rare photo, Minnie is always put together, in sensible dress and shoes, and smiling warmly. Two years younger than Phil, also the child of immigrants, she had reddish hair, which my older sister inherited.

She loved reading classic literature and listening to classical music, and volunteered her time punching out books in Braille for the blind. She tended expansive gardens, including a flourishing Victory Garden during the Second World War that produced corn, potatoes, tomatoes, onions, string beans and lima beans.

She clearly was a kept wife, but also kept up with lots of women friends; she knew the mother of the man who would marry her daughter, and the mother of the guy who would room with my father at college. When Phil was away at work, she was happy to have her children bring home schoolmates of any stripe, be they from prosperous families or from the other side of the tracks. Likewise, the poorer cousins still living in apartments in the city were welcome out at the big house.

She was gracious toward the live-in help, a young Danish-German couple who moved with the family from Mamaroneck to Harrison: Edward Hansen, whom everyone called Hans, and his wife Elsie. Shortly after the move, their son Edward junior was born. Hans did the driving and maintenance and odd jobs, Elsie the cooking and cleaning, leaving Minnie to her pastimes, most of which Phil deemed frivolous and effete ("hoity toity," he called them).

A few letters Minnie wrote to Ted as he was starting his Army service indicate that she was no pushover. And that the son perhaps took after his father a bit more than he would like, with scant patience for people whose opinions or behaviors he thought objectionable.

Ted evidently had made fun of wealthy retirees enjoying their comforts and doing charitable work. Minnie accused him of being "smug." She told him that getting along did not mean accepting injustice or cruelty; it meant "making allowances for ordinary human weaknesses and trying to make the best of one's life."

When Ted in one letter ridiculed Mother's Day as an occasion for florists to bamboozle simple people, Minnie took issue, hearing echoes of Phil, who also denigrated the holiday as a rip-off. "I agree with you, dear, that we have come to a sorry state when

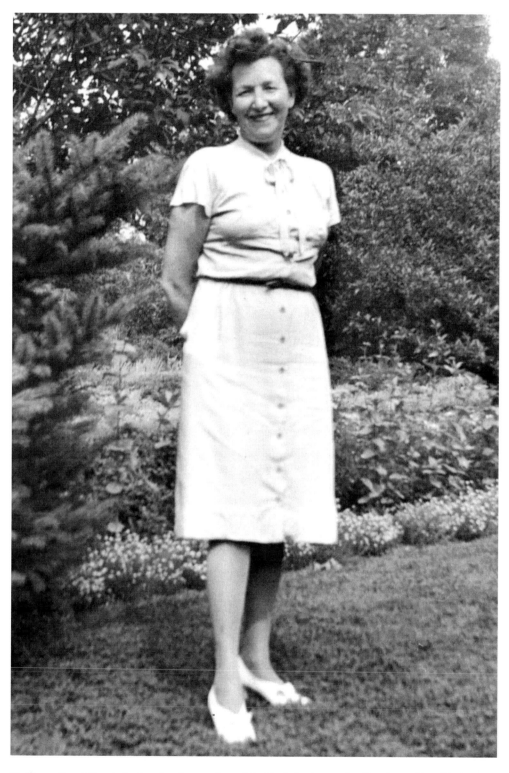

Ted's mother Minnie in her landscaped yard behind the house in Harrison, New York, 1946 (family collection).

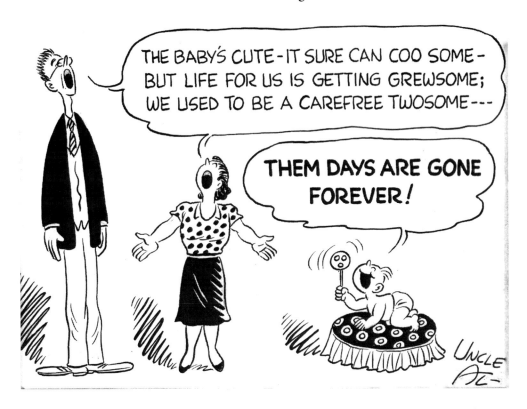

Cartoonist Alvah Posen's handiwork marking Miki's birth, 1950 (family collection).

we must be coerced into thinking of our mothers," she wrote, "nevertheless, I claim, if it makes the mothers happy, what harm is done?"

I am more certain about the influence of Minnie's sole sibling, Alvah Posen, my father's favorite uncle. A syndicated cartoonist, a friend of the comedic Marx brothers, a perpetual bachelor who often squired a beautiful woman on his arm, Al lived in New York's Marcy Hotel and took care of his mother up to her death. When my sister was born, he produced a cartoon my parents used as the birth announcement, depicting husband and wife and squalling baby, with a ditty bemoaning the couple's loss of a carefree life, ending with the kicker that served as both title and windup for one of his popular comic strips: "Them days are gone forever!"

My Great Uncle Al was an enthusiastic globetrotter long before ordinary folks took trips abroad. From Japan or Greece or wherever he'd been, he brought back dolls in national dress for my sister and me. We all adored him for his irreverence, generosity, and adventuresome spirit. Just a couple of weeks before his death from cancer, he came up to Boston to visit us and insisted on playing to the very end of a ferocious bout of tennis with Ted.

In his will, my Great Uncle Al left Ted nine thousand dollars. In fitting tribute, my parents bought round-the-world plane tickets, pulled my sister and me out of elementary school, and dragged us to live in sweltering climes on the other side of the globe for the better part of a year. With her equal bequest, Ted's sister Peggy bought living room furniture.

4

A Potentially Very
Rewarding Occupation

The best Connecticut Valley wrapper leaves have a worldwide reputation, are highly priced, and have always been sure of a market.
—Elizabeth Ramsey, *The History of Tobacco Production in the Connecticut Valley*

All three of Phil and Minnie's children seemed destined for a conventional existence. Peggy, with a willowy figure, long legs, and a smile that set boys' hearts aflutter, would get a good education, meet a good provider, and raise a family. Ted, smart and athletic, would go to the Ivy League and follow his father into success in business—perhaps even in the same line of work, the tobacco industry. Bobby, a bit insecure but with a flair for science, would be the doctor.

Then Peggy married a rebel. Ted started questioning the use of child labor in the tobacco fields. Bobby, who idolized Ted, felt increasingly isolated as both older siblings left for college. The departure of the resident help, Hans and Elsie, who took their son back to Europe to start their own inn, compounded Bobby's insecurities; and relocation during the war, when his mother's failing health prompted a move to a classy residential hotel in Manhattan, set him further adrift. Leaving the sprawling suburban homestead for high-rise urban living could not have been easy. Years later, watching home movies in which the child he'd been in Harrison raced around ebulliently, Bobby told Ted and Nyna he couldn't remember ever being happy like that.

Once Peggy and Ted were gone, their father's remoteness undoubtedly affected Bobby most of all. Phil's absences, other than an attentive period during Minnie's illness and rapid decline, were frequent and prolonged. During the Westchester County years, and then through the war and into the early 1950s, his work for American Sumatra Tobacco often took him to Hartford, Connecticut, the hub for the company's vast network of farms and fields in that state. Phil even kept a residence in downtown Hartford, in the grand Hotel Bond (the historic building now houses a Homewood Suites by Hilton).

Those were still flush days for shade tobacco cultivation in the Connecticut River Valley, where American Sumatra grew strains originating in the Dutch East Indies and Cuba to produce a plant yielding excellent cigar wrappers. Demand for the leaf had grown rapidly from about 1870 into the 1920s, with federal tariffs on imported cigars and tobacco increasing the advantage for domestic producers. When a US Department of Agriculture survey in 1899 established that Connecticut soil had qualities similar to areas of Florida already growing shade tobacco, the system was quickly and successfully

introduced up north. The plants matured each summer under miles and miles of cheese-cloth tenting, producing what company literature described as "a silky-type cigar wrapper which has a fine mild flavor and is attractive in color."

Vagaries of weather—rain, humidity, dry spells—could affect the crops from year to year; overall, however, during the quarter century Ted's father worked at the highest executive tier, American Sumatra showed growing profits and delivered handsome returns to investors. Phil Polumbaum was appointed executive vice president and general manager in 1930, and promoted to president (and concurrently still general manager) in 1950, holding that position another five years. He regularly delivered the company report to the annual shareholders' meeting; each October, a brief item in the *Wall Street Journal* recorded his characterization of the crops, the market, and prospects for the year, in terms such as "fair," "favorable," "satisfactory," and "profitable." With the exception of 1952, which brought loss due to drought, every year of Phil's executive tenure was profitable, the company sometimes paying extra dividends, as well as additional taxes for "excess profits."

As one historian puts it, tobacco cultivation was a "high risk, labor intensive, controversial, but potentially very rewarding occupation for owners if not for laborers." Ted evidently was never tempted to follow Phil's path. The one summer during high school that he worked as a picker did nothing to provoke his interest; to the contrary, the nausea, headaches, and other symptoms of "green tobacco poisoning" he experienced while absorbing daily overdoses of nicotine through his pores only fortified his distaste for the business. And the industry's reliance on immigrant and child labor would stay with him, fueling his criticisms of his father as well as his growing reservations about capitalism and profit maximization.

The vagaries of weather aside, labor was critical to American Sumatra's fortunes. In its fields and sheds, the company sponsored the sort of brutalizing circumstances that the adult Ted would come to deplore, as well as the endurance and resilience that the photographer Ted would seek to elevate and dignify.

Shade tobacco cultivation was a cyclical process of onerous work, requiring a versatile labor force and great attention to detail. The very notion of shade was deceptive, since the cloth filters that kept insects and wind at bay also were designed to reproduce tropical heat and humidity. Workers on the Connecticut plantations—as the large corporate farms were still called—would prepare and sow seedbeds in March and April; erect the mammoth tent structures over the fields in May; transplant seedlings from beds to fields in June; harvest plants leaf by leaf from July into August and sometimes September; sew the leaves onto wooden laths to be hung in barns for curing during August and September; move the drying leaves to warehouses for "sweating" in bulk piles during October; sort wrapper grades for color and quality in November; size leaves of uniform length into batches in December; and bale the product in January, with manufacturers sampling the bales and making purchases in February. Each step occurred two months earlier on the company's southern properties, in Georgia and Florida.

Seasonal crews for the Connecticut Valley harvest were recruited mainly from immigrant communities in the Hartford and Springfield areas, to be trucked back and forth for ten-hour workdays in the fields. They included people of Polish, Italian, Lithuanian, Jewish, and African American heritage, and sometimes "colored students" brought up from southern colleges. Post Office Square in Hartford, where in 1917 photographer Lewis Hine immortalized a wagonload of tobacco pickers, mostly young girls, bound

for an American Sumatra farm in the town of South Windsor, remained a main point of departure. Child labor was widespread; a government report from 1926 estimated that 5,000 boys and girls, half younger than 14, worked in Connecticut tobacco and onion fields.

Generally, males did the planting and hauling jobs, females the threading and hanging and sorting of leaves. When demand for labor peaked in the summer, all available hands of all ages were enlisted for picking, known as "priming." The procedure entailed going down each row of plants four or five times, at intervals of about a week, plucking four or five leaves from each plant on each pass. A 1930 monograph on Connecticut Valley tobacco production made the key role of children clear: "The smallest children do the first picking, crawling along the bottom of the rows to pick out the bottom leaves, which they lay in piles beside the plant. Men or boys haul baskets along between the rows and set the leaves in them. The second picking is done by larger children." This study noted that most of the children were "of foreign parentage," and reported that, "The women and girls are commonly paid by the piece, the boys by the day."

Not surprisingly, those corporate annual reports shed little light on the human complexities behind the numbers—although in 1942, Phil did say: "Like most farmers, we are faced with a labor problem which we will do our best to solve." Of course he was speaking not for "farmers," but for managers, directors, and owners; the "problem" was unspecified, but it likely had to do with wages and working conditions for those who actually did the farming.

During Phil's final two years as president, American Sumatra and several other large tobacco companies were fighting a US Department of Labor lawsuit alleging violation of the Fair Labor Standards Act. A federal district court ruled against the companies, a federal appeals court reversed the ruling, and the US Supreme Court upheld the original district court decision. As a result, American Sumatra was liable for back wages, although the company reported that the balance sheets could easily accommodate the judgment, as the amount was "not great."

With Ted a lost cause, Phil eventually pulled one brother into the tobacco business, mainly to get him a job and keep him away from his baseball fancies. Irving, known as "Sonny" in the family and "Polly" to his schoolmates, was the second youngest of Phil's siblings. At his Brooklyn high school, he played third base and shortstop his freshman and sophomore years, sat out most of junior year due to illness, and returned as a southpaw pitcher his senior year. He dreamed of a career in the major leagues. Phil, by then the ultimate authority in the family, disapproved. Irving settled in Hartford, Connecticut, to work as a foreman in American Sumatra's drying sheds.

Ted would not go rogue until after the war, but harbingers were appearing toward the end of high school. After spending two years in Harrison's old high school building on Halstead Avenue, which had opened in 1897 and would be converted to a middle school, he started junior year in the fall of 1940 in the brand new Harrison High on Union Avenue, farther from the center of town and closer to the neighborhoods of large lawns and big houses. Elder sister Peggy already was a co-ed at the University of Michigan in Ann Arbor. Brother Bobby was in seventh grade; his eighth grade class would be added to the new high school Ted's senior year, bringing the combined student body to 544—big enough to offer a breadth of academics and lots of clubs and activities, but small enough to foster a spirited sense of belonging.

Whether cause or effect, indications that Ted might deviate from convention

coincided with his involvement in student journalism. Harrison High's fledgling newspaper, *Maroon Murmurs*, offered plenty of leeway for experimentation. Wayne Pomfrey, a native of Brattleboro, Vermont, and graduate of Kent State University in Ohio, had launched the paper after joining the faculty in 1937. Pomfrey also introduced the traditions of Senior Day, Better Speech Week, and the Annual Spelling Bee. He taught English and journalism and advised both *Maroon Murmurs* and the school yearbook, *Reminiscence*. Ted was feature editor of the newspaper his junior year, and chief editor his senior year.

Perhaps high school classes were broadening Ted's horizons; his keen concern for national and international affairs and his awareness of great trouble brewing in the world surfaced in a "View of the News" column he wrote as a junior. A precocious faith in reason and dialogue also was showing itself. In November 1940, the lad of 16 cheered President Franklin Delano Roosevelt's reelection to a third term and urged fellow students to become informed citizens. "The world has grown smaller; forces of destruction are spreading in all directions, enveloping the weak," he wrote. "We must rise to meet the situation. Read your newspapers greedily; hear what experts have to say; discuss with your friends the foreign and economic problems; see what makes the United States of America click. It is evident that this younger generation will bear a heavy burden. We are up to it if we only start now."

The final issue of his junior year included a pledge from the newspaper staff, which Ted would lead the next year, to promote "liberal and progressive" views and policies in 1941–42. Ted's tenure as editor saw the bombing of Pearl Harbor and the US entry into World War II. Harrison High put up a "service flag," with a blue star added for each faculty member or student entering the armed services, replaced with a gold star for anyone killed in action. By Ted's graduation, four young male teachers had left for the military, including Pomfrey, who enlisted in the US Navy.

With occasional references to the gravity of the world situation, *Maroon Murmurs* primarily chronicled the staples of high school: academics, sports, drama and band, student council, school spirit and etiquette, new books in the library, hijinks in the cafeteria, the latest honor roll—which Ted perpetually made for his 90-plus grades. Editor Ted also furnished the unbylined "Exploits of Harry H.," recounting the vain strivings of a hyperbolic high school student.

The jocular tone culminated in the April Fools' issue, reincarnated as *Moron Murders*. The 1941 version, printed on salmon-colored paper stock, featured a banner headline announcing that one Commissar Andreyevich Beriberi Lemonov was calling on "Reds to Overthrow Profs." The 1942 edition, on green paper, with the legends "All-American Imbecility" and "First Class Yellow Journalism," proclaimed that homework was being rationed, school office personnel had been called to Navy mess duty, and the newspaper staff had rebelled against their slave driver of an editor, Ted Polumbaum—whose gory obituary could be read on the next page. A sketch of a fellow smoking and gambling divulged that Harry H. "isn't always such a good boy." The sports page reported the abolition of boys' athletics; the girls were taking over. Even the classifieds got goonied up: Seligson's stationery offered "Flesh Gordon comics; also Stuporman," Harrison Market invited "Take a gander at our chickens ... our experts will give you the bird," and Joe's Friendly Service Station claimed to be "really quite nice when you get to know us—Heheheh!"

As Ted neared the end of high school, his sister Peggy was embroiled in a whirlwind

of social activities at the University of Michigan and dating the varsity tennis player she would soon marry. The May 12, 1942, issue of *The Michigan Daily* carried news of Marjorie Polumbaum's engagement to Gerald Schaflander. Like Peggy's parents, Gerry's were offspring of New York Jewish immigrants. They had long since moved to Detroit, but Peggy's mother knew Gerry's mother from years before, and Gerry had been asked to look out for Peggy. Both sets of parents could only be pleased: Peggy was lively, charming and popular, Gerry ruggedly handsome, charismatic and articulate, and a big man on campus, pillar of a winning tennis team in both singles and doubles.

In the years leading up to the war, the University of Michigan had evolved from a campus known for parties and winning football teams to a worldlier intellectual milieu, into which Ted's future brother-in-law fit well. Gerry's leftist views on national and world affairs, although not yet ringing alarm bells with the family elders, would have an important influence on the evolution of Ted's political views.

Gerry also would turn out to have wild mood swings that brought on extreme mania, grandiose schemes, and paranoid imaginings. Down the road, at Peggy's request, Ted would find himself delivering Gerry into the care of a private psychiatric facility. Phil, to protect Peggy, would find himself covering Gerry's bad checks. For now, with Ted graduating high school and his sister and her fiancé finishing college, Gerry was a guy to look up to, and a vigorous tennis opponent who usually won.

In the spring 1942 *Reminiscence*, Harrison High's yearbook, Ted gazes seriously from group photos of newspaper staff, honor society, student council, and swing band (on saxophone, although his true instrumental love was clarinet). At the top of his senior class, he was named "most studious" in a cartoon gallery. His countenance in pictures betrays not a whit of the jokester impulses lurking beneath, but as usual, his words would: Across a two-page spread tracing the graduating Harry H.'s progression through high school, the prototypical student also took a final bow. By the time Harry had risen to the "supreme heights" of senior year, "he began to doubt his high and noble place in school," his inventor wrote. "Something faintly resembling humility hit him. He was beginning to Think, to Find Out, to Become Aware: there were many bigger things than being a Senior in High School." And with that, Harry H. bid adieu and good luck to all, wherever they were bound, be it college, work, or the military.

Without realizing it, Ted also was sending off the self he might have become, dispatching the prodigal son in the mold of his father who could grow up to be a tycoon. It would be quite some time before Ted was his own man, but already, the better angels of his nature were asserting themselves. The person he did become was modest yet assured, irreverent but with deep faith in the ordinary, serenely unmaterialistic but fretful about details, adaptable yet obdurate, daring yet apprehensive, an empiricist and a utopian, a poet and a wag, unimpressed by status, aghast at injustice, determined to find goodness.

5

Seek, Strike, Destroy

Why do we use the term "greatest generation" for participants in war? Why not for those who have opposed war, who have tried to make us understand that war has never solved fundamental problems?
—Howard Zinn, "The Greatest Generation?"
The Progressive, October 2001

As a kid, Ted thought waving around BB guns with little brother Bobby a lark, until the day he got a swell shot on a rabbit. Walking over to examine the corpse, Ted felt sickened. He was not a natural killer.

Nor was he eager to tempt death. He did not see combat in the Army, although he came under Japanese bombing and earned some battle stars, which along with a few other medals he called undeserved went astray with his duffel when he returned stateside. Later, as a photographer, he never wanted to cover war; the closest he came was inadvertent, when Time Inc. sent him to Southeast Asia, and he discovered US military advisers in Saigon. That was in 1961, a year our family spent mostly abroad, the longest stretch in India. When we got home, my parents started convening community meetings to examine the growing intervention in Indochina that hardly anyone knew about. Discussions turned even some hawks into doves. In our little town of Lincoln, Massachusetts, a 1968 referendum calling for US withdrawal from Vietnam garnered 39 percent of the vote, winning with a plurality. Ted joined Veterans for Peace.

But before all that, he would be a willing soldier for a cause most saw as just. Being drafted into World War II was no surprise; the 1940 Selective Service Act empowered FDR to order new rounds of registration with increasing frequency after Japan's attack on Pearl Harbor in December 1941, and Ted knew his turn was imminent. He was a college freshman at Yale when the call came. Withdrawing from his second semester, he reported for Army induction in New York City on February 18, 1943, and entered active service a week later, a few months short of his nineteenth birthday.

The first stop was Camp Upton on Long Island, where physical exams, inoculations, and intelligence tests were administered to new recruits. As a college boy, Ted anticipated placement in an office job, or perhaps further schooling on one of the campuses throughout the country hosting special military programs. Instead, he was assigned to tank destroyer training—TD for short—at Camp Hood, Texas.

Camp Hood, later Fort Hood (and like other military installations named after Confederate generals, now destined for possible renaming), sprawled over 340 square miles of limestone, between high plains and prairies. Its construction in the early 1940s displaced hundreds of farm and ranching families, while bringing in thousands of civilian

workers and then tens of thousands of soldiers. The encampment would focus on preparing tank destroyer troops to go up against mammoth machines "without regard to personal safety," according to their field manual. These specialized fighters would rely on "mass, mobility, firepower and aggressiveness." Their shoulder patch featured a black panther with the motto "Seek, strike, destroy!"

The first TD recruits arrived in spring 1942, before Camp Hood was even on the maps, for initiation rites that went considerably beyond the usual basic training. Commando-style drills simulated combat conditions, with obstacle courses, mock villages, ambushes, raids, and use of small arms and more substantial artillery, plus "improvised weapons" such as Molotov cocktails and socks filled with dynamite and dipped in tar to make them stick to the sides of a tank. For the first time in US Army history, live ammunition was being fired over troops in training. At the same time, the trainees confronted heat, chiggers, ticks, rattlesnakes, scorpions, and other venomous creatures. In the forests and fields around the base roamed wolves and cougars, bear and bison, deer and antelope. MPs patrolled the firing ranges on horseback, herding wayward cattle away; and K-9 sentries guarded the water wells.

Ted spent his first weeks of training feeling miserable and ended up hospitalized with the grippe. Convinced he'd been misclassified, he complained in letters home about stifling hierarchy, stultifying indoctrination, gratuitous abuse, and putting up with a bunch of racist yahoos. Although the Army had ordered desegregation of buses on base, the surrounding Jim Crow laws still held sway; Camp Hood's concession was to load Blacks from the rear of the bus forward and whites from front to back. Jackie Robinson, a second lieutenant assigned to a segregated "Black Panthers" tank destroyer battalion at Camp Hood during 1943–44, would take a different tack on a local commercial bus, refusing to move to the back even when ordered to by MPs. He was court-martialed for insubordination, but exonerated, and honorably discharged.

In her replies to Ted, his mother alternately soothed and chastised. With a didactic tone that could not possibly have pleased her son, Minnie wrote that Army life was "designed to teach one how to work with his neighbors and to instill in each man a sense of responsibility." In a subsequent letter, she admonished that challenges to one's values would teach "what to discard and what we need to hold on to," and added, "You are being trained for war, and, unfortunately, must be so disciplined as to be able to do your job—whatever it may be—with precision and dispatch." More solicitously, she wondered whether he'd made any friends at camp, had he gotten paid, and did he have spending money for his weekly day off. She assured him things would get better. She was happy to learn that Ted had taken and passed the Army's specialized training test, raising hopes for his reassignment.

Before long, the physical challenges of tank destroyer training were lifting Ted's spirits; his letters grew less bitter, even cheery, as he reported being in "tip-top" shape. Transcending his misadventures in rabbit hunting, he took to the grueling martial regimen with an ease that astonished his drill pal Ted Kazanoff, a fellow from the Bronx who would become an even closer friend as they both raised families in the Boston area. The trainees did lots of pushups, and ran up to 25 miles a day with packs on their backs. They learned to use hand grenades, Enfield and M1 rifles, carbines, 75-millimeter and three-inch freestanding and mounted artillery, 50-millimeter machineguns, 45-caliber handguns, bazookas, and Thompson submachine guns (tommy guns). They practiced assaulting and occupying dummy houses where play-acting enemies lurked. They

scaled steep walls, climbed barbed wire-covered embankments, and forded rivers, going hand-to-hand along wire strung between trees. "Ted had the muscle for it. I couldn't do it, and dropped in the drink," Kazanoff reminisced long afterwards.

By this time, spring 1943, some 80,000 men had come through Camp Hood for TD training. Over the opposition of top commanders, FDR had agreed to join the British in the North Africa campaign, the first major test for the man-against-machine strategy. Initial TD battalions deployed to North Africa did poorly against German Field Marshal Erwin Rommel's mechanized juggernaut, suffering 85 percent casualties. Ultimately the Army scaled back its ambitions for these shock troops, forming only two brigades instead of more than a dozen originally envisioned. Within a year, one was disbanded, the other sent to Europe. The concept was abandoned entirely soon after the war.

Pure luck saved both Teds from becoming immediate cannon fodder. Ted Kazanoff shipped out to the Pacific. On the basis of his advanced test results, Ted Polumbaum landed on the campus of Ohio State University for three months of Spanish language immersion. Although his Spanish never got used for the war effort, he held onto the hefty textbook, and the studies came in handy much later when he was taking pictures in Latin America.

With need for replacement troops growing in Europe, and fighting in the Pacific intensifying, the Army was emptying classrooms and sending the extra-bright boys back out with everyone else. My father's next posting was Camp Crowder, Missouri, for Signal Corps training, a cinch compared to the TD experience. Then he, too, joined the flow of reinforcements to the Pacific Theater.

General Douglas MacArthur's island-by-island campaign through the southwest Pacific was advancing steadily when Ted's troop ship left the California coast in the fall of 1944 to help consolidate the territorial gains. He was stationed in New Guinea into the summer of 1945. The world's second-largest island after Greenland, New Guinea was an early priority as the main buffer for Australia. Once the Japanese had been dislodged, enormous engineering efforts had turned tracts of primeval forest dotted with villages into a vast staging area, with airfields, roads, docks, pipelines, and tent encampments servicing the permanent bases.

Signal Corps units installed and maintained radio communications, with extensive networks of wiring that had to be repeatedly inspected and replaced in the tropical humidity. Ted's outfit strung wire through the jungle, and did supply work, loading and unloading trucks. Between forays into the thick vegetation of the rain forest and slogs through the mud, the soldiers played cards and ball games, swam, did laundry, cleaned their tents, smoked, and shot the breeze. The chorus of birds and insects was constant; mosquitoes and flies were everywhere. It rained frequently.

Ted learned to play bridge. Dengue fever knocked him out for a couple of weeks. His fingers got infected with jungle rot, whose abrasive effects lasted a couple of years. He became a smoker, which lasted 25 years. Cigarettes, considered essential to morale, were included in field rations, given as awards for sharpshooting contests, handed out by visitors from on high. Every US soldier got five to seven packs a week and could buy more for a song; anyone who didn't smoke was considered a freak. Ted finally shook his two-pack-a-day habit in 1970. (Three decades after that feat, following his death from a mysterious brain affliction, an autopsy found his lungs remarkably robust, despite obvious long-term tobacco damage.)

While Ted was in New Guinea, allied combat forces were advancing up the Philippine archipelago, retaking the islands from the Japanese. Support troops followed to

develop and maintain the bases. MacArthur had famously waded ashore on the island of Leyte to declare his return to the Philippines, and his forces reached the main island of Luzon in early 1945. Ted's unit arrived at Leyte later that year. Again, the soldiers lived in tents surrounded by jungle. Possessing requisite good diction, with no discernible accent, Ted was assigned to switchboard duty. He played more bridge and a lot of Ping-Pong.

The war in Europe was over; everyone knew the invasion of Japan was next. Across the Pacific, troops found welcome distraction in Hollywood movies, the industry's contribution to the war effort. Ted was watching an outdoor movie at his rustic base the night of August 6, 1945, when the projector suddenly stopped. A voice came over the public address system with a message from Supreme Headquarters: "Today an air force plane dropped a new type of bomb on the Japanese city of Hiroshima. The bomb is said to have the explosive power of 10,000 tons of TNT." Pandemonium and cheering ensued. Similar scenes occurred for the bombing of Nagasaki on August 9 and the announcement of Japan's surrender on August 14.

Ted was overjoyed, too. His feelings would change dramatically as more information emerged about the scale and nature of the human devastation. Later, when historical research suggested the Japanese already were prepared to surrender, he became convinced that use of the atomic bomb was unnecessary as well as immoral. He considered it a war crime, probably a political decision designed to alert the world, and particularly the Soviet Union, that the United States intended to be the number one power on the planet.

Even those whose thinking did not change realized the world had. "Hiroshima signified the pointless apocalypse—the sudden realization that we could extinguish ourselves as a species, with our own technology, by our own hand, and to no purpose," psychiatrist Robert Jay Lifton and his coauthor Greg Mitchell observed half a century later.

The bomb added horror and urgency to the great novels and memoirs that came out of World War II. Yet the glorification continued. "For the past fifty years," veteran and historian Paul Fussell would write, "the Allied war has been sanitized and romanticized almost beyond recognition by the sentimental, the loony patriotic, the ignorant, and the bloodthirsty." Reference to the Second World War as "good" or "justified" or "necessary" obscures the fact, he said, "that it was a war and nothing else, and thus stupid and sadistic."

Tom Brokaw extended the myth into best-seller status, dubbing the Americans who fought in World War II "the greatest generation." My father, who tended to see the best in people, might have called his cohort a compliant generation. My mother, less charitable, considered them a generation of sheep.

America's World War II vets came home, put their heads down, raised families, and got to work. At least that is the prevailing depiction. Most seemed to leave the war behind, saying little about whatever trials and tribulations they might have experienced.

My father certainly didn't talk about the war; the best account I have of his experience was elicited by my elder son, in fulfillment of a sixth-grade assignment. Ted's recollections and explanations are funny, self-effacing, and incomplete. It is to my perpetual regret that I never asked him to fill in the gaps. By the end of his life, it was too late.

He did have one story that he gladly shared, however, about his experiences with the apartheid military of his day. In a written account he prepared and revised numerous times for an adult education course, plus repeated recitation in family settings, supplemented by my additional research into US volunteers in the Spanish Civil War, the situation of Black troops during World War II, and the fare that Hollywood made available overseas, it goes like this:

A New York City Jewish kid who'd gone to City College, a wise guy named Irv, was Ted's good buddy in their outfit in New Guinea. Irv knew the greatest collection of dirty jokes imaginable; he could keep his bunkmates up until 3 in the morning in their tents, telling one unspeakably filthy joke after another.

Politically, Irv was a radical. He got his subscription to the progressive New York daily *PM* sent to him in the jungle and would pass the paper on to Ted.

One day, he summoned Ted for a walk. Irv obviously knew where he was going. The pair tramped through mud, past tanks and half-tracks—trucks with wheels in front and caterpillar treads in back—tipped on their sides in shell craters filled with yellow water, and on into the tangled tropical forest that after an hour or so opened into a clearing. A Black ordnance company was camped there. A Negro unit, as they were called in the segregated army of those days.

Out strode two Black guys in green fatigues. One was a giant, wearing the six up-and-down stripes of a master sergeant. His name was George. The other was a wiry street-smart staff sergeant named Frank Alexander. He was a veteran of the Spanish Civil War—a "premature antifascist," as international volunteers in that prelude to world war would come to be called.

Irv and Ted ended up visiting the Black unit from time to time, sharing copies of *PM*, listening to jazz, talking about politics.

Frank, son of a Black father and a white mother, had grown up on a Sioux reservation in Nebraska, an environment more accepting of mixed-race marriages than the world at large. His father was a cowboy who claimed to have ridden for the Pony Express (unlikely, given that the legendary service lasted only 18 months in 1860–61, though perhaps he'd been a horseback mail carrier later).

As a young man, Frank moved to Los Angeles, found lodging in a flophouse run by the Young Communist League, became a Communist, joined the Abraham Lincoln Brigade, and fought with the loyalists against Franco in Spain. When he got back to LA, he married a white woman. Since interracial marriages were illegal in California, their certificate falsely identified her as Negro. Once the US entered the war and fighting fascists was

Ted with Sgt. Frank Alexander in New Guinea, 1944 (family collection).

a legitimate pursuit, Frank enlisted in the Army. After the war, he would be followed and harassed for years. He and his wife both resigned from the Communist Party after the 1956 Soviet invasion of Hungary.

George, the unit's ranking officer, was a commanding, charismatic presence, obviously revered by his men. He'd been a sharecropper in Georgia, extremely intelligent but practically illiterate until Frank began teaching him and others in the unit to read and write.

Early on, the Army imposed no literacy standards, and took in tens of thousands of illiterates for war service. Then, for a while, a fourth grade reading and writing level was required—with a nice loophole, a quota for "intelligent" illiterates, up to 10 percent of men reporting to any given induction station on any given day. Finally, the literacy requirement got thrown out; there was too much potential manpower to pass up. Overall, about a third of the Blacks entering the service during the war and about 5 percent of the whites were illiterate. The Army was supposed to bring them up to a minimal level before deployment. The Communist Frank Alexander was doing a lot more, truly teaching men to read and write.

George showed Ted and Irv a letter he was sending to his landlord that read: Dear Boss, I'm writing to say I'm sorry, but I won't be working for you anymore.

One time, with darkness falling as they wrapped up a visit to the Black encampment, Irv and Ted invited Frank and George to accompany them back to their camp to see a movie. Hollywood was on board with the war effort, and sent over a constant stream of first-run movies—musicals, comedies, lots of military-themed pictures: *Mr. Winkle Goes to War, To Have and Have Not, The White Cliffs of Dover*. On such fare, the 16-millimeter projector got pretty much a nightly workout. For the white troops, it was a great break from the monotony of camp life.

The invitation to their Black friends was spur of the moment, without thought for how the whites might react. Ted and Irv were starting to wonder, even worry a little, as they walked back through the jungle.

They approached the benches set up for the outdoor screening. Guys already were filling the seats. A bit of murmuring arose. Then the second lieutenant stood up decisively, welcomed the visitors loudly, and commanded his men to make space and bring the guests some beers. They all watched the movie. It was altogether a comfortable scene.

On July 26, 1948, Harry S. Truman issued Executive Order 9981, as follows: "It is hereby declared to be the policy of the President that there shall be equality of treatment and opportunity for all persons in the armed services without regard to race, color, religion or national origin." Irv and Ted had integrated the army—in one company, for a couple of hours—four years before President Truman got to it. My dad relished telling the tale.

Given Ted's admiration for Frank, I sometimes wondered whether, had he been older, my father would have joined other stalwart young internationalists in violating US neutrality laws and going abroad to fight on the loyalist side in the Spanish Civil War. I'm sure he would have been inspired by the noble cause. The German and Italian fascists were happy to assist Franco, and the democracies were letting them demolish the Spanish republic. Around 3,000 Americans signed on with the international brigades; only about 1,800 survived. So if he'd gone, there's a good chance I wouldn't exist.

But Dad always professed to being a coward, so he probably wouldn't have gone.

6

The Ivied Idyll

Learning is ever in the freshness of its youth, even for the old.
—Aeschylus, *Agamemnon*

Ted Polumbaum was among some 900 freshmen who left Yale College for military service and were entitled to return. After the circuit that took him from Texas, Ohio, and Missouri to New Guinea and the Philippines, the spring of 1946 found him back on the New Haven campus.

He makes a cameo two-thirds of the way through *We of '48*, a heavy blue-bound tome produced by alumni for an upcoming fiftieth reunion in 1998. Among hundreds of mugshots the size of postage stamps, studio-posed half a century before, my father's smooth, narrow face, with high forehead, even features, and mildly ruffled crew cut, offers a youthful half-smile. Not that he ever emanated angst, but this does not look like a man returned from war.

The class of 1948 was actually a medley of overlapping classes on a variety of often interrupted, and then often accelerated, calendars. Some members in fact graduated in 1947 or 1949. The cohort included about 600 admitted as new freshmen in July 1945, as well as many enlisted men brought to campus during the war for foreign language, area studies, engineering, medical, and officer training programs who stayed, and hundreds more arriving after the war with support from the GI Bill.

As the fiftieth gathering approached, the addition of vets, transfers, and those with redefined years had nearly doubled the official class count to 1,172. The most famous member undoubtedly was George Herbert Walker Bush, 41st president of the United States.

A browse through *We of '48* brings to mind the phrase "male, pale and Yale," which long summarized standard qualifications for the diplomatic corps. The description is no stereotype here: Even with vastly expanded college enrollment, Yale's immediate post–World War II constituency was not exactly a rainbow. Among these undergraduate faces are one Asian, George Lee; and one Black, James Jay Swift, who played three seasons of Yale varsity basketball.

No female faces, of course; the first women undergraduates would not enroll until the fall of 1969. But a few women had infiltrated graduate programs, my mother among them. Nyna Brael was studying at Yale Drama School in the fall of 1946 when a friend introduced her to a lanky guy wearing Army cast-offs. She and Ted quickly paired off and married the following year.

Nevertheless, Yale's postwar students did represent a newly democratic air in higher education. The college continued to favor prep school graduates, legacy sons of alumni,

and otherwise entitled boys, the so-called white-shoe crowd (its members fond of wearing fashionably scuffed white buckskins), but the GI Bill brought far more economic and social diversity, not to mention heightened respect for academic diligence. The bill's beneficiaries were considered keenly motivated and mature. One observer of Yale history says the returnees "created an academic golden age on the campus." Another scholar says the widespread impression of student-vets as "gracious and grouseless white males" ensured the legislation's popularity for years. Historians agree that the bill—officially, the Serviceman's Readjustment Act of 1944—was an important factor in the emergence of America's postwar middle class.

The GI Bill also forced Yale to relax admission policies discreetly instituted in the 1920s to limit rising Jewish enrollment. The unofficial quota had been fine-tuned to discriminate "seemingly impartially," as one historian puts it, against groups in which Jews tended to be well represented, including public school boys, high academic achievers, and those from relatively poor backgrounds. Nearly 10 percent of entering freshmen in 1947, and even more the next year, identified as Jewish. For a time, until social snobbery reemerged in the 1950s, meritocracy made visible headway. That did not stop the university from opposing bills in the Connecticut legislature to ban bias in college admissions; into the 1960s, Yale retained its reputation, says the historian, as "the most Gentile college in the Ivy League."

In my father's case as a returning second-generation American Jew, the GI Bill further freed him from his aloof, conservative, businessman father. Phil identified not with the poor Eastern European Jews of his Russian forbears, but with the prosperous and assimilationist German Jews. The family celebrated Christmas, and status and appearances were of utmost importance. Given the -*baum* (German for

Nyna's notepad impression of her new beau Ted, 1946 (family collection).

"tree") in Polumbaum, some German heritage was assumed. The assumption was wrong, the antecedents lowlier than Phil ever let on. Decades after his death, a simple Internet search of ancestry records supplied the details: Phil's father Moses and uncle Marks, serving as each other's witnesses for their 1882 naturalizations, were immigrants from Tsarist Russia and, respectively, a fishmonger and a butcher.

Upon his initial admission to Yale in the fall of 1942, my father had been one of those rare Jewish tokens, albeit with a bit of an edge: The Ivy League gates opened to him by virtue of his father's wealth, enhanced by his stellar academic record. He'd been curious about experimental Antioch College in Ohio, a notion probably implanted by brother-in-law Gerry, but Phil would pay only for Yale.

Back on campus on the GI bill, Ted no longer needed Phil's support. He resumed his freshman job shelving books in the law library, supplemented by a factory job setting up cardboard shipping cartons. Yale tuition then was $300 a term—around $4,000 in today's dollars (up from $215 his freshman year, about $3,400 today). Rooming in the residential colleges cost $162.50 a term, plus $10 a week for meals, with a gymnasium fee of $5 and accident insurance of $15 a year. The federal minimum wage in 1946 was 40 cents an hour.

The Yale to which my father returned had conservative inclinations, to be sure, but the ambiance had yet to give way to Cold War sensibilities. A 1948 survey of Yale students found that 60 percent considered themselves "liberal," and that "communist infiltration" was not a widespread fear. Fifty percent identified themselves as Republicans, 16 percent Democrats, 31 percent independent, and 4.5 percent communist or socialist. William F. Buckley, class of '50, chairman of the *Yale Daily News*, sometime FBI informant, future conservative columnist and TV host, was not yet an outsized force on campus. Buckley would rise to national attention with his acerbic tract *God and Man at Yale*, published in 1951, in which he extolled free markets and Christian individualism, and condemned certain Yale departments and faculty members as propagandists for secular, atheistic, and socialistic views. At this point, however, the sort of invective and paranoia that would devolve into wholesale inquisition was merely gathering force. For now, the intellect was free to roam.

That atmosphere reflected Yale's relatively enlightened and engaged administration in the years surrounding World War II. Charles Seymour had grown up in the orbit of the Yale system and returned as history professor, provost, and finally president from 1937 to 1950. He vigorously supported study of the liberal arts; one biographer says he viewed the university as "guardians of our culture, and especially of those aspects which do not serve an immediate material utilitarian purpose." Anticipating wartime mobilization, Seymour had added a summer term to the academic year so that undergraduates could earn their degree in three years. Once the US entered the war, he welcomed year-round armed forces programs that would bring nearly 22,000 uniformed men through campus. During the early days of what came to be called McCarthyism, he defended academic freedoms and declared that there would be no witch hunts at Yale.

His successor, Arthur Whitney Griswold, president from 1950 to 1963, had different sentiments. While paying lip service to freedom of expression for faculty, Griswold railed against "the menace of Communism" and sought to purge the ranks of any such taint. During the same period, in the early 1950s, the renowned Rev. Henry Sloane Coffin—graduate of Yale College and Yale Divinity School, retired president of Union Theological Seminary, and father of William Sloane Coffin, who as Yale's campus chaplain became a prominent activist against the Vietnam War—decried the atmosphere of the day with its "childishly hysterical … stupid attacks" on academic freedom.

The political sands were still shifting half a century later, as the class of 1948 planned its fiftieth reunion. Contributors to *We of '48* found reason for cheer as well as intimations of trouble. Half a dozen distinguished class members set the mixed tone of uplift and chagrin in introductory essays. The sunnier compositions extolled economic and technological progress, advances in biomedical research and quantum physics, and the American commitment (if not without lapses) to the rule of law. More sanguine authors bemoaned the shredding of the US social safety net since the Reagan years, the twin threats of population explosion and environmental degradation, and the growing hostility toward government.

The reunion volume is stocked with attorneys, engineers, physicians, manufacturers, and investment advisors, with a smattering of writers, artists, small-town pastors, a retired Reform rabbi, a Trappist monk living in Brazil, and many educators. In comments with their profiles, a few mention the demons of atheism and the political left; the motto "For God, for Country and for Yale" remains their touchstone. Other, in contrast, celebrate the fading of elitist trappings, snootiness, and class prejudice that lingered over the Yale of their day. A few commend the ostensible demise of anti–Semitism, with proof cited at the highest ranks of their beloved university: "A man named Levin is president." Richard Charles Levin led Yale from 1993 to 2013.

In line with the foreign service stereotype, a good many of the pale, male Yalies in the class of 1948 indeed went into diplomatic service and other civic roles. The class secretary notes the cohort's contributions to government and industry leadership: Along with that one US president, he counts three US congressmen, four ambassadors, and a bevy of other diplomats, legislators, mayors, commissioners, judges, and federal officials. Several men worked for arms control, environmental protection, and other prescient public causes. Some became spooks.

One man lists his occupation as "Research Engineer," employed by the US Agency for International Development, surely his intelligence cover. Recalling his time as a USAID adviser stationed in "the nether reaches of Vietnam" as the war there escalated, he recounts meeting a fellow Yalie on an Air America flight—not mentioning that this transport service was the CIA's covert airline.

My parents hadn't known this fellow on campus but made his acquaintance years later through pure happenstance. Ted first encountered the man's wife, neither realizing the Yale link, in late summer of 1961, as our family's long sojourn in India was coming to a close. My mother and my sister and I were cooling off in Kashmir. My father was returning from his picture assignments in Southeast Asia. In the lobby of the Delhi hotel where he'd booked a night on his way to rejoin us, he encountered a distraught American woman with three children. She was en route from South Vietnam back to the US, and the hotel had no more rooms. Dad gave her the bedroom in his suite, settling himself in the sitting room.

A few years on, the husband discovered the college connection in alumni notes. He also lived in the Boston area, and immediately invited my parents over to thank Ted for extending shelter to his wife and kids. As a descendant of Polish aristocrats, he was a "pathological anti–Communist," he explained cheerfully. Above all, he was an adventurer, and very grateful to Ted.

A fair number of '48 men went into journalism. Some worked for newspapers and wire services, as Ted would until his HUAC appearance and unceremonious dismissal from United Press. A few of his classmates rose in broadcast news organizations,

including Martin Plissner, a CBS News pioneer in network television coverage of presidential elections. Several became prominent correspondents for Time Inc., the magazine empire that would open the doors for my blacklisted father's new career.

Time-LIFE patriarch Henry Robinson Luce, Harry to his chums, came from Yale's class of 1920. As a senior, he'd been managing editor of the *Yale Daily News*, with his prep school pal Briton Hadden a rank above as chairman. With $86,000 coaxed from 72 investors, Luce and Hadden went on to launch *Time* as a weekly news magazine in 1923. Within four years, it was turning a profit. Following Hadden's early death in 1929, Luce gradually expanded his offerings, adding *Fortune* in 1930, *LIFE* in 1936, newsreels during the war, and *Sports Illustrated* in 1954. The Time Life Books division began in 1961. It was one of the last great personal media kingdoms, seeking to address broad swaths of audience, not yet transformed into an impersonal corporate entity.

The conventional pipeline from Yale's campus paper to Time Inc. was established early on: The best prospects from the Yale newsroom "all make it," wrote novelist John Leggett about a barely fictionalized version of prewar Yale, "and after graduation they all go straight down to Harry Luce and get on with it."

Ted was never part of that patrician network. Indirectly, though, he would always be beholden to Luce. Publication in *LIFE* would be my father's big break as a professional photographer. Despite the publisher's fierce anti-communism, the editors in New York had license to ignore the blacklist in the interests of getting first-rate pictures.

Although my parents formed lasting friendships at Yale, they never bought into the prestige, preferring to hang out on the margins, with lefties and theater geeks. Nyna was always convinced, with no proof, that the Yale administration had provided information on progressive students to the House Committee on Un-American Activities when HUAC was trolling for educational subversion in the early 1950s. In response to fundraising appeals, she'd write letters back explaining why she wasn't contributing.

As a photographer, Ted would return to New Haven on assignment for *Time* magazine over May Day weekend in 1970 to cover rallies in support of the Black Panthers. Yale President Kingman Brewster, Jr., had been castigated by conservative alumni for his accommodating attitude toward protesters, and was somewhat vindicated when no violence occurred. My parents occasionally detoured through the familiar campus grounds on drives between Boston and New York, and revisited once for an alumni seminar program. They kept up with Yale in the news, and were especially delighted to read in *The New York Times* about a younger physician friend attending a reunion (class of 1968, MD 1972) pursuing and catching an arsonist who'd set fire to a student encampment protesting investments in apartheid South Africa. But they were not reunion-goers and did not go to that fiftieth in 1998.

Another decade on, after my father's death, my mom told a disconsolate grandson (my younger son) that he was fortunate to have known his grandfather and could be thankful Grandpa wasn't "a geezer in a blue blazer," which is how she thought of most Yalies of that era. Dad was a bit more forgiving, at least about the postwar crowd.

Before the war, during his freshman year, as a Jew and a studious product of public schools, he'd felt quite out of place. He was especially perturbed by the crudeness with which Yale men talked about women, and even shared his concerns with a progressive New York City psychiatrist someone had recommended. The doctor told Ted not to worry, that those guys were the misogynist sickos, and he was just fine.

Upon his return to Yale, Ted had plunged back into the humanities, taking courses

with some of the teachers William Buckley would soon revile in print. And, casually but fatefully, he'd joined the John Reed Club—the affiliation that landed him before HUAC some years later. The original, prewar John Reed Clubs, named after the journalist famed for covering the Bolshevik revolution, had been loose clusters of left-wing intellectuals and artists. The postwar rejuvenation was a minor project among progressive students, starting with a chapter at Harvard. Buckley belittled Yale's offshoot as "fringe," which aptly described its influence, if not its ideology. With negligible membership, openly receptive to communist ideas and adherents but essentially innocuous in constitution, the group's main activity was hosting leftist speakers on campus.

My father's favorite professors at Yale were Raymond Kennedy and Ralph Turner, two of the individuals William Buckley would excoriate as dangerous infidels in his 1951 book, *God and Man at Yale.*

Kennedy's appointment was in sociology, but he was really an anthropologist, and an expert on Indonesia. Ralph Turner was a pioneer in the field of world history. Both were gifted teachers who packed the lecture halls. Buckley himself conceded that they were knowledgeable and competent; in his view, their charisma and popularity made them all the more pernicious. He claimed they held religion up to contempt and mis-led masses of young acolytes—a lot of hooey, Ted would have said, as if students couldn't think for themselves.

In those days, the history purveyed in the classroom unfolded mainly in America and Europe, and not much elsewhere. Turner, who began his career as an American-ist, gradually expanded his repertoire to encompass the enormous diversities of societies and civilizations. In 1935, he'd been dismissed from the University of Pittsburgh, purport-edly for "discussing religion in the community and the classroom," although subsequent inquiry made it clear that his New Deal enthusiasms and other progressive inclinations were a larger factor. He continued teaching, at the University of Minnesota and then at American University, before landing at Yale, where he shared his unending quest for a unified understanding of cultural patterns and changes. In his best-known work, the two-volume *The Great Cultural Traditions*, he observed: "Historical synthesis does not consist of piling up more and more subjects; actually it involves the integration of data in always more ways so that the history becomes increasingly understandable as social movement in time."

Kennedy, animated, outspoken, charismatic, himself a product of Yale College and graduate studies, taught introduction to sociology and anthropology. He'd established Yale's first interdisciplinary studies program, focusing on Southeast Asia, long before the US wars in Indochina brought attention to that region.

Before settling on an academic course, Kennedy had been a car salesman—a field representative for General Motors in what was then the Netherland East Indies. His inter-est in Southeast Asia ignited, he returned to Yale for his doctorate. During World War II, he worked for the Office of Strategic Services and the State Department.

Buckley faulted him for stooping to entertaining students—a charge that looks mildly ludicrous today, when the competitive pursuit of customer satisfaction on college campuses suffuses the teaching mission. Kennedy indeed was a showy lecturer, speak-ing with great enthusiasm, his hands drawing circles in the air, but he was far more than a crowd pleaser.

He didn't like to see people pushed around. He called the Dutch in Indone-sia a bunch of bastards like all the colonialists. He attacked racial prejudice, seeing it

as the central thread in oppression and exploitation. He claimed to be an agnostic, and expressed some level of religious reverence, but did get in digs at the Catholic Church. He didn't mince words, holding that teachers should speak out for what they believe. He didn't think Yalies were dummies; he respected their intellectual level.

Turner, by contrast, was not a showman. Still, he held his audience, using poetry and proverbs in his lectures. He would start with prehistoric times, tracing transitions from nomadic to agrarian to urban ways, from self-sufficient isolation to the rise of trade and commerce. He then proceeded through the great cultural traditions—Egyptian, Iranian, Hebrew, Chinese, Indian, Greek and Roman, Western Christian civilization. He humanized primeval man and woman, and drew connections among these different times and places and societies: high and low, good and bad, the exalted, the destructive. He didn't disparage. His lessons incorporated reverence for nature and celebration of artistic creation. He talked about imperialism, slavery, class distinctions, literacy, ethics, humor, configurations of power, the shapeshifting of tyranny and democracy.

Turner especially loved the heritage of classical Greece, considering it deeply humane. He worked for the State Department also, and later for the United Nations Educational, Scientific and Cultural Organization, in charge of preparing a comprehensive history of humankind. He passed away at 71 in 1964 with only the first of a projected six volumes completed.

Shockingly, Kennedy would be murdered by bandits in Borneo in late 1950, along with a *Time* correspondent, Robert Doyle. The maverick professor had just commenced a long-planned period of fieldwork to study interactions of Western and local cultures. He always drove his own jeep; Doyle, working on a story about Indonesian peasantry, had hitched a ride. The killers were never identified. Kennedy was 44 years old. Even Buckley called the death tragic, not that it mitigated his disdain.

The breadth, depth, and passion that scholars like Kennedy and Turner brought to the lecture hall surely helped shape my father's approach to the world. These learned men's keen curiosity about human beings, respect for cultural and individual differences, and readiness to cross boundaries of discipline, time, and space would have propelled my father's appreciation for study, analysis, and discussion of big ideas. Their esteem for the minds of their students may have fostered my father's tolerant approach to others, even those with whom he disagreed. Kennedy's outrage at discrimination based on race and color certainly reinforced Ted's concerns for social justice.

Obviously, my father valued his Yale experience. Even when his occupation revolved around images, he always treasured words. His incessant reading meant he was never bored. Throughout his life, he continued to husband knowledge. While resting on some bedrock principles, his thinking remained flexible, ready to adapt to new discoveries.

Yet he loved to make fun of academicians—seldom in their presence, but merrily in mine. As I was earning my PhD and entering the professoriate myself, I'd set him off roaring with laughter merely by reading him titles of papers from scholarly meetings. Even my own dissertation title, with the obligatory colon followed by a long subtitle, was cause for mirth. In my dad's estimation, they didn't make academics quite like they used to. The fragmentation of knowledge into smaller and smaller divisions meant fewer scholars had the scope of those amazing guys who taught him at Yale.

Dad's glee over academic conceit was my reminder not to take myself too seriously. At the same time, his pride in my academic career was a gift—albeit an extravagantly amplified one. In my younger days, I was mortified by his habit of striking up

conversations with just about anybody, anywhere, and delivering unsolicited tall tales about my superlative aquatic skills, my genius as a swimming instructor, my growing Mandarin fluency, my stellar reporting and dazzling writing. By the time I was on the tenure track at the University of Iowa, I was used to his risible claims, and his penchant for sharing them with total strangers. Now he bragged that I was the world's foremost expert on Chinese media. I merely rolled my eyes.

Like father, like daughter? According to my mother, my dad was painfully shy when they first met. Evidently, his subsequent job as a newspaper reporter, which compelled him to talk to people, and his work as a photographer, which required him to loosen people up, generated expanded powers of speech. I was pathologically fearful as a child—afraid of thunder and lightning, terrified that the atomic bomb would drop, good at schoolwork but mute in class, paralyzed when I needed a bathroom break and thus forever holding it until I got home. Once I, too, became a newspaper reporter, I experienced the same compulsory emergence from my shell. I, too, strike up conversations with total strangers everywhere.

When my father came down with his baffling brain ailment, I was ten years into my professorial run. In another year and a half, he was gone. With his death, I lost my greatest fan. He never got to see me through promotion to full professor, nor to hoot and holler over the lofty title I acquired upon leaving my Iowa teaching job: professor *emerita*.

Researching my father's Yale days, I discovered that his beloved Professor Turner had begun life as a small-town Iowan, earned his undergraduate and master's degrees at the University of Iowa (then called the State University of Iowa), and taught there for a while. I could imagine Dad guffawing and coming up with some silly twist on words: "Ah hah! All roads lead to Iowa! Or maybe from Iowa."

Since my brainy dad aced high school, I was curious to see his college grades. He was gone, so he couldn't request his own transcript, and couldn't give me permission. Yale Corporation rules decreed that nobody else could get it for 75 years after the individual's death, and I'd be dead myself before that. I made phone calls, and with commendably little fuss, Yale's senior vice president for legal affairs granted the exemption.

Ted's abbreviated freshman year (July 1942 to January 1943), he took English, History, Philosophy, Psychology, and Spanish, earning mostly As and Bs, with one A-plus his first term of Philosophy and one C his second term of Spanish. In his delayed sophomore year (March to June 1946, with credit granted for an additional term "in consideration of war service"), his now-numerical grades were no more impressive, ranging from 60 in Classics to 85 in Psychology, with Econ, History, and Sociology in between. Things perked up a bit for the 1946–47 and 1947–48 academic years, though he attained nothing over 91. His major is listed as History; I'd always thought it was English.

His final classes concluded June 5, 1948, a day after he turned 24. His BA was granted June 21, 1948. He was already married to Nyna, over his father's objections. Phil had underscored his displeasure with a not entirely successful campaign to keep relatives away from the wedding. Ted did not attend his own graduation ceremonies, sparing Phil the chore of orchestrating another boycott.

Seeking Haven

May the forces of evil become confused on the way to your house.
— George Carlin, HBO stand-up special *Playin' with Your Head*

During the war, with Minnie suffering from cancer (although nobody uttered that taboo word), Phil sold the estate in Harrison, and Ted's parents moved to Manhattan to be closer to Sloan Kettering Institute, the nation's foremost cancer center. The new home was a two-bedroom, two-bath apartment, furnished with antiques brought from the Westchester County homestead, on the twenty-seventh floor of the legendary Warwick Hotel—a Renaissance Revival tower built by newspaper magnate William Randolph Hearst out of love for his mistress Marion Davies, whom he'd installed in the penthouse when it opened in 1926. Davies was long gone; Cary Grant was yet to move in. Phil became known as a generous tipper. Minnie, bedridden but gracious the one time that Ted brought Nyna for a visit, would be dead by the end of 1946.

Ted felt embarrassed just walking into the Warwick lobby. Increasingly, Nyna's family would offer refuge of a much more modest sort, along with the kind of warmth and acceptance that his relationship with Phil lacked.

Nyna's parents, the common-law couple Ruth Amdur and Lazer Israel, had met amid the hothouse of educational and social activities for new immigrants on the Lower East Side. Lazer, a tailor who made his own sports shirts and played the mandolin, had arrived from the Ukraine with his parents as a youth. Following a reluctant stint back in Europe as a World War I draftee, who even during the worst battles in France fired only into the air to avoid hurting anyone, he moved restlessly from job to job in New York City.

Ruthy, one of seven children orphaned in a typhoid epidemic, had left Belarus by herself as a young teen, a basket of belongings on her arm. From Warsaw, she worked her way west across Poland and Germany to Holland, mostly in hat factories, saving enough for sea passage to America. World War I was underway, and an encounter with German U-boats prompted the ship she was on to return to Rotterdam, but eventually it set out again. Ruthy finally arrived at Ellis Island on the Dutch vessel *Noordam* in May 1917. Her skills as a hat trimmer translated easily to sweatshops in New York's garment district.

Lazer and Ruth ran a candy and cigar store in Coney Island during the Depression. A dashing fellow named Morris Zweiban often came around to chat up the tiny, beautiful proprietress. Murray drove a taxi, cared for his Romanian mother, and practiced speed skating at a rink frequented by an Olympic star. Ruth and Lazer split up, without rancor, when Nyna was about 12. Lazer married a younger woman, Jean, whose

homebody tendencies tamed his restlessness a bit. Ruthy married her admirer Murray, who soon was running his own wholesale business in dry goods. Everything worked out, and everybody got along.

Nyna's beau Ted now had two new paternal figures. Murray was something of a worrier, wary of the unexpected; as a kid, he'd blown off a thumb and forefinger with a firecracker. Solicitous and vigilant, he never saw the need for Ruthy to learn to drive. Why should she? He would take her anywhere. But he was constant in his love and allegiances. He and Ruthy would lead long lives and would never fail my parents. Lazer, who lived only another decade, was someone else altogether: the ultimate maverick, with an unfettered mind, expansive emotions, and a lavish spirit. Both men immediately took to Ted, and he to them.

The first time Nyna brought Ted to meet her mother and stepfather, Murray asked Ruthy, "Where did she find that kid?"

She'd found him on the Yale campus, adding a romantic interest to his small but expanding circle of friends.

Since his return from the war, Ted was sharing a suite in Branford College with Bob Grant, another New York Jew from an affluent background, also a veteran. Bob had been born in Cuba, where his father worked as legal counsel to Pan American Airlines.

Branford, Yale's first residential college, had opened at the southeast corner of majestic Memorial Quadrangle in September 1933. It was named after the Connecticut town where clergymen meeting in 1701 agreed to donate books to form an institution of higher

Nyna and Ted, the courting couple, flank Nyna's stepfather Murray and mother Ruthy, New York City, 1946 (family collection).

learning in their colony. Soon there were half a dozen more such residences, with their neo-Gothic architecture, vaulted chambers and paneled studies, maids to make the beds, dining halls with white tablecloths and waitresses and jackets required at dinner, each house with its activities, groups, traditions, and symbols.

Most of the mannered mystique went away with the war, and cafeterias replaced formal dining, but some old traditions persisted—including Tap Day, recruitment day for Yale's secret societies. The Branford courtyard, bell tower looming above, was still the staging ground for this annual rigmarole.

The oldest and most notorious society was Skull and Bones, known for its bizarre initiation rituals and nocturnal lockstep marches across campus, which drew mainly fraternity and prep school men. Bonesmen were destined to rule the world, some to run for, and some to attain, the presidency of the strongest nation on earth. Yale President Seymour had been tapped as an undergraduate. So were *Time-LIFE* founder Henry Luce, George H.W. Bush, and his son George W. In this club that presumed a WASP pedigree, William F. Buckley, a moneyed Catholic, was an anomaly. John Kerry, later leader in Vietnam Veterans Against the War, US senator, presidential candidate, and secretary of state, was a quasi-exception: raised Catholic after his father, Boston Brahmin on his mother's side.

As Jews, Ted and Bob were ineligible for (and uninterested in) the elitist clubs. And as sons of privilege themselves, both roommates were destined to travel far from their upbringings, albeit on divergent paths. When Ted was striking out as a journalist, and later building a freelance photography career out of his house in the Boston suburbs, Bob became a novelist (under the name Robert Granat), and retreated to an austere subsistence in New Mexico. In his first novel, *The Important Thing*, published in 1961, narrator James Warsaw and his Yale roommate Leonard Sundell share a common Jewish heritage, but take on the world with markedly different demeanors: Leo, modeled partly on Ted, is the self-assured Marxist intent on changing the world, while Bob's avatar James is uncertain and unprepared for the shock of war.

The real-life friendship was ambivalent but deep and lasting, enduring largely through protracted correspondence in which the two men, from opposite sides of the country, traded family news, affection and insult, convictions and delusions. Bob saw Ted as something of a bourgeois phony, himself being the real deal. Ted admitted to pragmatic inclinations but not unprincipled failings, and saw Bob as the real deal, too, albeit off in another galaxy. Bob's letters tended to be heavy and brooding, prompting Ted to find slights, often erroneously; Ted's were intricate, confessional, and leavened with humor that Bob habitually misinterpreted as affront.

Bob's daughter Beata and I, who'd met indifferently as children, would turn out dissimilar in temperament as well, but highly compatible once we rediscovered each other as adults. We were doctoral students at Stanford at the same time. I'd landed in a highly quantitative communication program, my non-mathematical mind somehow conquering statistics by divination rather than aptitude. I also clung stubbornly to China interests that some of my theory-oriented professors considered a distraction—area studies, grounded in place rather than in universals, thus mildly heretical. Beata studied premodern Chinese literature and Buddhism. My Chinese husband and I adored her Chinese-style habit of dropping by our campus hovel unannounced to hang out with us and our two little sons. It was thanks to Beata that my husband's memoir of the Cultural Revolution made its way to Stanford University Press.

If Bob was Ted's psychic affliction, Beata was my psychic respite. Along with our

common interests, her calm spirituality and affinity with the humanities offered relief from my immersion in hardcore social sciences and statistical analysis. Unlike our fathers, with their constant verbal pugilism, we didn't judge. We adored our own fathers, and relished their adoration of us, but perhaps saw them more clearly than they saw themselves or each other. In one letter, Bob said that Beata, having reencountered Ted after a long lapse, had reported, "He's so young, and you're so *old.*" Bob did wear the weight of the world more heavily than Ted, but lasted longer: His death followed Ted's by a decade.

The other Yale friendship that endured with intensity, and with greater proximity, comfortable fellowship, and regular mutual visits, took the form of a quartet: Ted and Nyna and Pat and Diana.

Pat was Pasquale Vecchione, a brash, radical Italian American with a virtuoso intellect, who also lived in Branford. He would soon marry the former Diana Rowe; she'd changed her surname from the overtly Jewish Rosenhouse to enhance her higher education admission chances. A sultry coed from Cornell, where she'd majored in math, Diana was at Yale on scholarship for graduate studies in Chinese.

It was Pat who brought my parents together, introducing them one day in the fall of 1946 as they converged outside Yale Station, where everyone picked up mail.

Nyna was studying for a master's in theater. She'd originally been Nina Israel, until a high school friend, regarding her signature on a painting, suggested she could squash the letters I-S together into a B to create a more flamboyant surname. The change appealed to her, and her free-spirited father, Lazer Israel, entirely approved. Lazer had never married her mother, Ruth Amdur, whose married name was now Zweiban. When the precocious teen hired an inexpensive lawyer to become Brael, she also remedied the spelling of her first name, turning Nina, which everyone mispronounced as "Nee-nah," into Nyna, with the long sound "Nigh-nah."

Ted's flame was a city girl, an artistic, nervy, grade-skipping, school-hopping product of Brooklyn and Manhattan, whose talent for drawing and painting had landed her a spot in the inaugural graduating class of New York's High School of Music and Art, the country's first such specialized arts public high school. (In the 1980s, it merged with the city's High School for Performing Arts to become Fiorello H. LaGuardia High School of Music and the Arts, named after New York's most popular mayor ever, sworn in when my mom was 10, reigning through World War II.) She then studied architecture at the prestigious, tuition-free Cooper Union, endowed by industrialist Peter Cooper 80 years before with a mission of educating working-class New Yorkers (it would remain tuition-free until 2014). On a whim, she spent an offbeat year at Stanford, assigned to an experimental house that gave a group of young women unprecedented independence. Ahead lay Yale.

My mother's admission to one highly selective institution after another somehow occurred with no particular planning or striving on her part; as the only child of strong-willed immigrants, raised with both indulgence and freedom, headstrong and self-confident by nature, she never thought twice about what nowadays would count as a major academic feat. Then again, beyond her high school diploma and a certificate in architecture, she never stayed anywhere long enough to earn a degree.

In the interim between Stanford and Yale, during wartime, Nyna worked at a naval architectural office, situated over a French restaurant in Brooklyn Heights. There she became firm friends with another firebrand, Estelle Reiner. Estelle was married to comedian Carl Reiner, then acting abroad in a military troupe. Long afterwards, obliging their filmmaker son Rob Reiner by taking a cameo role in *When Harry Met Sally,* Estelle would

steal the hearts of millions of moviegoers as the elderly diner patron who—upon over-hearing Meg Ryan's Sally faking an orgasm across the table from Billy Crystal's Harry—uttered the immortal line, "I'll have what she's having."

Nyna and Estelle sat at facing desks. The day President Franklin Delano Roosevelt died, the two draftswomen wandered into the street to get away from their reactionary bosses, who were celebrating, and ended up at an Episcopal church. The minister was giv-ing an impassioned eulogy to people seeking solace. Nyna and Ted later consulted him about possibly presiding over their wedding but set aside the idea when he said he would have to refer to entities quite alien to their backgrounds, namely the Father, the Son, and the Holy Ghost.

Yale Drama School sat right across York Street from the quadrangle where Ted lived. Nyna's emphasis was scenery and costumes, with ancillary ventures across the porous bor-ders of the school's departments. She filled notebooks with her stage visions and clothing designs, planned sets and sewed elaborate period garb for student productions, and dab-bled in whatever else came up—a little acting, some lighting work, construction crews.

Best of all, New Haven's Shubert Theatre was a favored launching pad for new pro-ductions. With their free tickets to pre–Broadway tryouts, drama students and their friends could see the future on stage before it hit the headlines. The Rodgers and Hammer-stein collaboration that transformed American musical theater had made its debut there in 1943, under the working title *Away We Go*, soon changed to *Oklahoma!* The 1947 sched-ule included Tennessee Williams's *Streetcar Named Desire*, with Marlon Brando and Jes-sica Tandy, and *All My Sons*, Arthur Miller's first success, both plays soon to be Broadway sensations. My parents were among that year's exhilarated New Haven audiences, whose standing ovations and cries of "Author, author!" failed to draw out either playwright.

Warm companionship emerged from Pat's inadvertent matchmaking. Together, the Pat-Diana-Ted-Nyna foursome raised beers at the 1947 Derby Day boat races, named for the Connecticut town on the Housatonic River where the competition took place each May. They shared meals, occasionally in a New Haven restaurant, more often at Branford. Pat was quite the epicure. My mother tells of the time he rose to his feet in the Branford cafeteria after taking a mouthful of spaghetti and announced in his stentorian voice, "I've been poisoned!" Pat marveled that Diana would go back for seconds of dorm fare, recall-ing that she once explained, "The Jews always eat dinner as if it were the Last Supper."

Pat would have earned his bachelor's degree in 1942, just before Ted arrived as a freshman, but as with many, the draft intervened. He returned to finish and stayed on for graduate studies. Already known on campus before the war as president of the Yale chap-ter of the American Student Union, he made an even greater splash afterwards, as chair of Yale's chapter of the Progressive Citizens of America and, above all, as chief antagonist to Brent Bozell, Jr., William Buckley's classmate and brother-in-law, widely viewed as Buck-ley's stooge.

Their now-legendary political brawl erupted when Bozell, head of the United World Federalists chapter, labeled Pat's group a Communist-dominated organization. Vecchi-one of course took issue: Progressive Citizens of America, with a roster of cultural lumi-naries on its national board, was an independent entity. After facing off in the pages of the *Yale Daily News*, the two took the stage for a public debate, airing their clashing ideol-ogies at Yale's law school in February 1948.

Bozell's assertions hinged first and foremost on personalities, the main exhibit a list of PCA national officers affiliated with other organizations that US Attorney General

The gang of four: Yale schoolmates Ted, Nyna, Pat, Diana at the Derby Day regatta, Derby, Connecticut, 1947 (family collection).

Tom Clark had tagged as "Communist Fronts." (Included were such august names as playwright Lillian Hellman, historian Howard Fast, editor Carey McWilliams, and singer Paul Robeson.) The PCA consistently fell in line with the Soviet Union in criticizing American foreign policy, Bozell said. Support for Henry Wallace's 1948 presidential campaign was further proof of communistic leanings.

Vecchione countered that such smears were inevitable for a group taking on powerful interests and opposing the mounting frenzy of anti–Communism. He objected to the premise of "guilt by association," challenged the attorney general's roster of subversion, and called Bozell's charges "unfounded, unfair, malicious, and the product of a line of reasoning characteristic of fascists."

The combatants both stood their ground before what the campus paper characterized as an "orderly but vociferous" audience. My parents savored the kerfuffle, although by then they were eight months married and focused more on making a life off campus.

Nyna doesn't remember a marriage proposal. Certainly, there was no engagement ring. She and Ted exchanged gold bands in a civil ceremony on June 14, 1947, before a justice of the peace in Westchester County; it was a Saturday and New York City offices were closed. That evening, Ruth and Murray hosted a wedding reception in a function room over a restaurant on the Upper West Side, with 70 or so friends and relatives in attendance.

Noticeably absent from the celebration was Ted's father. Phil famously had said a man has no right to get married if he can't support a wife. Understood, but not explicitly expressed, was his disapproval of Nyna's downscale family and the bride's bohemian flair; a respectable man wouldn't marry an artist who sported long hair, bare legs, and sandals. Phil commanded his siblings to forgo the event, and the uncles obeyed, but the aunts did not. The cousins showed up, too.

With a generosity that would never flag, Ruth and Murray turned their apartment on Prospect Park Southwest in Brooklyn over to Ted and Nyna for the summer of 1947, while they took a rental at the western tip of Coney Island, in Sea Gate, New York's first gated community. Created in 1899 as a summer retreat, originally with a restrictive covenant barring Jews, by the 1920s it was a pleasant enclave for Jewish immigrants of intellectual bent.

Ted was on the "52–20" plan, an unemployment provision of the GI Bill providing discharged veterans with $20 a week for 52 weeks. This enabled him to spend the summer as a volunteer intern under James Aronson, editor of the Newspaper Guild newsletter *Frontpage*. Nyna occasionally contributed cartoons.

Her first year at Yale, my mother had lucked into a palatial suite all to herself, with marble bathroom and huge sunporch, in a mansion used as a dorm at the top of Hillhouse Avenue that later was converted for academic use. With classes resuming in the fall, my parents sought a place together. Yale's Quonset huts, built after the war to house married couples, had a long waiting list.

The offer of a rent-free vacation home across the street from the beach seemed too good to be true. It came through a friend of Ted's from freshman year, who'd finished his bachelor's degree during the war, stayed on for a doctorate, and now lived with his wife in the Quonset huts. The friend's mother owned a seedy Victorian south of New Haven, in the town of Woodmont, perched on the Connecticut side of Long Island Sound. She'd just installed a furnace and wanted to see how the winterizing worked. The tenants only had to cover utilities.

Also, the household kept kosher, with separate sets of pots, dishes, and utensils for dairy and meat, so Ted and Nyna were asked to conform to a practice with which neither of them had been raised. It seemed a fair request.

They needed a car for the ten-mile commute. Fifty dollars bought a 1926 Ford from a garage owner who swore it had belonged to two little old ladies. It had two seats, and a trunk instead of the more common rumble seat. Other than requiring a new coat of tar smeared on the roof every few months to seal out rain, it was a great little vehicle that served them for the next few years.

And would they mind housemates? People to share the grocery shopping and split the utilities sounded good, and the rambling place, with its myriad odd-shaped rooms and turrets, had plenty of space. A few days after Ted and Nyna finished cleaning and settled in, another young couple arrived: the friend's brother and sister-in-law. Plus an elderly maid and an aging sheepdog with bad breath.

The winterizing did not work; that autumn and into the winter, the wind came through the uninsulated wooden structure in force. Hanging blankets on the bedroom walls hardly helped. The oil bills were staggering, more than rent near campus in New Haven would have been. The mangy moose head mounted over an enormous fireplace seemed to be mocking them.

The resident maid was cranky, possessive, and unwilling to collaborate, so Ted and

Nyna ended up shopping and eating separately from the others, although they continued to bring kosher meat from New Haven for everyone. The husband would come and go, his job unspecified. The wife, a self-styled poet, took off running whenever it rained. Otherwise, she hung around the house, pawing through Ted and Nyna's things when she got bored.

One rainy day, the scatterbrained young woman came flying inside crying for help: She'd taken the dog on her outing, and the poor thing had simply vanished. Everyone went out to search. Ted found the creature at the bottom of a cesspool. He jumped in and handed the dog up, whereupon the couple departed, leaving the rescuer in the muddy pit. Ted managed to climb back out, covered in mud; back at the house, he had to wait his turn for the single bathroom while the couple finished the lengthy cleanup of their beloved beast. Ted and Nyna decided it was time to move again.

With a lead from the Yale housing office, they trudged through a snowstorm to visit a divorced gent looking for live-in help. His substantial, somewhat dilapidated house was on one of New Haven's loveliest streets. He greeted them with a drink in hand. Declining his offer to join in libations, the visitors sat on a sofa while he explained the job: taking care of his two children, mainly getting them ready for school in the morning before the maid arrived, in exchange for the attic apartment. By the way, this was a job for a woman alone; the man could stay put in his dorm.

Housing next directed them to an apartment near the Winchester gun factory. The landlady, widow of a New Haven sheriff, told them, "You'll be safe here, I have the gun my husband gave me and I know how to use it." There they lodged for the remainder of their first year of marriage.

When Ted finished his BA in June 1948, Nyna was two years into her three-year MFA program in drama. She left without a degree. They headed the little Ford down to York, Pennsylvania, where Ted had a job lined up at the daily newspaper.

8

Looking to Launch

Once you're on a newspaper, you'll be judged chiefly by your product. You'll be expected to cover the news and report it quickly and clearly. If you do that, you'll have no need to worry about your job security or future advancement.

—Charles Stabler, "The first requirement is a college diploma," in *Do You Belong in Journalism?*

The York *Gazette and Daily* was nationally recognized as a gutsy, forward-looking training ground for young journalists, oddly situated in a community where a hidebound mentality reigned and Jim Crow institutions prevailed. A morning paper, turned tabloid amidst the newsprint shortages of World War II, it regularly won awards for design and typography. Publisher Josiah (Jess) Gitt, a Pennsylvania Dutchman of strong conviction and many contradictions, adored by his staff, editorialized early and tirelessly on behalf of unions, civil rights, and other enlightened causes. His was the only daily in the country besides the Communist Party's *Daily Worker* to endorse Progressive Party candidate Henry Wallace for president in 1948, the year my dad joined the newsroom.

Ted and Nyna moved into the apartment of a fellow just fired from the paper, who asked them to keep his furniture until he had another job and place to live. York had yet to become an industrial town; its eponymous manufacturing works, originator of air-conditioning, was still fairly small. Nyna illustrated ads for Kaufmann's department store in the state capital, Harrisburg, commuting the twenty or so miles by train, her wages just about recouping the fare back and forth. Ted was a reporter and photographer, covering meetings, picnics, accidents, burglaries, fires, and other local miscellany.

A stash of his yellowed newsprint clippings from those days yields stories about highway construction, grain harvests, the birth of twins, the inexplicably low volume of letters to Santa coming through the York post office, the high caseload confronting the county children's services agency, a benefit dance to raise money for new uniforms for the high school marching band and majorettes. He reported on cruelty-and-neglect charges against a pet and lab animal supplier after the discovery of 19 dead animals, "along with about 50 dogs and puppies and dozens of rabbits, pigeons, guinea pigs and hamsters, as well as assorted goats and pigs," in filthy facilities. He profiled a 13-year-old boy who had "lost his southpaw throwing arm" in a traffic accident and emerged cheerful and confident, now tossing the baseball with his right arm and refereeing sandlot football. He drew back the curtain on the "Atomic Age Girls" attraction at a local carnival, with a "family" show followed by a show "for men only" costing an additional 50 cents: "First round featured three dancing girls in scanty attire. Second round featured the dancing girls unattired."

Among the trivia and human interest, a significant story arose for Ted when the York City Council chose to close the YMCA-run public swimming pool in Farquhar Park rather than open it to African Americans. The alternative was the "inky stinky" Codorus Creek, polluted by discharge from the Glatfelter pulp and paper mill upstream. While the pool stood unused, the drowned body of 9-year-old Charles Zambito was pulled from the creek; two other boys had been unable to save him from the swift current above a pumping station dam. Charlie was white, one of the companions was white, and the other, Charlie's inseparable best friend, was Black. The Black child was taken to York Hospital "in a condition of shock and hysteria," Ted wrote. "These boys had no other place to go. They were buddies and always stuck together," the best friend's father told the reporter. "If my boy had been allowed to go to the city pool, he would undoubtedly have gone there with Charlie. It's a shame that the very people I helped elect to office are the ones responsible for closing the pool."

Ultimately, the Boys Club took over the pool's operation and began admitting all colors. Yet desegregation was plodding. Ted and Nyna joined a sit-in with an integrated group at the Dinner Bell, a storefront restaurant whose sign proudly advertised AIR CONDITIONED, likely with one of those early York cooling units. A chef emerged, theatrically sharpening a knife; management turned off the air-conditioning and stopped serving; a local thug knocked down a newsroom colleague who was covering the story. A police officer on the spot claimed to have seen nothing, and the day ended with little else happening. As with the pool, eventually the place had to accept Black patrons, although the atmosphere remained unfriendly.

Into their second year in York, unable to find work in town and distressed with the parochial environment, Nyna was impatient to move on. Plus she was pregnant. Ted wanted to work for a bigger paper sooner or later, so they decided to try their chances back in New York.

It was with mixed feelings that the couple took leave of the *Gazette and Daily*

Boy, 9, Drowns In Creek As Rescue Attempt Fails

The Gazette and Daily, York, Pa., Saturday Morning, July 17, 1948

Body of Charles Zambito, youngest son of Mr. and Mrs. Richard Zambito, 423 Codorus street, recovered from Codorus creek near pumping station after six hour search by corps of 50 volunteers. Drowned boy and two companions, all inseparable friends, went swimming in Codorus because one was barred by race from YMCA pool.

The body of nine-year old Charles Zambito, youngest son of Mr. and Mrs. Richard Zambito, 423 Codorus street, was recovered at 8:55 p.m. last night from Codorus creek near the Pumping station, after a six-hour search by state police and volunteers.

The boy had been swimming with two companions yesterday afternoon when he succumbed apparently to exhaustion and was drowned.

The three inseparable youths went swimming in the Codorus because one, a colored youth, was barred from the YMCA pool because of his race. The city's swimming pool has been kept closed, awaiting court action on a suit to halt a move by the city to sell the Farquhar park installation.

Yesterday, shortly after noon, Charles and his friends, Billy Bridgett, 13, son of Mr. and Mrs. James Bridgett, Jr., 417 Codorus street, and Bob Steinkamp, 13, son of Mr. and Mrs. Charles A. Steinkamp, 320 Allison street, *(Continued On Page Five)*
See Boy Drowns

—Photo by The Gazette and Daily
GRAPPLE FOR DROWNED BOY'S BODY—State and Spring Garden township police search the swift-moving waters of Codorus creek near the Pumping station to recover the body of nine-year-old Charles Zambito, who went swimming with friends there yesterday afternoon.

Ted's report on a drowning that resulted from racial discrimination at the local swimming pool in York, Pennsylvania, 1948 (used by permission, *York Daily Record/Sunday News/Gannett*).

newsroom's close-knit fellowship and the fond friendships formed there. Over time, they were able to pick up with some of these dear friends, notably Jim Higgins, a Harvard graduate and former shipyard worker. Higgins had been covering Henry Wallace's speeches from the road. He arrived in the newsroom in 1949 as assistant editor and stayed 20 years, to the very end of the Gitt era, then returned to his hometown of Boston to teach and write. The cohort also included sports editor Jack Hough, from a venerable newspaper family, who would go home to Cape Cod to work for the *Falmouth Enterprise* and take over as publisher upon his father's death; Louis Stone, youngest brother of the maverick weekly newsletter founder I.F. Stone; Philip Gordon, who would rejoin his family jewelry business in Waltham, Massachusetts; and Dave Lachenbruch, who became a consumer electronics expert and editor of the trade journal *Television Digest*.

Later interviewed by Gitt's biographer, Mary Hamilton, Lachenbruch described his few years in York as "unquestioningly the most interesting job I ever had." He continued, "It was by far the most fun I ever had in a job—and the most freedom." Hough's recollections were likewise happy: "I look back on my five years with the *Gazette and Daily* with undiluted nostalgia. In my case it was the opportunity for a callow youth to learn the rudiments of an old and honest trade; to go out and report the news as it happened, as we saw it. We attended aldermanic hearings, the police court, school board meetings, and the township commission meetings. We covered the churches and visited undertakers, hospitals, the YMCA and YWCA, courthouse and county fair. The news for us was a live thing, to be hunted down and captured."

Said another staffer from the era: "The *Gazette and Daily* was what a newspaper should be and what none now is—and, alas, probably never will be again, since the bottom line now determines newspaper policies and not public interest." In October 1970, about to turn 86, Gitt described his company as "dead broke" and asked his staff to take a 10 percent salary cut; instead, they went on strike. Within the month, a local syndicate headed by York's district attorney bought the paper and renamed it the *York Daily Record*.

Gitt died in 1973; in a tribute published in *The New York Times*, Jim Higgins called him "a personal journalist of the old school." The paper went through a succession of group and chain ownerships, culminating in its 2015 purchase by Gannett, publisher of *USA Today*, as part of a package of Pennsylvania community papers. The acquisition, the *Daily Record* itself reported, would give Gannett "a broader appeal to regional advertisers looking to reach customers in different markets in the region." Four years later, GateHouse Media, a subsidiary of a large investment group, acquired the entire Gannett chain to produce a supersize merger, still under the Gannett name, with more than 260 daily news operations.

Earlier phases of media consolidation were well underway when my parents left York, and New York City's newspaper landscape was in turmoil as Ted began seeking his next job. He'd fancied landing something at the maverick *Daily Compass*, funded by a Chicago benefactor as a successor to the now-defunct *PM*, but the new paper already was struggling and would last less than three years. Throughout the fall of 1949, the Newspaper Guild was wrangling over contracts citywide. By spring 1950, employees at the *New York World-Telegram & Sun*, a recent merger in the volatile industry, were positioned for a major strike over stalled negotiations. On June 13, 1950, about five hundred members of editorial and commercial departments covered by Guild contract walked out. Mechanical unions, including the printers, refused to cross picket lines, and none of the paper's seven editions came out. The strike lasted eleven weeks. Home to nineteen dailies in the

1920s, New York would be down to seven by 1960. Only three survived the much bigger strike of 1962–63.

Prospects for a newspaper job dubious, Ted took a mind-numbing position with a clipping service called Radio Reports that supplied news leads for radio broadcasts. On Valentine's Day in 1950, Nyna gave birth to a daughter in Brooklyn Jewish Hospital, the same hospital where Ted was born. In memory of Ted's mother Minnie, they named her Mini Ann, immediately shortened to Miki. My parents rented an apartment in Vanderveer Estates, a sprawling complex with 2,500 apartments, newly built on the former site of the Flatbush Water Works in Brooklyn. Barbra Streisand would live there in her teens. Its devolution into a notorious slum was decades off, efforts to remake the real estate as Flatbush Gardens even more distant, but the place already felt anonymous and unpleasant. The woman next door came over after her husband beat her up and stabbed her with a fork, but refused to let Ted and Nyna call the police; otherwise, most interactions with neighbors arose from waiting in line to use the public telephone.

Given the slim prospects in New York, they decided to explore opportunities in Boston, where Ted found a job at a wire service called Acme Newspictures. He went ahead, taking a room at the Huntington Avenue branch of the YMCA while scouting apartments. A new thoroughfare along the Charles River, Storrow Drive, was under construction nearby; spurred by the swampy project, the mosquitoes multiplied in profusion. Ted's workplace occupied cramped quarters three floors up, housing a small studio, three telephoto machines, assorted desks, file cabinets, and two typewriters. He worked a swing shift, editing news photos and assembling a late newscast for the then-new medium of television—so new my parents didn't yet own a set. At the time, TV news consisted mainly of still pictures with voice-over. Contents were culled from the newswires and newspapers. A newscast always ended with a "kicker," typically about a cute kid or animal.

The pay was abysmal but the job seemed secure and promising, a connection with Boston journalism that could lead to better. Nyna and Miki rejoined Ted, and after a spell in an apartment near Coolidge Corner in Brookline, they moved to the sunny second floor of a house in Newtonville, two doors over from a carpet mill. Downstairs were Mrs. Murphy, a lovely white-haired lady and devout Catholic, whose friendship toward my parents never wavered, and a teenaged daughter with Down syndrome. Mr. Murphy was hardly visible. An older daughter was sometimes around, and also a son, who years later made the front page of the *Boston Globe* for murdering his wife.

Ted's father Phil had remarried, with conciliatory overtures that brought Ted and Nyna to the wedding. Brother Bobby had said he wouldn't go unless Ted did, and their absence would have embarrassed Phil in front of business associates in attendance.

Mildred, his new wife, was a vain, finicky woman, attuned to money and status in a way Minnie had never been. Daughter of immigrants from Poland, married once before, she had some income of her own as a smalltime landlord. Her two brothers were involved in various mysterious deals; on a handshake, Phil once put money into a parking garage scheme touted by one of the brothers-in-law, and lost it all—an early harbinger, perhaps, of the sinkhole of medical costs engendered by Mildred's eventual dementia, possibly deepened by a few more unwise business decisions, that would wipe him out entirely.

One member of Mildred's clan who might have become my parents' friend was her nephew Jacques Nevard, son of her sister Pauline. Events took a different course. Nevard became a *New York Times* reporter, first local and then in Asia. He helped us navigate

Hong Kong when we passed through en route to India in the spring of 1961. He later left journalism to work for the city of New York, becoming deputy police commissioner for public affairs. In late 1977, while acting as spokesperson for officials enmeshed in an expense account scandal, and fearful his career was indelibly tarnished, he threw himself off a balcony at Metropolitan Transit Authority headquarters.

The decline of Phil's fortunes and Mildred's mind and all the other family dramas and traumas to come were unimaginable as Ted and Nyna settled into their new lives in Boston with their angelic-looking but difficult toddler, my sister Miki. Nyna did some work for a friend's trade magazine, and began to meet congenial activists. She joined the group Minute Women for Peace, whose success collecting signatures on peace petitions, about 10,000 in the Boston area alone, naturally marked the organization as a tool of the "Communist peace offensive," as the FBI and other government agencies termed it.

Boston-to-New York remained a well-traveled corridor, usually trips to see Nyna's mother and step-father, Ruthy and Murray, in Brook-lyn. There were occasional, very

Ted's father Phil with his second wife, Mildred, mid–1950s (Ted Polumbaum / family collection).

brief, visits to the West End Avenue apartment where Phil and Mildred lived amidst Minnie's collections of leather-bound books and fine china. Phil had left the regal Warwick in a huff over a minor rent increase.

Ted and Nyna's hardy little Ford, which lasted out the York period, had been supplanted twice. The first replacement was a mint condition black Plymouth sedan passed on by Murray, whose only self-indulgence was swapping his always pristine vehicle for a new car every two years. In a singular act of one-upmanship, by far the priciest gesture he ever extended to Ted and Nyna, Phil insisted on trading in that perfectly fine auto and presented them with a new two-toned black and turquoise model. That second Plymouth would take us to New Mexico and back in the summer of 1958, just before I entered kindergarten.

But I was still in the womb as my father was approaching the major pivot of his life, the event that would define his integrity as a human being, spark his new career as a photojournalist, and lead to many more adventures.

In early 1953, the wire service United Press (which had not yet acquired International

Press Service to become UPI) bought out Acme. Ted stayed, doing the same job. It was satisfying, but not exciting—until the day a portly federal marshal came huffing up the wooden staircase to the second-story Newtonville apartment. He carried a subpoena directing Ted to appear in Washington, D.C., before the United States House Committee on Un-American Activities, colloquially called "hugh-ack"—HUAC. It was the height of the Red Scare, and politicians hunting for insurgents were hot on the trail of the flimsiest of clues, like my father's camaraderie with the John Reed folks back in college. Nyna was pregnant again, with me, due that coming summer.

Ted's ensuing rebuke of the Committee's sorry search for subversives, resulting in loss of his job, notoriety, and blacklisting, snuffed out any movement toward rapprochement with his father. Mildred choked over her breakfast when she saw the next-day account in the New York *Daily News.* His mystified sister Peggy said, "Teddy, why couldn't you just tell them what they wanted to know?"

9

Defiance

Men feared witches and burned women.
—Supreme Court Justice Louis D. Brandeis,
concurring opinion in *Whitney v. California*, 1927

The color might have alerted Ted: not an actual pink slip, but it came on pink paper. A subpoena signed by Harold H. Velde, the Illinois Republican appointed to chair HUAC after his predecessor, J. Parnell Thomas of New Jersey, went to jail for taking kickbacks. Ted was to report to a Capitol Hill hearing room on April 21, 1953. The Committee was investigating "Communist subversion" in education.

Consulting with progressive lawyer Lawrence Shubow, Ted prepared to exercise his Constitutional rights. The case of the Hollywood Ten, prominent film professionals convicted and imprisoned for contempt of Congress after refusing to bow to HUAC, had shown how standing on the First Amendment alone could land unfriendly witnesses in jail. Fifth Amendment guarantees of due process and protection from testifying against oneself were more promising.

Everybody knew that if you cooperated with the Committee, admitted past association with pernicious forces, professed penitence, and agreed to name names, they'd declare you a great patriot, or alternatively, take you in a back room for a quiet executive session. With his attorney Larry at his side, Ted faced a panel of antagonists determined to give him a public drubbing. It would be a long morning.

Ted was the second witness of the day, following Leo Hurvich, a psychologist employed by Eastman Kodak. From Hurvich, the Committee sought to elicit information about his time as a researcher at Harvard University, alleging he'd had knowledge of a Communist cell. Hurvich acknowledged he'd been a member of the American Federation of Teachers, but to questions about politics and other people, he asserted his Fifth Amendment privilege. The Committee dispensed with him in half an hour.

The next fellow was more brazen; in addition to invoking his rights, Ted had the temerity to talk back. His session lasted three times as long. Government document collections in the bowels of academic libraries used to be the main repositories for such testimony; now, tens of thousands of pages of transcription from these inquisitions, including Ted Polumbaum's effrontery, are handily perusable online.

After a few queries about Ted's employment history, Committee counsel Robert Kunzig zeroed in on the incriminating allegations:

MR. KUNZIG: Now, during your student days at Yale University, were you acquainted with an organization known as the John Reed Club?

COPY

BY AUTHORITY OF THE HOUSE OF REPRESENTATIVES OF THE CONGRESS OF THE
UNITED STATES OF AMERICA

ToUnited States Marshal...

 You are hereby commanded to summonTheodore S. Polumbaum.........................

...

to be and appear before theCommittee on Un-American Activities, or a duly authorized sub-
...committee thereof,
C̶o̶m̶m̶i̶t̶t̶e̶e̶ of the House of Representatives of the United States, of which the Hon.
.....Harold H. Velde.. is chairman,

...

...

 in Room 226, House Office Building
in their chamber in the city of Washington, onTuesday,..................

..............April 21, 1953........................, at the hour of10:30 a.m.......

then and there to testify touching matters of inquiry committed to said Committee; and he is
not to depart without leave of said Committee.

 Herein fail not, and make return of this summons.

 Witness my hand and the seal of the House of Representatives

 of the United States, at the city of Washington, this

 9th day ofApril...............19 53

 Harold H Velde

 Chairman.

Attest:

...*Clerk.*
16—25308-2

 A true copy—
 Attest:

 Deputy U. S. Marshal

The HUAC summons—it came on pink paper! (family collection).

MR. POLUMBAUM: I would like to state to the committee that I will not answer that question
or any similar questions referring to my political affiliations and beliefs, and I will not
cooperate with this committee in any attempt to get me to waive my rights under the
first and fifth amendments. Further, I should like to state that I will not answer any such
questions on grounds that I will not be compelled to bear witness against myself or
against any others and to turn informer before this committee and to cooperate in the

apparent efforts of this committee to disparage and belittle the Bill of Rights, on which I am standing, and ultimately, I believe, to destroy these rights.

After a bit of back and forth, the more pointed question arrived:

> **MR. KUNZIG:** Were you a member of the John Reed Club?
>
> **MR. POLUMBAUM:** I repeat, I will refuse to answer that question because to answer it would be cooperating with this committee's purpose to disparage the Bill of Rights, and I will not waive my rights under the first and the fifth amendments in answering this question. I refuse to answer the question because I cannot be compelled to bear witness against myself or others under the fifth amendment.

When a couple of the congressmen badgered him about his interpretation of the founding fathers' precepts, he replied, "I will answer all questions which I believe proper."

He was not about to be turned into an informer, he said, prompting Kit Clardy, Michigan Republican, to impute: "You would object, then, to telling this committee about anything of which you had knowledge concerning someone else if that someone else was engaged in some conspiracy against the United States?" Ted clarified that this was not his view of the situation here, saying, "If I were asked to give my testimony concerning the illegal activities or an illegal conspiracy in which other people are involved, I would disassociate myself from such people by condemning them and denouncing them."

More back and forth, and the grilling resumed:

> **MR. KUNZIG:** Have you been at any time a member of the Communist Party?
>
> **MR. POLUMBAUM:** I won't answer that question on the grounds I have previously stated, and I would like to state further that this committee is asking me questions and implying certain accusations in such a way as to assume the functions of a grand jury without affording the protections of a grand jury.

Additional goading from Francis Walter of Pennsylvania, a Democrat who would become the next chair of HUAC, culminated in a declaration of certainty that Ted had been a Communist, to which Ted responded: "If you have any information or evidence that I have engaged in any illegal conspiracy or any illegal activities, or committed any illegal act—and you cannot have such evidence because I have never committed any illegal activities—you should take this evidence to the proper authorities and you should have me prosecuted and give me a day in court under due process."

Addressing him as "Mr. Witness," HUAC chair Harold Velde, signatory to the subpoena, assured him "that any accusation that is made against you is not in the form of an indictment. This is not a court of law. It is not in the form of an indictment which might tend to incriminate you."

Ted fired back: "But what the committee is doing is trying me by publicity and endangering my employment."

The wheels continued to spin:

> **MR. POLUMBAUM:** I don't believe this committee has the right to investigate political opinions and associations.
>
> **MR. CLARDY:** In other words, we have no right or duty to investigate the Communist conspiracy; is that your position?
>
> **MR. POLUMBAUM:** If this committee has any evidence of illegal activities or illegal conspiracy, it is certainly within its right to bring this evidence before the proper authorities and have any persons so charged brought into court.
>
> **MR. CLARDY:** That is what we are doing. We are bringing it to the attention of the American

people—the real jury that will convict those of you that may be engaged in that conspiracy.

MR. POLUMBAUM: In other words, you are admitting this is trial by publicity.

MR. CLARDY: No, sir; this, sir, is giving the people an opportunity to see how this apparatus works.

Kunzig proceeded with a string of do-you-knows, offering up names of others implicated in the Yale subversion scene. Ted continued to refuse to answer these and all similar questions. "I will not put the finger on myself or other persons before this committee," he said.

The interrogation then turned to a document Ted had signed for his United Press employment, stating that he had never belonged to a subversive organization. Kunzig asked if Ted would "reaffirm" that statement. Ted refused to answer on the grounds already covered. "That was a question between my employer and myself," he explained, adding that he would willingly discuss political beliefs with associates, friends, and family, but would not waive his rights for a colloquy with the Committee.

For an extended period, Clyde Doyle, a California Democrat, tried to draw Ted into an understanding of the Committee's vital mission: The congressmen needed his help, Doyle pleaded, in uncovering forces bent on destruction of the American government and way of life. When Ted maintained that the American way was to permit dissent, even to an extreme degree, Doyle said, "I agree with you, or may I state it more emphatically than you did—I think that America is great in no small measure because we do have, and in our history have had, people who dissented." Larry Shubow, Ted's lawyer, commented: "Very good, Congressman."

Further bemoaning Ted's failure to cooperate, Doyle said, "I regret it very much, young man, because some young men about your age gave their lives in the uniform of their country." Then he remembered that Ted also had been in uniform, quickly adding, "and I compliment you on the service you also rendered." Ted said, "And I would do it again." Persistently, Doyle entreated, "But why, then, won't you help this congressional committee in uncovering where there are subversive people?" Ted reiterated, "Because this committee asks questions of political affiliations and asks me to be an informer."

And so it went, around and around, until Kunzig said there was nothing more to be extracted from this witness. Velde dismissed him. The Committee adjourned for lunch.

"Storms at Red Probers, TV Scripter Faces Rap," read the next morning's headline on page 6 in the New York *Daily News*, over choice quotes from the "lanky, chain-smoking Polumbaum." In remarks to the reporter, Velde had threatened Ted with contempt charges.

The very day Ted appeared before the House examiners, Frederick Palmer Weber, a New York economist, came under scrutiny before a kindred outfit, the Senate Internal Security subcommittee. Weber had been a congressional staffer during the war, a researcher for labor unions, and a Progressive Party representative backing Henry Wallace's 1948 presidential campaign. He, too, had taken the Fifth. *The New York Times* combined reports on Weber and Polumbaum in a single article.

As Wallace's chief organizer for the state of Pennsylvania, Ted's brother-in-law Gerry had worked with Palmer Weber. Gerry was in a psychiatric facility in Connecticut where Ted, at his sister Peggy's behest, had taken him not long before. When Gerry read the *Times* story about two people he knew well getting raked over the coals on the same day, he decided maybe he really was crazy.

United Press announced that Ted was relieved of his duties. When he went to collect his belongings, the Boston bureau chief told him off as a traitor. Other UP coworkers remained silent, although one phoned Ted in the middle of the night to confess his admiration, saying he'd summoned the bravura to make the call because he was drunk.

The American Newspaper Guild fought Ted's firing, an unusual show of gumption when most organizations bent to the blacklist. The American Civil Liberties Union also backed Ted, but much more discreetly, mainly through private correspondence with UP executives.

In the view of UP management, Ted's actions before HUAC raised doubts about his honesty and made him "a serious liability." An arbitrator, sympathizing with the company, nonetheless said UP lacked sufficient cause for firing Ted. Meanwhile, the company's own close review of Ted's news scripts, Korean War stories and all, found no bias or errors, even by the Red-scare standards of the day.

The Guild demanded Ted's reinstatement with back pay. The company refused. A New York court then upheld UP's position on a technicality, pronouncing the arbitrator's decision "void, for want of jurisdiction," and concluding, "No one is thereby required to do anything."

From firing to verdict, nearly three years had passed. Ted was well on his way to building a new career as a freelance photographer, but not yet in the clear. At the time of his dismissal, his salary had been $115 per week (something like $1,100 in today's dollars). His final paycheck from United Press, dated April 25, 1953, included a bit over $650 in severance pay, based on length of service, plus $325 for vacation not taken, and $44 for earnings from the week he was fired, totaling $872.49 (some $8,400 today). He wrote a $130 check (about $1,200 today) to Larry Shubow for legal services. His net earnings from photography in 1953 amounted to $27.01 (about $260 for the year in today's terms). He now had two daughters. And he and Nyna, firm partners in their resistance to political persecution, were engaged in battle on another front.

My older sister, Miki, had been diagnosed at age two as autistic—a term known to few beyond the Viennese psychiatrists claiming expertise in the subject. The conventional wisdom of the time blamed parental rejection for autism, the chief culprit said to be the "refrigerator mother." The sole center in Boston treating autistic children therefore put no less effort into judging the mothers; Nyna, who brought Miki in twice a week, was targeted in the notes for her long hair, higher education, and artistic "pretensions." Only the most strong-willed parents, mine among them, resisted this assault on the spirit. The resisters were far ahead of the times; special education, mainstreaming, therapeutic and vocational support, the Americans with Disabilities Act, and autism advocacy groups were decades off.

The generosity of Nyna's mother and stepfather tided our family through those lean years. Ruth and Murray extended whatever financial support they could, along with a great deal of logistical help and moral sustenance, including absolute love and acceptance of grandchildren. Nothing was forthcoming, nor expected, from Ted's far wealthier, and highly indignant, father and stepmother. Phil and Mildred would not talk to him again until he had made it in unmistakable fashion—not until he was photographing for *LIFE*, which was a big deal.

Even before the HUAC hearing, Ted had contemplated returning to a childhood dalliance with photography, and occasionally fooled around with his cameras. One excursion led to a useful credential. In 1950, a community of about 140 Trappist monks

had moved to Spencer, in central Massachusetts, after their monastery in Rhode Island burned down. The community is still there, now renowned for its jams and jellies and Spencer Trappist Ale. Ted was an early visitor, documenting the brothers at their daily routines in a halcyon rural environment. In 1952, the deCordova Museum in Lincoln, the town outside Boston where my parents later built a house, announced a contest for photographic depictions of New England. Ted entered a series of his pictures of Trappist monks, and won. The prize was a future deCordova exhibition that would prove a crowd-pleaser: monks in hooded robes crossing the abbey grounds, monks at services, at prayer, reading, writing, monks preparing meals and working in the gardens.

One of the contest judges, a physicist and ardent photographer himself, had followed up with friendly overtures, phone calls, and invitations. His eagerness to get to know Ted better abruptly vanished after the HUAC hearing. Seeing the man and his wife on a sidewalk one day, Ted and Nyna watched the couple scurry to the other side of the street to avoid crossing paths with them. To its credit, the deCordova kept its commitment, showcasing my father's pictures in the summer of 1954.

Deliberate street-crossings were not unusual, although the notoriety also earned my parents new allies. An elderly neighbor came by to say he was a Methodist whose church teachings compelled him to congratulate Ted. A local journalist, Joe Garland, showed up at their door and said he had to meet Ted. Joe's physician father had founded the *New England Journal of Medicine*. Joe would work for the Associated Press in Boston, the *Providence Journal*, and the *Boston Herald*, then move to Gloucester and write books about the sea. He became a lifelong friend.

Ted inquired about doing publicity photography for a local college, and a jaunty gentleman with a beret and a glass eye came to the Newtonville apartment to see the supplicant's portfolio. First, Ted explained the background to his quest for freelance work. As the retelling of the HUAC encounter unspooled, the visitor began chuckling, which turned into uproarious laughter, which upset his equilibrium to the extent that he fell backwards and got wedged between the makeshift backless sofa and the wall, head down, legs sticking up. Ted extricated the gent, whereupon he declared, "Now I have to hire you!" Thus did we come to enjoy lavish Sunday brunches at the home of Henry Balos and his demonstrative Swiss wife, Dora, who ran a preschool.

Beyond ringing testimony, ostracism from some quarters, new and renewed solidarity from others, and a new livelihood, the HUAC episode led to heightened attention from J. Edgar Hoover's men. Along with countless other harmless Americans, Ted was unaware of the existence of his FBI file. After Ted's death, a doctoral student researching FBI relations with the press requested his FBI file through the Freedom of Information Act, and got back some 170 pages, names of informants and agents blanked out. The record had accumulated over 40 years. It resembled nothing more nor less than a Keystone Kops caper.

The surveillance started when Ted was at Yale, stopped during the war, resumed in York, and followed him to Boston. The dossier fattened up during the 1950s, mostly with repeated dates and details of his education, military service, employment, residences, relatives, and HUAC appearance. The watchers recorded an address change from Newtonville to Lincoln, and later to Cambridge. The records initially got his birthday wrong (listing June 15 instead of June 4), along with height (put at 6'¾" when he was 6'2"), eye color (not hazel, actually green), and a few other things. One curious revelation inflated his work repertoire, saying that in addition to photography, he was self-employed as a mural painter.

Numerous entries over the years said Polumbaum was unknown to "reliable informants" claiming familiarity with Communists in the Boston area. When the Boston office tried to close the case as early as 1954 for lack of leads and absence of "overt acts" of subversion, the director's office kept it open, maintaining that the HUAC episode itself was an overt act.

In 1963, an informant reported that Ted had secured a visa to visit Cuba. In fact, although the US State Department had approved a waiver of its travel ban for his photojournalism plans, the Cuban authorities had rejected his application on the grounds that he worked for bourgeois publications. A year later, a supposed friend of the family, who identified the quarry as "Edward" Polumbaum (even casual acquaintances knew he was Theodore), called photography Ted's "hobby." This clairvoyant source reported that Ted had traveled to India and China, and been impressed by the "mighty deeds" accomplished by the Chinese. Our family had spent much of 1961 in India, but my parents would not get to mainland China until 1981, visiting me while I was teaching journalism in Beijing.

The meandering, redundant, wacky litany concludes in 1986. An agent sought to interview Ted about a Soviet economist he'd befriended—a delightful man, fluent in English, an expert on the American economy. My parents had hosted him in Boston, and he and his wife had taken my parents around Moscow, where Ted was photographing a gathering of international physicians conferring on the prevention of nuclear war. My father declined the agent's invitation to chat. That was the final contact. At last, a dozen years after J. Edgar Hoover's death, the Bureau declared an end to the fruitless pursuit.

In my childhood, my father's showdown with the House Committee on Un-American Activities was family lore, dangling in the background but never really discussed. Not until I was well along in a doctoral program did I seek the details, descending into the basement of Stanford's Cecil H. Green Library, where row upon row of paperbound hearing transcripts produced by the US Government Printing Office were stashed on arrays of metal shelving.

An odd experience had prompted my excursion. After nearly a year of fieldwork to explore the topic of "journalism reform" in mainland China, my two small sons in tow, I'd returned to Northern California to produce a dissertation. One day, still the landline era, the phone rang in our cramped graduate student dwelling. A woman was calling from the FBI office in San Francisco. They'd heard, she said, that I'd recently returned from China. Since that was a place they were interested in, they wondered if I'd come in for a chat.

For a moment, I was speechless. Not scared, not worried, simply taken aback. Somehow, I found the self-possession to decline the invitation, saying that anything I might wish to share would appear in my publications. Suddenly, I had a hankering to know more about my father's HUAC encounter. I was at the library almost every day anyway.

Reading the transcript, I was floored by my father's fortitude. Politely, yet unyieldingly, he had faced off a squadron of vapid but powerful bullies. Little but appearances mattered for these men, as they blithely steamrolled over law-abiding citizens. Everything was at stake for my dad—his reputation, his ability to support a family, whatever would come next.

The next time we spoke, I asked him how, at age 28, he'd summoned the courage to defy the Committee.

Actually, he was terrified, he told me.

My mother was adamant that he resist, and we joked that he couldn't cross her. Still, I was in awe.

"It's not as though they were pulling my fingernails out," Dad said. "Worse things happen to people every day."

So he spit in HUAC's eye, got tossed out of work, and found himself in the quixotic world of the blacklist. Nobody could tell you exactly how the blacklist operated, emerging as it did out of an amorphous fever of fear and intimidation. The spell was spread through the media and the grapevine, and sustained by the connivance of authority at every level, the complicity of private enterprise, and the cowing of spineless Americans.

Enforcement could be arbitrary, or quasi-organized. Ted would go somewhere for a job interview, and the next day the FBI would show up and ask questions. Some of the fallout was plain stupid. Neighbors in Newtonville threw Miki out of their yard, as if a 3-year-old was going to infect their kids with communistic notions.

Upon realizing that anybody who considered him for employment would get grief, Ted started telling potential employers up front about his run-in with the Committee. That usually shut down the conversation. A rare exception arose when two fellows were considering him for a job writing catalog copy for a new business, a chain of electronics stores called Radio Shack. One of them said, "That's what we like, a guy with balls!" Nyna wouldn't let him take that job; she knew he'd hate it.

After Ted gave up his quest for a permanent sinecure, instead seeking freelance work as a photographer, he continued to alert clients to his political history, until he got a foothold with national publications and nobody seemed to care anymore. The period of ostracism was past.

"Some blacklisted people died of politics," wrote the late screenwriter Walter Bernstein in his memoir of the period. "They died of the insult to their hearts." Bernstein did not. Along with his integrity, he maintained his sense of humor. Ted did likewise. They were among the lucky victims. As the history got rewritten, their audacity was turned into valor.

In his correspondence with Yale roommate Bob Grant, my father described how he'd "joined the company of assorted schmoes and radicals who became heroes by the simple chance of being victimized." He marveled that defying congressional bullies would turn out to be "the easiest way to be liked and admired ever levied since the invention of the stud."

In the process, he continued, "I also discovered that, thank God, I had married a woman who, although she often irritated me, never bored me, who was a real person, stubborn, and with thoughts and feelings of her own, a definitely unsubmergable type."

I never asked my father point-blank if he'd been a Communist Party member. I don't think he ever was. My mother, who has stories of her own about spurning recruitment efforts, says Ted was never more than a friendly fellow traveler. Certainly they had card-carrying (and former card-carrying) friends. But with minds of their own, my parents could never be true believers. They were irked by zealots of any stripe. They were mystified by those who remained Soviet loyalists even as revelations of Stalinist abuses mounted. On the other hand, they were repelled by the turncoats, the onetime acolytes of revolution who proclaimed their repentance in the service of the inquisition. My mom preferred the attitude of Jessica Mitford, who in her memoirs wrote that the boredom of Party meetings drove her away.

Ted's fattening FBI file would find no associations with "known" Communists. In

fact, Party apparatchiks had approached him a couple of times during the 1950s trying to prevail on his sympathies.

The overtures came while Dad was still working for United Press in Boston, rewriting the wire for the 11 p.m. television newscast. Hardly a day went by when the Korean War did not lead the news. My parents and sister Miki, not quite 3, had moved into the second-story apartment in Newtonville.

A lengthy trial in New York had found eleven Communist leaders guilty of violating the Smith Act, a 1940 statute prohibiting advocacy of violent overthrow of the government. The US Supreme Court had upheld the verdicts, spurring the federal government into a frenzy of additional prosecutions through the 1950s, snaring more than a hundred more CP-USA officers and members. Only in 1957 did another Supreme Court decision end the circus with a ruling that defendants could be prosecuted only for actions, not for beliefs.

But this was 1952. Thanksgiving was approaching. Somebody asked my father to host a Party official who had gone into hiding. For a week or so, my parents took in an insufferably arrogant woman, who spoke only to the man of the house, and showed nothing but disdain for the lowly "homemaker" wife.

My father was always a soft touch. My mother had her limits. Nyna told Ted she was going on strike; if he wanted to serve his guest a holiday meal, he'd have to make it. Ted's oven calculations were way off. Nyna's revenge was duly dished out in the form of an undercooked turkey. Recalling the episode scores of Thanksgivings later, my mom said, "I think he thought it was a chicken."

Another time, a stranger showed up at the door, identified himself as a Party representative, and proceeded to instruct Ted on how to present the Korean War in the news. My father was not receptive, as would become clear after the HUAC hearing and his firing, when UP admitted that scrutiny of all Ted's scripts for evidence of a subversive slant found none.

Not that I'd care, but my parents were doers, not joiners. They also were great fans of progressive and alternative journalism. My dad indeed had a subscription to the CP-USA *Daily Worker* way back when, although by my time, it had long since lapsed. His durable flow of radical publications included *I.F. Stone's Weekly* as long as that lasted, a bygone product of a muckraking outsider who was staunchly independent but definitely not communist; and he was a lifelong subscriber to *Monthly Review*, overtly Marxist but critical of most institutional communism. *The Nation* and *The Progressive*, and later *Ramparts*, came with regularity. Far more important in our household, however, was my native New Yorker parents' addiction to *The New York Times*. Before home delivery reached beyond the New York metro area, these transplants to Boston got the early edition by mail, usually just a day late.

Ted was far from the only journalist to fall afoul of congressional investigators in the early 1950s. Along with the series of hearings into education in which my father had his bit part, the dragnets raked through entertainment, labor, news media, and other fields. Senate and House committees had done a job on Hollywood, and were snaring reporters, editors, and producers, from print media and broadcasting alike. Many news organizations required loyalty oaths. Scholar Edward Alwood counts more than a hundred journalists called to testify, and fourteen who refused to cooperate and were fired. Some sad cases ended in suicide.

The New York Times went along with the witch hunts. Newspaper mogul William

Randolph Hearst conducted his own. In the view of Ted's mentor Jim Aronson, who had welcomed him as an assistant at the Newspaper Guild's newsletter one summer, and would go on to cofound the independent weekly *National Guardian*, the press became "a voluntary arm of established power."

Curiously, the hysteria doesn't seem to have ensnared photojournalists; Ted wasn't yet one when HUAC came calling. A partial explanation might lie in the relatively innocent acceptance of photographs as "truth," a prevalent view before skepticism, postmodernism, conspiracy theories, and digital technologies added nuance and complication to visual interpretation. As my father was learning his new profession, the notion of the photograph as unalloyed reality still dominated, with the picture-taker a kind of mechanical extension of the camera. Perhaps the inquisitors assumed photographers were automatons who couldn't possibly entertain any ideas at all, let alone subversive ones.

10

Assignment: Exploding Stars

They disciplined her and lavished affection on her to tear down the wall between Miki and the world.
—"The struggle against autism: Miki's triumph," *LIFE* magazine, May 1979

Jacques May was a medical doctor, educated at the University of Paris. He and his wife, Marie Anne, worked in Indochina during World War II, helping the French Underground against the Japanese. In the 1950s, the Mays relocated to the United States, where Marie Anne gave birth to twin boys who were severely autistic.

Exasperated with child psychiatrists who were building reputations on unscientific theories and unkind therapies, the Mays collaborated with other parents to establish the Parents School for Atypical Children. Their center, which opened on Cape Cod in 1955, emphasized a highly structured schedule, an affectionate environment, and creative play. It was geared for children with far greater handicaps than my older sister Miki's, but Ted and Nyna knew the Mays, and Ted got permission to photograph there for possible publication. On one of his periodic visits to *LIFE* photo editors in New York, he proposed a story on the Mays' innovative school. The editors liked his pictures, and were encouraging, until they made inquiries and discovered the ruling experts' ferocious disdain for these new approaches to autism.

The Mays' vision long outlasted the experts they challenged. Their endeavor eventually grew into the May Institute, a national nonprofit serving people with autism and other developmental disabilities in four residential schools, additional programs across the country, and partnerships around the globe. Back then, however, *LIFE* was not about to lend credence to small fish swimming against the tide. Ted's intense depictions of boys and the occasional girl lost in some primitive cosmos while gentle, persevering adults tried to connect with them never saw print.

By degrees, Miki was making progress. Her tempestuous tempers were lessening, her recalcitrance diminishing, her ability to learn unmistakable. She had an unexpected breakthrough at age 3, when she began to repeat words, and what started as mimicry evolved into speech. By age 5, she was talking fluidly and learning to read. After two years of dealing with antagonists at the Boston children's center, Nyna had found a nursery school that was happy to accept an oddly behaved little girl who might space out or scream but was clearly teachable. After another two years, Miki went on to a private day school, attending a transitional program into the primary grades. From third grade on, she went to public school in Lincoln, Massachusetts, which had become our hometown.

As Miki emerged from her carapace of strangeness, my father wrote former

Marie Anne May on the Cape Cod bluffs with one of her autistic sons, 1956 (©Ted Polumbaum / Newseum collection).

college roommate Bob Grant of the discovery that "our first born, a beautiful, golden haired, vigorous and healthy girl, was an autistic child—variously described as 'atypical,' 'pre-psychotic,' or 'schizophrenic.' This was a child about which very little was (or is) known in medicine and psychiatry.

"You may feel this is very sad," Ted's letter continued. "You can imagine the toll this took on Nyna, how frightened and anxious were grandparents and relatives. But this child enriched us immensely and, I believe, deepened our understanding of all people. It is something I would ask for no one, but I can't help feeling that I would have missed something important if it had not happened."

About me, Dad wrote: "The second one was a complete organism, or, I should say, a real child, warm and alive, selfish and generous, fully integrated, and, when not a pest, always interesting."

By now, Miki, too, was a real girl; and thanks to Miki, my formal education began with a considerable academic boost. She'd been bringing her lessons home even before I entered Lincoln's community nursery school. On a daily basis, after school and on weekends, she would sit me down in front of a blackboard in our playroom and bombard me: from A is for apple to Z is for zebra and everything she'd latched onto in between. Her uncanny memory, attention to rote, and fierce powers of concentration made her a fabulous instructor. When I started public kindergarten during Miki's last year in private school, my older sister already had taught me to read. While my kindergarten classmates were learning letters and words, a goodly part of the curriculum, the teacher left me in a corner with a pile of books.

Gradually, it dawned on me that my sister was a little, well, different. The word

autism was no use, because nobody knew it back then. Mostly, I didn't try to explain her. She got teased relentlessly in school, yet a few sweet kids always accepted her. Her coordination was a bit off; she was not athletic and walked stiffly. My parents addressed that more in her early teens, when she did crawling exercises to activate brain patterns skipped in infancy. Most teachers put up with her; a few found her special. Her third grade teacher preferred Miki to most of the spoiled kids in his class, and liked her idiosyncratic ways of looking at things. With delight, he reported to our mother that, when Miki's feet fell asleep, she'd declared: "My feet have stars in them, and they're all exploding."

Miki earned her driver's license, completed high school, studied voice at a music conservatory, graduated from a prestigious fine arts program, became a silversmith, and held a job in customer service with a university press for many years—until the press sent in a hatchet woman to implement downsizing. When Miki and several others filed grievances against her, they discovered their whole department was being eliminated, and the work outsourced. My sister, backed by my mother's fierce advocacy and implied threats of bad publicity, wrested a retraining agreement from the university, and acquired the skills and tools to tune pianos. Meanwhile, in a bit of karmic justice, the hatchet woman and another nasty supervisor soon got laid off as well.

By the late 1970s, the accumulation of small victories added up to something even *LIFE* could endorse. The old weekly *LIFE* had long since died, to be reborn as a monthly. The magazine published Miki's saga of emerging from a cocoon of self-absorption into confident adulthood, chronicled through the pictures our father had taken over the years. While the story identified her only as Miki, anyone paying attention could figure out that the photos credited to Ted Polumbaum channeled the views of a loving parent, who also happened to be a professional photographer.

Miki's triumph over a hostile world is due in no small part to her own doggedness, spurred by our parents' determination that she would lead a fulfilling life, and in particular, our mother's insistence on forging ahead, regardless of who or what stood in the way. What remains baffling, despite today's far greater understanding of autism, and the availability of services unimagined when my sister was small, is that parents of autistic children and adults even now must fight relentlessly for recognition, respect, and help.

For Miki, happily, the worst is far behind. She lives independently, tends an exotic bird, meditates, cycles, sings and plays guitar, reads a lot, does

As a young adult, Miki jogs along the Charles River, Boston, 1978 (Ted Polumbaum / family collection).

crossword puzzles, and belongs to a taekwondo dojang. Her only concession to accumulating birthdays is mild hair dye, to keep gray flecks from marring the luscious dark red locks of which she is so proud.

She still has some ritualistic habits and a few obsessive interests—above all, a grand attachment to the movie *West Side Story* (the 1961 classic, which she swears the Steven Spielberg remake will never top). She'll go just about anywhere within driving distance to see the original on the large screen. It turns out, however, that my sister is merely one among hordes of ostensibly normal people who connect on Internet fan sites. Nowadays, Miki and her fascinations are quite acceptable.

11

The Portals Open

I would live all my live in nonchalance and insouciance
Were it not for making a living, which is rather a nouciance.
— Ogden Nash, "Introspective reflection"

As Ted confronted unemployment in the early 1950s, a group of young families was searching for a piece of land suited to their vision of forming a cooperative community near Boston. Five couples put down $100 each for an option to buy a tract of rough woodland in the town of Lincoln, west of Boston. They publicized the endeavor on bulletin boards and in radio ads. More families signed on. Eventually, the group would purchase 40 acres, gain town approval for a subdivision with 23 lots, put in two roads, build homes, and create a neighborhood in which individual households shared values, tools, chores, and whatever else emerged from collective deliberations. Decisions were made by consensus, requiring unanimity for approval; objection from even one person would sink any proposal.

Someone told Ted and Nyna of hearing about the project from a promo on an FM radio classical music station. In the Newtonville apartment, Ted was using the pantry as a darkroom, fetching water from the kitchen sink, wearing nothing but boxer shorts in the heat of summer. With assignments picking up, he needed a real darkroom and a studio. Nyna wanted more space to draw and paint and spread out her art supplies. Two active daughters made the thought of a new house all the more appealing. The Polumbaums joined the group.

A nonprofit corporation owned the land until it was transferred to individual owners. Each family saw to design and construction of its own house, with everyone reviewing the plans, and a few caveats: innovation was prized, so no colonials, capes, or ranches. Extended discussion resulted in naming the two roads after local wildflowers: Laurel Drive (for the mountain laurel) and Moccasin Hill Road (for the velvety plant also known as the lady slipper). The roads crossed en route up hilly terrain, ending in circular turnarounds. Most lots were one to two acres. An elaborate procedure was devised to allocate home sites, incorporating individual preference, tenure of membership in the group, ballots, and swapping. One lot was reserved for a playground, another larger parcel set aside for a possible swimming pool. (Both eventually would be sold as additional house sites.) The cash investment ultimately required for an average lot was something over $3,000 (which translates to about $28,000 in today's dollars), including costs of the raw land, road construction, and legal expenses.

When taking pictures was still a pastime for Ted, his photographs of quaint Trappist monks had earned him that exhibit at Lincoln's deCordova Museum, housed in a former

mansion on the rolling estate of a merchant who'd collected art from around the world. So my parents already were familiar with the low-key town, a place inhabited since colonial times, serenely obscure, yet harboring a few notable destinations.

"Some had lived there for generations," writes Marilyn R. Brandt in a study of the town's residential land use. "Some came because they lived in the city and Lincoln was the country. Others came naively, by chance."

Minutemen from Lincoln had fought in the opening salvos of the American Revolution, joining the battles of Lexington and Concord, peppering the retreating British with potshots from behind stone walls. Lincoln was on the way to Walden Pond and the Old North Bridge, where any good Boston area host was obliged to take guests. A historic homestead in Lincoln, Hartwell Farm, housed a picturesque restaurant serving country fare, with an ancient parrot squawking from a cage, until the place burned down in 1968. Lincoln was home to Drumlin Farm and the Massachusetts Audubon Society. Lincoln had a hokey, homespun Independence Day parade, and a nighttime fireworks extravaganza that brought crowds from all over. Lincoln also had more sophisticated pilgrimage sites, like a Walter Gropius house.

Our spot in the emerging neighborhood of Browns Wood was a scrubby acre perched on the rise near the end of Laurel Drive, just before it dropped down to the cul-de-sac. Nyna drew on her Cooper Union training to design a split-level house, built on bedrock, ready for occupation in 1956. A chunk of boulder would forever protrude from the concrete of the basement, a bothersome conduit for seepage when it rained. Otherwise, with large windows, ingenious cabinetry, cork floors, and other features unusual for the times, the place was modest but masterful. The scruffy lawn behind the house descended a steep slope into the woods. The living room had magnificent views of sunsets over the treetops. A later addition made it more spacious, creating a line of bedrooms toward the back, leaving our former chambers downstairs, off the playroom, for guests.

Today's Lincoln, a trendier and far costlier bedroom suburb, touts my childhood home as a fine example of midcentury modern architecture. My parents expended about $25,000 and lots of sweat equity on the original house, selling it for $165,000 in 1980 to move to a fixer-upper in Cambridge. It went to third owners in 2002 for $840,000. The assessed value now hovers around a million dollars, fluctuating a bit with real estate trends. Land alone has appreciated tenfold; wooded plots in Lincoln now list for a cool quarter million an acre. Tech moguls and captains of finance live there.

In our time, the neighborhood was full of baby boomers. My birth year, 1953, took the crown, eight girls and eight boys my age busting out of a majority of the 21 initial families. A logical consensus creation was the babysitting exchange, with points earned for watching your neighbors' kids, and expended when neighbors watched yours.

For reasons nobody quite understood, Browns Wood claimed an unusual concentration of mostly secular Jews, nearly a third of the households; and Jews, if not oddballs generally, are likely what realtors meant when they referred to "those people" in our vicinity. Lincoln was a very WASP town, boasting branches of prominent Boston families among its denizens, including descendants of the two Adams presidents. The old part of town harbored the colonial homes and historic community structures. The ranches were in newer subdivisions on the north side, across Route 2, where the Catholics tended to live.

Some farming families, rich in acreage and heritage, still carried on raising crops and animals. Eventually, many landed residents would turn over large tracts to Lincoln's

farsighted conservation program, securing the privileged tranquility residents and visitors enjoy to this day.

In times predating a universe awash in digital imagery, my sister and I, and later our brother, grew up surrounded by the accouterments of old-fashioned photography. In a wide open studio off the living room, Ted stashed rolls of backdrop paper and his expanding stock of equipment: tripods, lights and stands, coils of extension cords. He kept his camera bags packed: Leica and Nikon bodies and lenses, plenty of film. The new black-and-white standard was 35 millimeter Tri-X, introduced in 1954, with fine grain, good tonal range, and flexibility. He bought 36-exposure rolls, and stored cellophane-wrapped packs of twenty, "bricks" in the lingo of the trade, in the kitchen fridge. Off the studio was a two-part darkroom: the sealed back room, with a red safelight, for developing and hanging film; and the main area, where printing occurred under yellow safelights, print trays lined up in a long trough sink, with the enlarger station, drum dryer, mounting press, telephone extension, and Rolodex.

Dad's livelihood became a way of life for all of us, and a bonus for neighbors and friends. During our neighborhood's planning and construction stages, he documented the Browns Wood gang, which included quite a few engineer fathers, doing their own surveying, clearing the woods with chainsaws for the roads and lots, and watching the houses rise. Over the next quarter century, he would document Lincoln people at home, at work and play, at antiwar marches and civil rights events. For a *LIFE* assignment on marijuana use in respectable suburbia, he photographed a pot party in a Lincoln home. After the Meyer family, at the foot of Laurel Drive, built a stable and horse paddock, his picture of my buddy Sara Meyer mucking out a stall made *Time* magazine.

As my parents prepared to move us from the Newtonville rental to the real home, Ted was getting paid jobs—advertising, publicity, the occasional news assignment—but had yet to reach the holy grail: *LIFE*, founded in 1936, still the most influential picture magazine two decades on. Maybe Lincoln was the charm. We moved there in 1956. The first official *LIFE* assignment came in 1957, photographs of Archbishop (later Cardinal) Richard Cushing's Thanksgiving party for the needy at Blinstrub's Village, a South Boston nightclub where the likes of Frank Sinatra and Jimmy Durante performed (destined, like Lincoln's Hartwell Farm, to burn down in 1968).

Photographers never knew precisely what their pictures would reveal until processing and printing, but as Cartier-Bresson observed, good photographers got a feeling when they'd captured a good shot. Cushing was dancing with an adoring elderly dame. Ted took the picture. He just knew that was the one that would run in the magazine, and it did.

From this point on, the portals opened. The arrival of *LIFE* in itself was news. When *LIFE* showed up, the rest of the press corps parted ranks in deference, surrendering the best positions. The wire service and newspaper people who'd viewed Ted as a pariah now treated him like an honored guest.

Ted's top patron, though they never met, was Henry Robinson Luce. The son of missionaries, Luce had been born and spent his first fifteen years in China. World affairs, and America's global status, became enduring preoccupations, reflected initially in *Time*, and even more vividly in *LIFE*.

The first issue of the weekly *LIFE*, dated November 23, 1936, had proclaimed lofty purposes: "to see the world; to eyewitness great events; to watch the faces of the poor and the gestures of the proud." From the outset, the magazine purveyed what Luce biographer Alan Brinkley characterizes as an "affirmative, inclusive vision" of a diverse yet

Part of a contact sheet documenting creation of the Browns Wood neighborhood in Lincoln, Massachusetts, 1955 (Ted Polumbaum / family collection).

united America. In its early years, this optimism about American virtue was set against the bleaker backdrop of the mounting conflicts in Europe and Asia. Toward the end of Luce's stewardship, this tenaciously positive view would come up against the grisly evidence from America's war in Vietnam.

Initially, the founder refrained from directly expressing his political views in public, let alone under his own name in his magazines. That would change, as *LIFE* became

his platform for an apocalyptic call to action. In a commentary headlined "America and Armageddon" in the June 3, 1940, issue, Henry R. Luce argued for the immediate "arming of America" as a bulwark for the coming assault on the nation's "democratic way of life." More emphatically, in the issue of February 17, 1941, he appealed to America's leaders to forsake isolationism and join the Allied cause, with the goal of defending and spreading democratic values around the globe. This much longer essay was titled "The American Century."

The piece was widely reprinted, and the phrase American Century stuck—to this day, easily read as a summons to empire, which Luce always insisted it was not. He would use his prerogative as *LIFE*'s chief editor and publisher to claim bylined space only twice more: once to share a long report of his return to China in wartime, with photographs by his second wife, Claire Booth Luce; and again, for a commentary after Japan bombed the US naval base at Pearl Harbor. Interestingly, Luce consigned his own writings to spots deep in the magazine—page 40, page 61, page 82—until the Pearl Harbor piece, "The Day of Wrath," page 11, with America finally going to war as he'd advised.

When Luce died in 1967, three years after his formal retirement, the enterprise had annual revenues exceeding $500 million (approaching four billion in today's dollars). Alden Whitman's *New York Times* obituary credited him with having "created the modern news magazine, fostered the development of group journalism, restyled pictorial reporting, encouraged a crisp and adjective-studded style of writing and initiated the concept of covering business as a continuing magazine story."

With the introduction of the weekly *Sports Illustrated*, Luce also spurred the creative expansion of sports journalism and photojournalism. Announcing that magazine's 1954 launch (Time Inc.'s fourth title, after *Time*, *LIFE*, and *Fortune*), he had written: "You don't have to read about [sports] in order to be a better executive or a better housewife or to do your duty as a citizen in the Hydrogen Age. But you'll surely want to have a look at this new magazine...." After a couple of years of multi-million-dollar losses, *SI* found its footing. By the 1960s, it was the go-to publication for insight into the games purveyed on television, both journalistically respected and lucrative. As late as the 1990s, *Sports Illustrated* was the second most profitable consumer magazine in the world.

The most profitable was Time Inc.'s *People*, a breakaway success from its inception in 1974, proof of the premise that humdrum doings of famous individuals, interspersed with a few extraordinary stories of ordinary folks, would captivate readers. Initially, my father had a good run of *People* assignments, usually in the company of capable veteran writers. Thoughtful articles, accompanied by bona fide photojournalism, could be found among the escalating proportion of fluff. In time, gossipy and formulaic tendencies put good journalistic intentions to rout. Thus, the version we now browse guiltily at the grocery store checkout line, replete with celebrity breakups and make-ups, baby bumps and adorable children, bewitching fashion statements, paparazzi sightings.

As mega-media companies ballooned with combinations, acquisitions, and new start-ups, Time Inc.'s catalog proliferated rapidly, ultimately accounting for more than a hundred magazine titles. These days, keeping track of the bewildering changes in ownership of the Luce heritage can induce vertigo.

Time Inc. merged with Warner Communications in 1990 to create Time Warner, then the world's largest media conglomerate. Meredith Corporation, the Des Moines, Iowa–based media company whose flagship magazine is *Better Homes and Gardens*, bought Time Inc. in 2018. Within a year and a half, Meredith resold three storied

publications: *Time*, to a tech billionaire and his wife; *Fortune*, to a Thai businessman; and *Sports Illustrated*, to a New York City branding company, Authentic Brands Group, or ABG, whose business includes licensing and merchandising deals for athletes, apparel, sports equipment, and bygone celebrities such as Marilyn Monroe and Elvis Presley. ABG then leased *SI* to a Seattle-based digital media startup called Maven, which promptly slashed the staff by more than a third, began recruiting for much cheaper freelancers and bloggers, and announced a relaunch for January 2020. A protest petition from *SI* staffers said the plans would "significantly undermine our journalistic integrity, damage the reputation of this long-standing brand and negatively affect the economic stability of this publication." ABG's chief executive countered that the situation at the magazine was "awesome." The 65-year-old pioneer of sports journalism seemed on track to become just another mediocre content factory.

Reduced to merchandise in a transactional delirium, Luce's crown jewels have long since lost their glitter. In his lifetime, however, Luce and his instruments of mass communication were mighty forces, and what Luce said and wrote carried weight. In particular, the notion of "the American Century," that phrase coined during the glory days of *LIFE*, supplied a durable maxim for an era of US supremacy.

As long as it lasted, *LIFE* would be my freelancer father's most reliable patron. He became a regular stringer, a mainstay at the *Time-LIFE* New England bureau, constantly pitching his own ideas to the photo editors in New York, and on call for the entire Time Inc. stable, including the book division. He also worked regularly for *Look* magazine, *The Saturday Evening Post*, *The New York Times* and its Sunday magazine, and many other publications.

Ted went on to do about 400 assignments for *LIFE*, often in company with a reporter. Subjects were many and varied, ranging over politics and religion, science and medicine, athletics and the arts, urban planning and the elements. The company paid him day rates, as well as picture rates for publication, along with reimbursement for expenses. In a cramped typist's scrawl, he meticulously recorded mileage, meals, and other items in little spiral notebooks.

Time Inc. was flush with cash, and some took advantage. Ted was extravagant only in emergencies. Once, his eyeglasses blew into the ocean as he was photographing a hurricane off the coast of Cape Cod. Back in Lincoln, nobody was home. He called Jack Corrigan, who ran the town taxi company, with instructions to break into the empty house through an unlocked window and fetch a spare pair of glasses from a bedroom drawer. The driver tasked with the mission drove 80 miles through the storm, stopping only to remove trees from the road, handed over the glasses, declined refreshments, and headed back.

My father routinely covered Boston's favorite family, taking pictures of John F. Kennedy's rallies for reelection to the Senate, appearances by Robert or Edward or Jackie, audiences with patriarch Joseph P. Kennedy, Sr., or matriarch Rose Kennedy. After Bobby Kennedy's assassination in 1968, amidst a scrum of press at the family compound on Cape Cod, my father looked over a fence and found bereaved Rose endlessly bouncing a tennis ball. In the summer of 1969, while Teddy Kennedy was in seclusion after driving a car off the bridge connecting Martha's Vineyard with Chappaquiddick Island, resulting in the death of passenger Mary Jo Kopechne, my dad produced an ominous nocturnal photo of that bridge for *LIFE*.

He would photograph Cushing, now Boston's Cardinal, many more times: blessing

the faithful in church, attending a Fenway Park baseball game with a bevy of nuns, presiding over the funeral of Joseph Kennedy, Sr.

Winter inevitably set Ted on expeditions throughout New England to capture snowstorms. He left a dinner party to get to the Spring Hill mine collapse in Nova Scotia. He flew to Canada to photograph the switching station whose malfunction had plunged the Northeast into darkness. He chronicled the destruction of swaths of Boston in the name of redevelopment.

Boston was a big sports town, and Ted got a fair share of sports assignments, often for *Sports Illustrated*, whose initial skeleton staff depended on the rest of the Time Inc. network for talent.

Ted's own sport was tennis—playing it, and watching it. As brute force increasingly came to dominate the men's professional game, he preferred watching the women, whose powerful finesse he thought much classier. He had no interest in attending tournaments; to him, the best seat was in front of the TV. He would turn off the volume, muting the announcer, fixed on the action alone, his eyes darting back and forth with the ball.

He seldom photographed tennis, which was fine with him, since he'd rather observe free of obligation. He felt no particular attachment to the rest, but dutifully reported to New England stadiums, courts, arenas and fields to capture the action. He covered professional baseball and basketball from time to time, boxing on occasion, ice hockey a bit, football, it seems, not at all.

Inevitably, the national press discovered the world's oldest annual marathon—the Boston Marathon, which made its debut in 1897 with a field of seven runners, and would grow to more than 30,000 registrants each Patriots Day. Before the fitness boom, before

The start of the Boston Marathon in 1966, when participants numbered fewer than 600 (©Ted Polumbaum / Newseum collection).

specialized shoes and running gear, before the proliferation of races across the land, it was a singular event that the locals loved to cheer, our family among them.

We'd drive downtown, park on Newbury Street or thereabouts, and walk the few blocks over for a view of the finish line on Boylston Street. We'd see the vanguard come flying in, the champion escorted by motorcycle police and crowned with an olive wreath. I remember watching an early finisher leave a trail of orange vomit in the air behind him just before he crossed the line. Heading back to the car, we came across another man felled by fatigue, a mere minute or two from the finish at sprint speed, instead on his hands and knees on the sidewalk, refusing offers of help, determined to crawl to the bitter end.

Ted photographed the Boston Marathon for *Sports Illustrated* in 1966—the takeoff at the starting line in Hopkinton, Massachusetts; the motorcycle entourage bringing in the striding Kenji Kimihara, fifth Japanese winner since World War II; elation and exhaustion in the refreshment and rest area, where finishers guzzled water and collapsed. It was the year Roberta Gibb entered illicitly for the first time, jumping out of a bush near the start, disguised in a hoodie and Bermuda shorts, becoming the first woman to complete the race—a breakthrough which Dad missed entirely. (Gibb ran the marathon again in 1967 and 1968, as the number of unsanctioned female participants grew; not until 1972 did organizers allow women to register officially.)

Assignments periodically brought Ted to Fenway Park, home of the Boston Red Sox. They'd been the last Major League Baseball team to integrate, taking on their first Black player in 1959, twelve years after Jackie Robinson joined the Brooklyn Dodgers. In 1967, when Boston seemed on track to winning the American League pennant (it did), and Dad was spending a good deal of time at Fenway, the roster had five African Americans. In the starting lineup was George "Boomer" Scott, first baseman and eight-time Gold Glove winner.

Elite athletes were not yet the unreachable celebrities they would become; journalists had far more access to them then, including license to linger at practices and (as long as they were male, which most journalists were) enter locker rooms. Overhearing baseball players in the shower comparing dick sizes, my father was not overly impressed with their intellectual concerns.

Nor was he distracted by the aura of hometown heroes. Red Sox slugger Ted Williams was Boston's premier icon, even after his retirement in 1960. One day, someone told photographer Ted that the superstar Ted wanted to talk with him. Williams apologized to my dad for being brusque the day before. My dad, no doubt engrossed in the business of taking pictures, hadn't even noticed.

When the Red Sox were hosting the New York Yankees, my father expended a few rolls of film on Yankee batting practice, and returned the next day with contact sheets and prints. In this era before video playbacks, the players were fascinated with the succession of pictures—especially several shots, closeups of a bat grip, that revealed Yankee home run champ Roger Maris cocking his wrist in an odd manner. Maris happened to be in a batting slump; seeing the photos of the quirk helped him out of it.

Ted's camera caught Yankee star Mickey Mantle in the visitors' locker room with a bottle of beer poised on his knee. Media were protective of the mythology of the wholesome athlete, and the photo did not see print at the time. Only with the release of tell-all books like Jim Bouton's *Ball Four* did the curtain begin to lift. A quarter century or so later, Dad's image of Mantle enjoying his alcohol appeared in *People* magazine,

Bill Russell, star center, soars for the Boston Celtics, 1966 (©Ted Polumbaum / Newseum collection).

posthumously. The power switch-hitter had passed away just two months after a controversial transplant operation to replace his cirrhosis-ravaged liver.

In contrast with the racially benighted Red Sox, the Boston Celtics were first in the National Basketball Association to integrate, drafting an African American player in 1950, and fielding the first all-Black starting lineup in 1964. The fabled Bill Russell arrived in 1956, playing thirteen seasons with the Celtics, my father memorializing some of those astounding leaps to the basket. Russell became the NBA's first Black player-coach, then head coach. Nevertheless, much as Bostonians might have cheered their twelve-time NBA All-Star and five-time league MVP, he made no secret of his view that Boston was a malignantly racist town.

LIFE enlisted Ted for the New England installment of the Sonny Liston–Muhammad Ali rivalry. Ali had recently converted to Islam. In an upset bout, held in Miami Beach in early 1964, he'd defeated Liston to claim boxing's heavyweight title. They were scheduled to fight a rematch in Boston late that year. In town to prepare, Ali famously called Liston an "ugly bear." Ted spent a few days photographing Liston in training, and found him good-natured and likeable.

The rematch was postponed when Ali needed emergency hernia surgery. "If he'd stop all that hollering he wouldn't have a hernia," Liston was quoted as saying. "It could have been worse," Liston went on; "it could have been me."

LIFE then tasked Ted with getting pictures of Ali—still called Cassius Clay by most media—recuperating in the hospital. My father found Ali's mother at his bedside, solicitously combing her son's hair. Ali was subdued but convivial, his mother gracious, and they immediately assented to my father's request to photograph.

As Dad left the hospital room, several large, intimidating-looking men—Fruit of

Muhammed Ali's mother visits the boxer as he recuperates from his hernia operation, Boston, 1964 (©Ted Polumbaum / Newseum collection).

Islam guards, detailed by the Nation of Islam to stand sentry in the halls—demanded he turn over the film. Nervously, but confident in his subjects' consent, Dad surrendered an unexposed roll. *LIFE* got its picture.

In the rescheduled fight, held in Lewiston, Maine, the following spring, Ali knocked Liston flat less than two minutes into the first round.

12

Assignment:
Prelude to Camelot

I liked Jackie Kennedy … she was not at all stuffy … she had perhaps a
touch of that artful madness which suggests future drama.
 —Norman Mailer, "An evening with
 Jackie Kennedy," *Esquire*, July 1, 1962

Five months into her pregnancy with John John, formally JFK, Jr., in midsummer of
1960, Jacqueline Bouvier Kennedy watched a live broadcast on television as the Demo-
cratic Party anointed her husband, John Fitzgerald Kennedy, its presidential nominee on
the other side of the country.

Boston-based freelance photographer Ted Polumbaum was on Kennedy duty yet
again. He saw a good deal of Jack, Jackie, and Caroline during JFK's time representing
Massachusetts in the US Senate, and even more of Teddy and family once the young-
est son assumed that same Senate seat. Polumbaum despised pack journalism and the
paparazzi ethos starting to develop around celebrities, but *Time* and *LIFE* retained their
aura, and often got exclusives. While the Democratic delegates convened in Los Ange-
les, and most of the media clustered there, Ted was the only photographer with Jackie at
the Kennedy compound in Hyannis Port, Cape Cod, on nomination night. Jack Kennedy
won on the first ballot, with Lyndon Baines Johnson a distant second.

A well-informed constituent, my father never succumbed to the reverence that large
swaths of the electorate and much of the media lavished upon Kennedy politicians and
their kin, although over the decades to come, he was gratified to see Teddy evolve from
puerile youth to seasoned public servant. He did like Jackie from the start, however, and
the lively way she "smoked and swore like a sailor," as he put it—always off-camera, of
course.

The morning after JFK's convention victory, the press showed up in force at Jackie's
redoubt, and Ted captured her holding court from the porch to a throng of reporters and
cameramen.

The one time Ted found himself in gotcha paparazzi mode was the last time. Eisen-
hower was still president, and Sherman Adams, an aristocratic Yankee who'd been gov-
ernor of New Hampshire, was his powerful White House chief of staff. Adams was
discovered to have accepted gifts from an old pal, Boston industrialist Bernard Goldfine,
who was in trouble with a couple of federal agencies. Goldfine had given Adams a vicuña
coat and an Oriental rug, and Adams had intervened on his behalf.

Fingered by Congressional investigators, Adams disappeared. He was rumored to be
fishing in northern climes. Ted and correspondent Paul Welch spent three days in a boat

pretending to be anglers, really angling for *LIFE*. They returned with three salmon and no pictures, to a revised assignment to pursue Goldfine.

They cornered the hapless old man in a Boston restaurant. Ted convinced him to receive them in the more dignified setting of his home, where they reconvened for the

Jackie watches JFK's nomination from afar in Hyannis Port, Massachusetts (©Ted Polumbaum / Newseum collection).

Jackie greets the media crush in Hyannis Port the day after her husband is chosen Democratic candidate for president (©Ted Polumbaum / Newseum collection).

portrait that ran in the magazine. "Goldfine genuinely liked politicians; indeed he seemed to take pride in just knowing important men, aside for what they might do for him," *LIFE* reported, in its story titled "The great vicuña coat tale." Goldfine was quoted as saying, "I never put a rope around anyone's neck, and I never will."

Adams resigned but was never prosecuted. The naïve, chastened Goldfine went to jail. Dad swore off stalking subjects forevermore.

In her third year as First Lady, Jacqueline Kennedy was pregnant again. Patrick Bouvier Kennedy, born three months before JFK's assassination, lived only two days. *Time* assigned Ted to the story as lifesaving efforts were underway at Boston Children's Hospital. Ted made no effort to intrude on the family. Instead, he found out which wing and floor contained the vigil that surely was taking place, entered a building across the way, and photographed that section of the hospital from the outside.

13

Family Pictures

No one's family is normal. Normalcy is a lie invented by advertising agencies to make the rest of us feel inferior.

—Claire LaZebnik, *Epic Fail*

My father taught me to tie my shoelaces by demonstrating once—over and under, loop one lace, circle the other around and through, and tug until snug—and then directing me to do it again and again. I must have been about 4. We squatted on the concrete slab at the back of the house in Lincoln. My Keds sneakers were blue, with the rubberized half-moon at the toe.

When I was small and very ticklish, he would capture me and tickle me mercilessly. I seldom could retaliate, since he was ticklish only on the bottoms of his long, bony feet.

When I was bigger, and would fall asleep in the car coming home from some evening outing, he'd still hoist me over his shoulder to carry me inside, and I'd still pretend not to have woken up.

Dad tricked me, or maybe coaxed me, into riding a two-wheeler. He took the training wheels off my bike, and said he'd be holding onto the back as we circled the turnaround down the hill at the end of our street. I didn't realize that he'd let go and was just loping along behind me.

He gave me my first camera, a Brownie. Although I never asked for an upgrade, he later retired a Nikon F into my hands. He introduced me to printing by letting me push the timer button on the enlarger, rock the emerging image in the developer, and transfer the picture with tongs to successive trays: stop bath, fixer—or hypo, as in "agitate the hypo"—and water bath. He taught me to wind film onto the reel for processing in the pitch dark by having me practice on ribbons of exposed film with my eyes closed. At his side in the darkroom, I inhaled a miasma of chemical fumes.

At his side in motion, I had to hustle to keep up with his long strides, three of mine to one of his.

He always had fresh Kleenex in his right front pocket.

Dad's favorite meal was boiled lobster and corn on the cob, both slathered in butter. Not even a mile from home, we could buy fresh sweet corn from the Brownings's farm stand at the foot of the fields straddling Conant Road.

His quintessential culinary production was bacon and eggs. He loved to get up early on a weekend morning and blast Dixieland through the house, usually a Benny Goodman record, while breakfast sizzled.

If he could have *been* Benny Goodman, he wouldn't have been a photographer.

He was a competent clarinetist, but no maestro. His standards were "When the Saints Go Marching In" and "Sweet Georgia Brown."

The division of labor in our household was familiar for the times: Dad the primary breadwinner, Mom in charge of domestic affairs. At the same time, my parents had unusually intermingled roles. By enlightened modern standards, Ted did not pull his weight with housework. But he probably helped more than the typical husband of his generation. He cleared plates, washed dishes, made breakfast, told bedtime stories. He performed seasonal male stuff, rolling the manual mower across the scruffy lawn, raking leaves, shoveling snow, but Nyna did much of that, too. Dad took the trash out to burn in the metal barrel that served as our incinerator. Mom, the creative one even when it came to heavy labor, contoured the gardens and built the stone walls. We kids were dragooned into chores that eventually became second nature, which I now know to be the cleverest parenting trick of all.

For most of their marriage, my parents had adjoining studios. And Ted had his hermetic darkroom space, first in Lincoln, in a custom-designed suite, later in Cambridge, in a cramped basement retrofit. Between assignments, Dad would be home developing film, making contacts and enlargements, drying prints. He'd package pictures to mail in big manila envelopes, sort equipment and film, and try out test shots against backdrop paper. Or he'd sit in his living room grasshopper chair, now a midcentury modern classic, and read, his favorite pastime when he wasn't on the tennis court.

Nyna, meanwhile, was prodigiously productive across mediums and methods—painting, printmaking, calligraphy, sketches, graphics, couture, collage, inventive hybrids. Her party invitations and holiday mailings were original works of art. Occasionally she placed pieces in gallery collections or shows. Mostly, her personal work accumulated. She also applied her artistry and organizational skills to political activism: She produced posters and masterminded murals and orchestrated exhibitions.

As far as making a living, Nyna was the indispensable backstop for Ted's photo business, his best picture editor, his smartest advisor on projects, his pretend receptionist—though we also had one of the earliest telephone answering machines, a reel-to-reel contraption rented from the phone company. The phone was the freelancer's lifeline; every call could mean a possible job. My father was the guy who went off to the salt mines and kept a roof over our heads. My mother, architect, remodeler, genie of major assets, engineered the roof in the first place. She conjured up visions of where and how to live, and compelled them into existence.

Both my parents were generous with affection toward us kids. And Dad could be embarrassingly demonstrative toward Mom. He would grab her and kiss her while she pretended to fend him off. Then they would dance across the living room to Dixieland music.

At the same time, my parents were weirdly uptight. They never talked with me about sex; my earliest inklings came from third-grade girl blather at pajama parties. They could be perversely protective. Late to the boyfriend game, I sensed from the start that my romantic interests were not particularly welcome under their roof, and kept my escapades to myself. To their credit, though, they were delighted with the husband I ultimately brought back from overseas.

My mother was the disciplinarian, dispensing swats that scared more than hurt. Miki got the most, as Mom refused to let the autism diagnosis permit brattiness. In my case, she finally put spankings to rest after I hit my head on the corner of a bookshelf

trying to escape, raising a purple welt that made her feel terrible. By the time Ian arrived, my parents had achieved some income stability, so he had more toys, as well as a series of au pairs that freed up my mother for her artwork. In the ten years separating me and my brother, Mom's disciplinary tendencies also relaxed a bit, although her standards for everyone and everything remained high.

Mom could be tough even when brushing our hair: out with the snarls. Dad waved the hairbrush over our scalps so gingerly as to accomplish nothing. Because he was milder, his moments of sternness stood out. My father never undermined my mother; they presented a united front. But he was less demanding, and more lavish with compliments. He also was far better at maintaining a semblance of equally distributed love. Yet there were distinctions. He might lose his temper at my sister or brother for wayward behavior, but seldom chastised me.

I don't recall him ever hitting me, although he maintained he did, once. As he told it, he'd just come off an exhausting *LIFE* assignment, shadowing a class of college students who were experiencing a week locked up in a mental hospital. Unlike the students, he wasn't staying overnight, but he left the house so early and returned so late that I hadn't seen him all week. Delighted to discover him home in bed one morning, I joyously jumped onto his stomach, awakening him from much-needed slumber, whereupon he sat up and slapped me. Or so he said, adding that immediately he was flooded with remorse.

Dad got furious at me twice that I do remember. One time, concerned about the Surgeon General's report on tobacco and cancer, I hid his cigarettes before he'd made the decision to quit. He was going to do that on his own terms. The other time, during my surly adolescence, I announced that I wasn't going to Thanksgiving dinner, that I didn't want to schlep to a New York City restaurant and get pinched and poked by relatives on his side of the family who scarcely knew us. Dad replied, in a low growl, that if I didn't go, he'd never speak to me again. Surprised that he felt any loyalty or obligation toward a clan that had snubbed him for so long, and especially toward the father who disowned him when he most needed support, I complied with his wishes.

Both my parents could yell; they were New York Jews, after all. Often as not, they would yell at each other. Dad was punctiliously prompt, Mom more leisurely about time, so the loudest exchanges frequently pertained to getting out of the house. On the other hand, once they got somewhere, they took different approaches to coming back. Given any occasion to linger and talk as a gathering broke up, my father would do so, long past the evident end. My mother never objected in public, but would tell him off later.

If my parents squabbled fiercely over trifles, they were in solid accord over matters that mattered. I vaguely remember them sitting me down when I was a teenager and saying they were thinking of separating. I'm pretty sure I collapsed into histrionics. Evidently nothing came of it, as nobody moved out. Much later, long after my father's death, when my mother was into her 90s, I asked her what that was about. She had no memory of it. "He must have done something that made me really mad," she said.

My thoroughly secular parents simultaneously appreciated and spurned their Jewish heritage. Dad joked that he was a self-hating Jew. Mom fretted that I had insufficient esteem for my cultural birthright. I would point out that, whereas her childhood flowered in a Yiddish-speaking environment, mine unfolded in a largely WASP town, due to my parents' own choices. In any case, Ted and Nyna neglected most Jewish traditions, and assuredly, if not always deliberately, violated many.

One custom, however, came to land on my siblings: the practice of naming newborns after deceased relatives. Even in this endeavor, my parents were imprecise. My sister Miki, three years my elder, is Mini Ann in eulogy for paternal grandmother Minnie, who died when my parents were courting. My baby brother Ian, born a decade after me, is Ian Louis, his middle name commemorating the Anglicized version that my mom's father Lazer often used.

Somehow, I escaped. I'm happy to be named after nobody in particular, other than perhaps the Old Testament Judith who tricks, seduces, and beheads an enemy general and saves her people. I've always felt especially lucky for being spared a middle name and the snickers the closest-held ones can produce.

What were my parents thinking? Not much, insofar as I can determine. Obviously unprepared with something for the middle, they also were slightly evasive about the choice of my first name.

My dad dubbed me Doodlebug from the start; it came to him, he said, as soon as he saw me through the nursery window in Boston's Lying-in Hospital for Women.

Women really did lie in there. After my own experience giving birth to my first son, I was eager to hear my mother's recollections of my emergence. She disappointingly told me, "I don't remember, they knocked me out." This at a hospital, eventually absorbed into what is today Brigham and Women's, renowned for great advances in maternity care.

The Doodlebug thing was pretty private, exclusively for Dad to say and mainly for me to hear; to this point, few outside the immediate family have been privy to it. I never thought much about the fond nickname until I was about to turn 36, now a mother of two, nearing the conclusion of my doctoral studies at Stanford. My teaching position in Iowa was already lined up. The kids were spending the summer with my parents on the East Coast while I was polishing off my opus on the West Coast. When I phoned to report that I'd passed the oral defense of my dissertation, my father said, "Congratulations, Doctor Doodlebug." To me, that fit far better than the pompous "Dr. Polumbaum."

So here's my dad's version: "The nurses told us, 'We're calling her Judy.'" It's Judith on the birth certificate.

Mom says that's not quite so. Yet she offers no alternative explanation, unusual for a woman who can offer detailed versions of just about everything that ever happened—unless she was knocked out, of course. Or demanding a divorce for whatever made her really mad.

Holiday season always brought surprises; we children of apostates never knew what would be celebrated. Some winters, a menorah scaled for birthday candles appeared, and little Hanukkah flames flickered for eight evenings running. My mother might produce small gifts for my sister and me each night, or do so for the first night or two, or not at all. Sometimes we lit candles for a couple of nights and then forgot. Some years we'd fetch a fresh pine tree, always a small one, from the Yuletide lots that sprang up all over New England after Thanksgiving, and drape it with paper chains and popcorn strings. One year, my father appeared to jump out of the fireplace wearing a Santa suit, the stomach amply stuffed with pillows. The next year, he wore the Santa suit without pillows, its bagginess billowing on his skinny frame. Once, he procured a fake Christmas tree for a seasonal photo shoot, so a tinsel topiary was the centerpiece for another year or two. Any Christmas gifts were likely to be larger than the Hanukkah trinkets, but they were never numerous, and often practical. One year, my sister and I got matching orange nightgowns. Another year, we got ice skates.

Perhaps most memorable was the Christmas morning my sister got a Tammy doll and I got a Chatty Cathy—astonishingly, just what I'd asked for. Miki had wanted a Patty Play Pal, but Tammy was a close approximation: tall, platinum hair, a turquoise plaid dress and matching bonnet, black shoes and white ankle socks. Cathy was smaller, a perfectly molded girl who issued banal refrains when you pulled the string at the back of her neck. She looked, I thought, like the perfect child Caroline Kennedy, whom I adored.

My pleas all through the year for a Mickey Mouse or Barbie were never indulged. My parents frowned on fads, especially of the corporate-conjured variety. Plus, they didn't have money to waste. They never used that legitimate excuse on us, sticking firmly to principle instead. I perpetually wanted stuffed animals, and whenever we went to Coney Island or Revere Beach, tried in vain to win one. When I was 10, my parents finally gave me Kvetchy the frog, maybe as solace from preemption by a baby brother. Within a couple of years, Kvetchy was in Ian's clutches, and I was complaining that he had tons of toys.

The day after Christmas, I'd usually go over to my best friend Becky's house, which would be littered with new acquisitions, the wrappings still strewn beneath the big tree, with its properly authentic decorations. Obviously, her folks knew what they were doing.

Rebecca Fernald was the eldest of five. Her mom, Taffy, came from a humble offshoot of a social register family, the Tafts, with tenuous ties back to the Taft who became chief justice and then president (and had been Skull and Bones at Yale). Her dad, George, an MIT-schooled engineer, had a responsible job at Polaroid, supervising the division perfecting instant film. He sometimes played tennis with my dad. Becky's parents were unselfconsciously good-looking and athletic, and wonderful, generous people. They were old-school Republicans, conventional in their views. From adolescence on, the kids all were moving leftward, and George puzzled about this to my father, asking him what to do. There was probably nothing to be done, Ted said. He suggested George remain as accepting as he already was.

Becky and I became friends in third grade reading class through a fluke: We were paired up for getting the same score, one wrong, on a spelling test. A check of the answers established that I actually had two wrong, but by then we were study buddies.

My family had just returned from our extended sojourn in India, and I entered third grade a bit late. My homeroom teacher, Miss Lamb, whose southern diction was a novelty, opened the school day with a couple of flourishes that also were new to me: After the familiar pledge of allegiance to the flag, she'd go to the piano and lead the class in a rousing rendition of Dixie, and then we'd recite the Lord's Prayer. A bit flummoxed, I managed to learn the words to both and join in. I never told my parents about the Southern anthem and religiosity; I know now they would have hit the roof. In any case, I usually skipped the "under God" in the pledge.

A year later, the US Supreme Court ruled prayer in public schools unconstitutional. Some schools balked; the following year, Ted's picture of pupils bowing their heads in a North Brookfield, Massachusetts, classroom appeared in *LIFE*. The town of Lincoln complied; my Miss Lamb experience was a one-off.

Quite naturally, my father's foremost photogenic guinea pigs were Miki, Judy, and Ian. Other families hung static studio pictures on their walls. Our family pictures were moments, gestures, emotions, silliness, light and shadow, curious compositions, compressed stories, accumulating in piles of black and white prints, occasionally semi-organized in albums.

My sister was a gorgeous toddler, and Dad almost always got her at her best. Once

Dad's camera catches Judy off and running, Newtonville, Massachusetts, 1954 (Ted Polum-baum / family collection).

in a while, he caught her whining, but he wasn't interested in recording her full-fledged meltdowns. Nor did he document her infatuation with what we called "flapping." She seldom made eye contact with people, but could gaze forever at an object of fascination, her favorite being a blade of grass that she'd twist back and forth inches from her face. The pictorial record memorializes none of that.

Dad happened to be home to capture my first steps across a sunlit floor in our New-tonville apartment. Other shots show me wearing Mom's high heels, sporting her bra over my coveralls, flung on my back upon gravel with my mouth smeared with dirt, hamming it up with assorted hats. I was always skinning my knees, but haven't found pictures of me crying.

Ted also took opportunities to document the doings of other people's children, mainly just for practice. He spent an entire day, from breakfast to bedtime, with the kids of close friends Bert and Louise Lown, whose third child, a daughter, had arrived a week before me. The parents filled an album with the prints he produced.

By the time Ian came along, crying was no longer out of bounds. A picture of me exercising my baby skills by holding a squalling red-faced imp over a bath while Mom looks on is displayed in the adult Ian's study. Overall, along with less finesse, Ian got less attention from Dad's lens. I partly made up for it, since I was peaking as a photographer when my brother was small.

Occasionally I would accompany my father on assignments. Memorable outings included a session at cinema verité guru Frederick Wiseman's studio overlooking Boston Harbor, and a visit to the sparsely furnished apartment of wunderkind conductor Michael Tilson Thomas, new assistant at the Boston Symphony Orchestra. Wiseman was famous for his discomfiting documentaries from inside an asylum, a high school, and an urban police department. Thomas had rocketed to fame in an unscheduled debut, taking the baton when the BSO's music director fell ill midway through a concert at New York City's Lincoln Center.

I spent time at the Boston University chapel that gave sanctuary to an AWOL soldier until the FBI pulled him out. I played with kids at Resurrection City, a shamble of shacks set up in the nation's capital as part of the Poor People's Campaign after Martin Luther King's assassination. In the days before consumer courier services, when Dad would drive right onto the tarmac at Logan Airport's cargo area, I'd sometimes ride along to put film on a plane for *Time-LIFE* processing in New York.

Ian went with Dad to meet Robert F. Kennedy, Jr., the RFK son who'd become a noted environmentalist. Trailing their subject after a TV interview, they witnessed at least two Kennedy stereotypes made manifest: One, a Kennedy never carried cash, prevailing on whomever was at hand (in this instance, our father) to tip the limo driver. Two, if a Kennedy encountered a stretch of grass and a relation or two, or adequate stand-ins, the requisite ball would appear for a bout of touch football.

As Dad phased into corporate work, he began hiring assistants to lug around equipment and set up lights, mentoring a succession of aspiring young photographers this way. I proved utterly incapable in the role of hired muscle; suddenly, instead of being funny and accepting, my father turned serious and demanding. My brother, more successful at fielding and following orders, became a valued helper. I failed my first test and immediately retired.

14

Assignment: Home Birth

As usual, the average proved to be exceptional. Readers were not uniform, like matches in a box. People, just ordinary people, were too individualistic, too cranky, too long in goodness or too short in malice or too thick in stubbornness to be made up into neat packages.
—Bruce and Beatrice Blackmar Gould, *American Story*

The experiment that became the Browns Wood community introduced my parents to a group of adventuresome peers. The ringleaders were MIT engineer and inventor Ranny Gras and his wife, Ann, whose rambling and perpetually unfinished home, with its concrete walls and floors, sat at the far edge of the roundabout at the end of Laurel Drive. They had the first solar panels anyone had ever seen. They also were the first people most of these suburbanites knew with kids born at home.

As the new Lincoln neighborhood took shape in the mid–1950s, future residents were scattered around the Boston area, convening to review plans and develop guidelines, meeting regularly on site to clear lots and view construction progress. The Gras family was renting a house in the adjoining town of Weston, and the Polumbaums were still in the Newtonville apartment, when Ted arranged to photograph the home birth of the fourth Gras child.

Ever alert for material to boost his fledgling freelance career, Ted pitched the story to *Ladies' Home Journal*, which expressed interest. His chronicle of son Seton's arrival, through labor and delivery, culminated in a scene of siblings Gerry and Robn glaring suspiciously at the newcomer—and clear rival. (Along with the Gras propensity for idiosyncratic name spelling came clever alignment of the children's first initials: Gerry, Robn, Adrian, Seton, sequentially inscribing their last name.)

Off went the pictures to one of the biggest and most influential magazines of its time. Eventually, the sequence reached *Ladies Home Journal* coeditors Bruce and Beatrice Gould. Natives of Iowa, where they'd met at the university that later would employ me, the Goulds lived on a New Jersey farmstead equidistant between the magazine's editorial headquarters in Philadelphia, home of the parent company (which also published *The Saturday Evening Post*), and the office in New York, where the couple also kept a pied-à-terre. The *Journal* would fall behind *McCalls* by 1986, when Des Moines–based Meredith Corporation took it over, and would succumb to competition from the web in 2014, when Meredith closed the monthly publication, keeping the brand name for occasional specialty editions. Under the Goulds, however, it was the world's best-selling women's magazine. As overseers of the *Journal* for nearly three decades, the couple vetted each month's issue and had the final say.

Dubious welcome for a baby brother born at home, Weston, Massachusetts, 1955 (©Ted Polumbaum / Newseum collection).

In many ways, the Goulds were progressive for their times. They ran articles on single mothers, birth control, and the dangers of smoking. They exposed fraudulent patent medicines and refused advertising for such products. They were big fans of Eleanor Roosevelt, who wrote a column for the magazine through most of the 1940s. Originally meant to clear up misconceptions and rumors about life in the White House, the First Lady's "If you ask me" soon was roaming over substantive topics, from family life, education, and health, to civil liberties, race relations, and war and peace.

Other popular features drew on the latest thinking about human frailties and foibles, offering readers solutions to problems that were not always recognized. The column "Can this marriage be saved?" alerted couples to the value of marriage counseling. Along with stories celebrating ordinary American families, the *Journal* introduced families from other parts of the world, including the Soviet Union. If the magazine sometimes seemed patronizing, it was only because the Goulds felt loyalty and responsibility toward their readers.

Beatrice also was a fashion maven, and keenly attuned to manners and appearances. Reviewing my father's photos, she was appalled at the casual disarray of the Gras household, and especially at the state of the maternal wardrobe: Ann Gras wore an unfashionably rumpled housecoat. Ranny, attired in an undershirt, smoking a cigar, most certainly did not exemplify the model father. The story of Seton's home birth, with its fabulous glimpse of sibling malice, got spiked.

15

Finding Perspective

India is a geographical and economic entity, a bundle of contradictions held together by strong but invisible threads. ... About her there is the elusive quality of a legend of long ago; some enchantment seems to have held her mind. She is a myth and an idea, a dream and a vision, and yet very real and present and pervasive.

—Jawaharlal Nehru, *The Discovery of India*

India was full of jolting disparities, splendor and squalor side by side. People lived in mansions and on sidewalks. Bullocks wandered through gasoline exhaust on roads choked with buses, taxis, cycle-rickshaws, and bikes. In the marketplaces, open-air food stands teemed with flies, and quiet nooks displayed stacks of saris threaded with gold. India was beggar children babbling and grasping, and stolid bearers bringing tea. India was movie stars and street performers. India also was dizzying devotion across a myriad of religions, evident in art and architecture, shrines and adornments, rituals and daily doings.

To my father, India was the place he truly began to realize his craft. Some photojournalists gravitate toward the visual heart of crisis and disaster—avalanches and eruptions, crashes and explosions, fires, floods, famine, war. Ted went where assignments sent him, but did not race to calamity by choice. He had no desire to showcase suffering and victimhood; rather, he looked for human ingenuity and resilience in the face of adversity. And he was entranced by the mundane—labor and leisure, camaraderie and solitude, serendipity and whimsy, small personal moments rather than conspicuous public events. Unfolding dramas of ordinary life, with their slow, steady rhythms, interested him far more than big breaking news stories. India offered a surfeit of these human tapestries.

To my mother, India was a country of splendid provocation—unending logistical challenges, bureaucratic hurdles, tests of fortitude. She took these on with a kind of relish, knowing that their successful negotiation could lead to astonishment and beauty, or at least to the next train ticket or acceptable meal or place to stay. Often the challenges had to do with accommodating or placating Miki and me: combing used bookshops for more volumes by prolific British author Enid Blyton about gremlins and sprites and daredevil children, identifying hotels where we could slip into the swimming pool, locating reasonably modern doctors when our fevers or stomachaches lasted too long, concocting lessons to make up for some of our missed schooling. In contrast to the atmosphere of benign neglect back home, where kids had free run, here Mom kept us girls under constant surveillance.

To Miki, age 11, and me, 7 going on 8, India was heat, congestion, and above all, smells. The cities and villages were permeated with cooking odors, fragrant with incense

smoke, fetid with human and animal excretions. To this day, encountering some inde-scribable yet familiar scent seeping into my nostrils, I will say, "It smells like India."

Our journey started in April 1961, when my parents rented out our house in Lincoln and pulled my sister and me out of fourth and second grades early. We'd be gone most of the year, and would enter fifth and third grades late.

I don't recall being consulted. I do remember the series of painful inoculations we endured in preparation over several weeks, starting with our appointment for cholera shots. That night, we had tickets to a Boston production of the musical *Oklahoma!*—Rod-gers and Hammerstein's first huge hit, on perpetual tour since taking Broadway by storm nearly two decades earlier. We watched most of the show in a vaccine-induced fever, and left a little before the end.

Round-the-world Pan Am tickets, bought with Ted's bequest from his Uncle Al, took us first across the Pacific. During a refueling stop in Hawaii, as we waited on the tar-mac in the middle of the night, greeters laid fragrant leis around our necks. After another stop in Guam, we landed in Tokyo.

Japan beckoned us gently into our global adventure, then jolted us with unflinch-ing historical corrective. The country proffered the unembellished comforts of small hotels, with paper-screen room dividers and futon bedding unrolled on the floor, per-fused with whiffs of green tea and bamboo. Worldly concerns momentarily dissipated in the enveloping steam of a Tokyo bathhouse. Only to resurface in the indelible artifacts of Hiroshima, where a skeletal dome atop a ravaged building still serves as reminder of the atomic bomb's devastation. A dank, disquieting memorial exhibition (forerunner of today's much expanded, far more restrained and sophisticated, state-of-the-art museum) funneled us through room after room of deformed fetuses, both human and animal, floating in formaldehyde in jars.

A week in Japan was followed by another week in Hong Kong. *New York Times* cor-respondent Jacques Nevard—the nephew of Ted's stepmother Mildred who later would kill himself—helped pave the way for Ted with contacts and logistics, including use of his bureau's car, complete with driver. Based in the British colony, Nevard was starting to cover the earliest stages of US involvement in Southeast Asia, a little-known entangle-ment that my father would soon see for himself. We obtained visas good for six months in India, where we would spend the middle stretch of 1961.

That fall, nearing the end of our wayfaring, we stopped in Jerusalem for a few days with relatives from my mother's side, who seemed far more obviously Jewish than any-body from our congenitally secular American branches. Then on to great classical sites, places since overrun with tourists that back then were tranquil and sparsely visited: the Sistine Chapel, the Leaning Tower of Pisa, the Coliseum, the Parthenon. The spectacular aquamarine currents of the Aegean Sea still swirl in my mind. On a dusty path descend-ing from the Acropolis, I scooped up a one-inch turtle, or what I long assumed was a tur-tle, like the ones sold in pet stores back home, although yellow-brown instead of green. (Only recently did a scientifically literate friend inform me that the little fellow had to be a tortoise, a land dweller, quite unlike those aquatic green critters in both ecological and evolutionary respects.) My parents loaned me the binoculars case to house it. A lax US customs officer smiled as I displayed my new pet, and let it through.

Thus did we tumble across the portals of East Asia, then cartwheel back over the Holy Land, the Holy See, and the Greco-Roman heritage. But those experiences were merely prelude and postscript to the prolonged main feature, which was India.

Now, between the paid assignments that sustained us, Ted wandered around urban neighborhoods and rural outposts, made friends with strangers who welcomed him into their lives, and documented what he deemed significant. For *LIFE*, he shadowed US Ambassador John Kenneth Galbraith, and took pictures of a group of tiny, malnourished but spunky Tibetan children who were being sent to live with families in Switzerland. For *Sports Illustrated*, he photographed turbaned boys playing field hockey. Time Inc. sent him on a side trip to Southeast Asia. For himself, he frequented construction sites and roamed railway stations; visited villages in the Punjab, homeland of India's Sikhs; and followed a man who hauled carts piled high with leather hides through the streets of Madras, now Chennai—still a job for untouchables, even though the caste system supposedly had been abolished for more than a dozen years. Thus, through the lenses of the cameras he declared at customs upon entry and kept locked up at night whenever possible, Ted found much that he sought, and beyond.

That inheritance of nine thousand dollars from my Great Uncle Al funded more than international travel. It empowered Ted to explore a quandary bound up in his approach to photography—how to address large, abstract questions that had long fascinated him, questions of politics, society, human nature, relationships, through the lives and struggles of real people. Dutiful about the practical issues of supporting a family, Ted also was idealistic, and always on the lookout for grassroots efforts to better the lot of the disenfranchised. This preoccupation naturally led him to study, chronicle, and at times join movements for social and economic justice. At home, the causes dominating his attention would be peace, disarmament, civil rights, and opposition to the Vietnam War. As he surveyed the rest of the world, what interested him were the demise of colonial empires, the rise of revolutions, resistance to foreign intervention, and experiments with new social systems.

Our time in India is better documented than just about any other stretch of our family experiences. Ted kept extensive notes, traveling with a portable typewriter so he could render his scrawls legible as soon as possible. He periodically sat down to gather his thoughts, later revising some of his rough writings into poignant vignettes. Nyna typed up long letters to friends and relatives, using multiple carbons, some of which survived, and produced occasional reflective pieces during and after the trip. Miki and I recorded rudimentary observations in journals with bright red hardback covers, hard to lose, residing now in my files. And of course all those words were rendered vivid, and greatly amplified, through the cameras Ted carried everywhere. He often struck out without us, sometimes on paying assignments, more often on personal expeditions, returning with exposed film—always shipped by air to New York for developing—and tales from the field. My account draws on all these materials, along with details not committed to paper or celluloid that nevertheless stuck in our minds.

Originally, my father imagined getting to mainland China, where a Communist-led peasant army had overthrown a corrupt and reactionary regime to set up the People's Republic. He even took Mandarin lessons from a Taiwanese student. When he told me that the Chinese word for "book" was something that sounded like "shoe" (written in pinyin transliteration as *shu*), I marveled at the thought that every Chinese word must have a counterpart in English meaning something entirely different. This absurd notion may have been the taproot of my own eventual studies of China and the Chinese language.

But China was not to be, not yet. US passports still bore the legend "not valid for

travel to or in communist controlled portions of" China, Korea, and Vietnam, with Albania also proscribed, and Cuba soon added. When the People's Republic of China had authorized visas for fifteen American correspondents in August 1956, the US State Department refused to make an exception for journalists. William Worthy, a reporter for the *Baltimore Afro-American*, and Edmund Stevens and Phillip Harrington, reporter and photographer for *Look* magazine, defied the ban and entered the mainland from Hong Kong. Only Worthy suffered consequences; the State Department refused renewal of his passport. A 1958 Supreme Court ruling established Americans' right to freedom of travel, yet US passports continued to list off-limits countries into the 1970s. China was a distant wish.

Thus, when Uncle Al's bequest made an adventure conceivably affordable (if not fiscally responsible), my parents decided on India. They thought highly of the Gandhian tradition of nonviolence that had led the way to independence from Britain. They were intrigued by the avowedly socialist programs of postcolonial India's first prime minister, Jawaharlal Nehru. And their friendship with an Indian novelist, Krishna Vaid, certainly figured into the decision. Krishna had arrived at Harvard on a Fulbright fellowship, and remained to earn a doctorate in American literature, joined by his family in our country as we were heading to his.

Following our brief pass through Japan and Hong Kong, we started our India sojourn in Delhi, staying at a frugal, British-style boarding house called Fonseca's. Delhi would be as close to an anchor as we had in India, with travels radiating out according to whatever leads, contacts, or curiosities enticed my parents.

Within two weeks, Ted left for his picture assignments in Vietnam and Cambodia, and Nyna spirited Miki and me off to Kashmir, which offered welcome respite from the capital's torrid temperatures, invasive dust storms, and olfactory assaults. The three of us stayed at a hotel that had been a maharaja's palace, the air suffused with carnation sweetness from the cutting gardens. Miki and I had fun hanging out with the house band, whose anthem was "Too much tequila," until Mom decided we were spending too much time with these friendly young men. We rode ponies into the foothills of the Himalayas, and threw leavings from our picnic to crows that nabbed the scraps in midair. Local children, instead of begging from us, actually played with my sister and me.

Upon Dad's return, we decamped to a houseboat, christened New King's Rose, moored in brackish waters at the margin of Nagin Lake, which was connected to the far larger Lake Dal by a narrow strait. An even longer pony ride took us around the northern curve of Lake Dal, to Shalimar Gardens. We returned at dusk, aching and exhausted, to a Persian feast that the kind houseboat owner had laid out for us. Miki and I gleaned cues from our stoic parents, trying our utmost to eat graciously when we simply wanted to keel over into slumber.

On an excursion to Srinagar, Kashmir's largest city, the strange and scary India returned. The streets were packed for a Muslim festival marking the anniversary of the death of Hussein, a grandson of Mohammed, the centerpiece an orgy of self-flagellation. Women and children surged around a broad procession of men from the Shia sect, as the men chanted and beat their chests in mourning, some with their fists, others wielding chains and knives. Ted went off with his cameras. Curious onlookers mobbed Nyna and Miki and me, until a squat little man led us into a building to watch the bloody spectacle from a raised porch.

When the height of the hubbub had passed, the man went off and returned with

Dad, saying my father was easy to find because he was taller than anyone else. Our self-appointed guide turned out to be a businessman who lived in a splendid house in the foothills outside the city, where he drove us for a look.

En route, he explained that he'd once hoped to do business abroad. He'd even ordered custom suits and flown to New York City, where he was so intimidated by the towering buildings that he retreated to his hotel room, skipping all his prearranged appointments, until his scheduled flight home. Nevertheless, he'd decided to find an American wife. He fixed on a visitor to Srinagar, who'd left a Michigan arts college to teach art to children on a US Army base in Japan, and was traveling a bit on her way home. Her suitor escorted her around and showered her with gifts, until she agreed to marry him.

At the house, we met his wife, a large, friendly woman, and their toddler son. Evidently, producing that child was the man's true objective. Out of the husband's hearing, the wife told my parents he'd tried to send her back to the US as soon as the baby was born—without the boy. He'd been hiring and dismissing unsatisfactory babysitters, and she managed to persuade him that she'd be the best caretaker, so he let her stay. Was there anything Nyna and Ted could do? my parents asked. Nothing, she said, seemingly resigned rather than distressed; she'd just have to wait until their son was old enough to make up his own mind.

Soon we were back in Delhi, occupying a rental in the expatriate enclave of Defense Colony while the usual Danish residents were on home leave. Even in this relatively comfortable suburban development, the power went off a dozen times a day, up to twenty minutes at a time during evening peak load periods. With the house came a live-in cook, a daytime amah tasked with traipsing after the children, a gardener on the grounds each morning, and a man who did the washing and ironing twice a week. At night, a block watchman made rounds, pounding his stick and blowing his whistle. Whenever Ted was out of town, the cook insisted on sleeping over outdoors for added protection. I tried to adopt stray dogs out the back door, and occasionally got away with feeding them, but never got to keep them. Miki and I found the amah insufferable; we were stupefied when she cried viscous tears upon our departure, saying we two girls were far better than the two awful little boys who were coming back.

For most of July and August, the hottest part of the year, my sister and I attended an English day school, where teachers would smack kids on the palm with a ruler for infractions of rules I could never figure out. My class was immersed in multiplication drills; to this day, in a head otherwise inhospitable to math, the gear for my times-three table whirls with ease. I picked up a bit of Commonwealth diction. A particularly naughty red-haired boy, who annoyed his elders, amused his mates, and terrorized everyone else, fell out of a tree and broke his arm, which gave me a measure of satisfaction.

From my narrow perspective, India had one great glory to offer: the Taj Mahal. The tourist brochures had me convinced that the gigantic white marble mausoleum, built in the seventeenth century by the Mughal emperor to shelter the tomb of his favorite wife, was the most splendid monument in the world. Ted and Nyna were certain it would never live up to its buildup.

We visited Agra to see the Taj at the end of July, coinciding with my eighth birthday. As we beheld the spectacle from the gardens out front, the sky dimmed to pink, flamed orange and red, then darkened to gray, the silhouetted building seeming to glow from within. Up close, the place was no less magnificent. We took off our shoes to go inside, our stockinged feet sliding over the smooth floor, every surface highly polished, inlays

My sister and I at the Taj Mahal, palace of my reveries, Agra, 1961 (Ted Polumbaum / family collection).

of gold and precious stones all around. I was vindicated, and my parents were more than surprised.

Having marveled at the Taj, we spent the night in a hotel room that was filthy beyond belief, without air-conditioning. The next day, Mom and Miki and I headed back to Delhi, while Dad took another photography detour. A journalist friend from Delhi who happened to be in Agra as well had invited him to visit a village recently raided by bandits. Ted's pictures show the village men gathered to plan their "dacoit hunt," long wooden staffs at the ready to administer retaliatory beatings.

By now, my parents were recognizing the large gap between the real India—the India of grime, graft, disorder, red tape, vice, and violence—and the forward-looking, harmoniously multicultural India of their Gandhian dreams. Nevertheless, Ted continued to discover people who buoyed his belief in the noble possibilities of humankind.

Even in the harshest of settings, Ted met with remarkable grace and goodwill. Early one morning, accompanied by a young Bengali guide, he ventured out onto a main street in Calcutta (now called Kolkata), where people by the thousands bedded down on the sidewalks at night. Along Chittaranjan Avenue, some were still slumbering, others just rising, as cattle, dogs, and a few cats wandered, while pigeons and crows picked at cracks in the cement. Many of the street sleepers were young men not long from the villages, the city's servants and casual laborers. There also were families, limbs entangled on the hard pavement, arms of mothers gently resting across children.

Ted began taking pictures, nervous because he had been warned to expect a hostile reaction to the cameras; he and the guide had asked their taxi driver to stay nearby in case they had to make a fast exit. Men were stirring and opening their eyes. Ted looked at them apprehensively, and was dumbfounded to get broad smiles in return. The guide translated his "Good morning," and they said good morning back. As Ted moved around, more friendly smiles greeted him. A few men stepped off the sidewalk to help him clamber atop a truck for a better vantage point. As the sun rose, the street came alive. People lined up at a tap to wash, or took off with clean clothes bundled under their arms to bathe in the nearby Hooghly River. Hand brooms appeared to whisk away dust. Rickshaws, carts, buses, and cars were on the move.

We liked Calcutta better than Delhi. People seemed friendlier. Our stay in a boarding house there concluded with terrific excitement that could have ruined everything, but didn't: On our final morning, ready to leave for Benares (now Varanasi) on our way back to Delhi, we arose to discover that we had been robbed. Dad had checked his watch on the bedside table at 3 a.m. It was gone at 7 a.m. So were his pen and a pack of cigarettes. Mom's purse was on the floor, her wallet empty, her ivory necklace missing. Two of my dresses had been taken.

My mother had heard a banging noise during the night. She thought it was the air conditioner, got up to turn it down, and went back to sleep.

The police came to investigate. They figured that the intruders had climbed up a slatted screen to the balcony at the back of our set of rooms, banged open a kitchen window, climbed through to a hall, and poked something through the bedroom door frame to lift the latch from the outside.

Undoubtedly, the thieves went away disgruntled. Thanks to Dad's care with the tools of his trade, his cameras remained securely locked up in a cabinet. Also locked up was a substantial stash of rupees; Dad had cashed travelers checks the day before to cover the final lodging bill. My parents were rattled but relieved; the bill would be paid, the mission of discovery through the lens would go on. I was thrilled, since I'd been reading Enid Blyton's Freddy books, notably *Freddy the Detective*, and knew just what to do. I went around scouring for clues, and wrote out an exhaustive account of the crime. The investigators appropriated my excellent report for their files. My parents always suspected it was an inside job.

Benares, India's holiest city, sits high above the banks of the Ganges River, yielding to ranks of stone steps—the ghats—that descend from the heights to the water. We arrived there on a summer evening, drained by the pre-monsoon mugginess, and took

a taxi from the airport to a shabby hotel; my parents generally spurned recommended quarters in favor of cheaper alternatives. The noisy evaporative coolers and the unbearable heat kept us awake and sweating all night, so at first light, Ted and Nyna took Miki and me for breakfast at the fancy air-conditioned place. There we met Jean, a marine biologist on his way back to Paris after two years of diving in the South Pacific.

Jean spent the day exploring with us. We visited temples where shrieking monkeys swung from the bells. We stalked narrow alleys and tiny shops. Down one alleyway, someone told us an American poet once lived there; from the description, Ted and Nyna deduced it was Allen Ginsberg. We ventured back into the alleys at night, to find the shabby little cubicles selling silk and brassware transformed into romantic gazebos illuminated by oil lamps. Under moonlight, we walked down the steps of a ghat, my parents and Miki and I stopping at the water's edge. Jean kept going, until he stood in the river up to his hips. There he planted himself for a long time, his eyes closed, scooping handfuls of water up to his face and letting it run down from forehead to chin.

Afterwards, my parents stayed up arguing with Jean over bottomless cups of sweet coffee. Ted and Nyna were horrified at his ritualistic devotions in the filthy Ganges. He accused them of being materialistic Westerners, insensitive to the mysteries of India, oblivious to the promise of tomorrow that made the pain of today so much easier to bear. They agreed to disagree. He remained our traveling companion on a river tour arranged for the next day.

At dawn, a black limousine delivered the five of us to the top of a ghat. We walked down the steps to the boat my parents had hired, passing a lineup of dozens of beggars, many crippled by leprosy. The river had been calm the previous day; now the brown water roared and swirled, debris skipping across its surface.

Six oarsmen strained to keep our boat under control when the current was with us, and struggled to keep us moving when the current fought us. The boat business was Muslim, and the fellows did not think much of the Hindus' fervor for the trash-strewn Ganges, whose sacred waters are said to tumble from Lord Shiva's hair. We glided past a succession of bathing ghats, slicing through swarms of waders engaged in their morning ablutions: here an old man brushing his teeth with the shredded twig of a neem tree, there an elderly woman slipping out of one sari and into another. All around us, individuals were soaping, scrubbing, spitting, changing clothes, jostling and crowding, while ignoring each other, as if to create a kind of invisible privacy shield.

The edge of the river lapped mere inches below the record flood line, marked on the walls of the stone buildings along the banks. The slippery steps glistened with water as people streamed up and down, sat, washed, prayed, pondered. The lower tiers all lay under water. There, the saddhus, or holy men, with scraggly locks and beards, wildly painted faces, and bare torsos, held forth from under large umbrellas woven of rushes, disciples forming semicircles around them. In and out of the water, muscular bodybuilders exercised and flexed. Spires of inundated temples rose in midstream, beckoning the young men and boys who swam out, clambered up, and dove back in.

Downriver, we passed the widows' ghat, the women dressed all in white, never to remarry—the alternative to *suttee*, or joining the husband on the funeral pyre (an ostensibly voluntary practice that would be banned in 1987, although not entirely extirpated). Farther along were the burning ghats. It was a slow day: two pyres, the fires transforming wood and bodies to charcoal and ash, and only a few mourners.

The boat returned to the ghat from which we'd embarked, and Ted paid the chief

Devotees bathe in the sacred Ganges River, Benares (today's Varanasi), 1961 (©Ted Polumbaum / Newseum collection).

boatman extra because the water had been so rough. We began the climb back up to the waiting car, passing the same line of beggars. At this point, my father made the error we repeatedly had been instructed to avoid: Moved by the empty, hopeless expression on the face of the one man who was not pressing and whining for alms, he reached into his pocket for change. That was the signal for all the others to surge around us, screeching and clutching at our clothing, many with hands missing fingers. Ted managed to toss some coins into the quiet old man's begging bowl before we took off for the top of the hill. We were faster, stronger, better fed, and frightened, and by the time we reached our ride, we had outrun them. Or so we thought.

A twisted dwarf with a huge head and gaping mouth had gotten there first. He grinned at us as he held the car door open with one hand and leaned on a crutch with the other. He was the same height as me, but loomed enormous and terrifying. He reminded Nyna of an apparition from her childhood—the leering old man who ran the horse-themed Steeplechase roller coaster in Coney Island.

Back in our room at the downscale hotel, my parents phoned Indian Airlines and managed to get us on a flight to Delhi that afternoon. We'd leave a day earlier than planned. Ted called Jean at the fancier hotel to tell him we'd been frightened out of the holy city. Jean was getting out as well, on the very same plane.

In India's cities—from Delhi markets and construction sites to Calcutta streets and sidewalks, from the commotion of Srinigar to the waters of Benares—Ted was struck by what he termed "the public pageantry of private lives." In rural areas, he encountered outsized hospitality, conviviality, and humor. Where others might have seen an undifferentiated mass, my father found individualism and idiosyncrasy. He learned and wrote down people's names, ages, and other details.

During an expedition to the countryside outside Madras (now Chennai), Ted visited a century-old homestead standing at the highest spot of a village, to one side a commanding view across fishing households bordering the Bay of Bengal, to the other a vista of agricultural fields and farm cottages. Under British rule, this twenty-room house had been the home of the *zamindar*, the privileged local tax collector. The extended family of twelve who remained in the dwelling was struggling to adjust to the new democracy. They still owned a thousand acres, most of which soon would be bought up by the government. For generations, attended by lower-caste servants, with coolies to till the land, the clan had flourished on its commissions. Now the oldest son, brought up to disdain manual labor, was learning to plod behind plow and bullocks as he worked his own plot.

The family head, Appaswamy, was absorbing the changes with good humor. He resembled a tropical Santa Claus, eyes twinkling above a gap-toothed smile and full gray-white beard. At 52, he was thickening around the middle, but still strong. Welcoming Ted, he then bellowed: "Why are you not wearing a dhoti? How can you be comfortable in this beautiful part of the country dressed in trousers, shirt, shoes and socks?" The traditional men's garment, a piece of material tied around the waist and extending over the legs, was quickly proffered. Ted stripped down, wound the stretch of cloth around his midriff and thighs, and clumsily knotted it at the waist. Family members laughed and applauded. Indeed, this attire was much more comfortable.

Among all the individuals Ted came to know in India, the Madras cartpuller, Vedachalam, left perhaps the most indelible image. A dark, sinewy man of 35, always barefoot, dressed only in a dhoti wrapped high around his hips, with a sweatband on his head, he had been hauling wooden wagons through the streets since his teens. Waiting

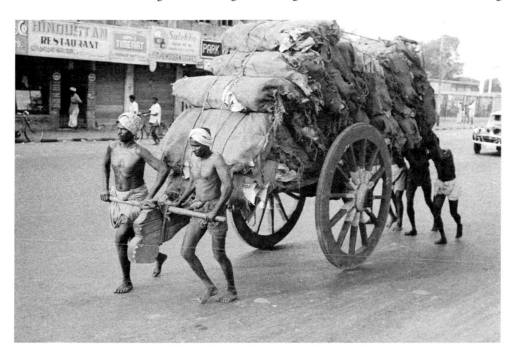

Madras cartpuller Vedachalam (front right) at work hauling hides, 1961 (©Ted Polumbaum / Newseum collection).

for work at the park near his home, on call from dawn to dusk, he usually got a job in the morning, and another in the afternoon if he was lucky. Typically, a crew of four would move a mountain of hides weighing more than two tons from the city's leather district to a warehouse, the cargo balanced on a flatcar between a pair of giant spoked wheels, two men straining against the crossbars in front while the other two pushed from behind. After deducting for the cost of cart rental, each man would earn a bit less than two rupees, or about 40 US cents, for three hours of labor, including loading up, a rest stop to chew betel nut, and unloading. On the way back through the congested traffic of the city

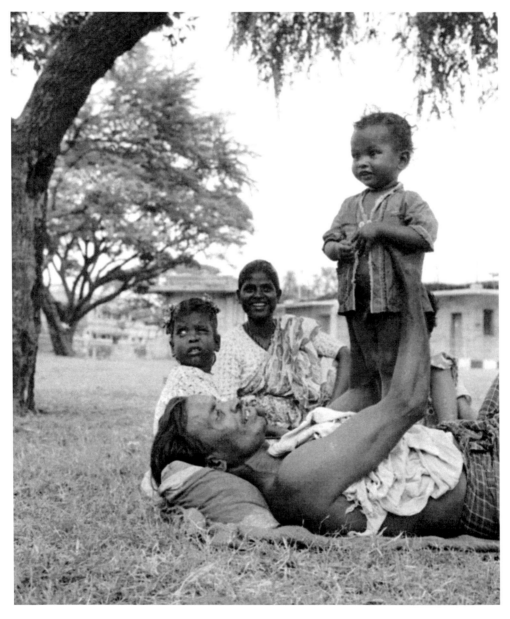

Vedachalam and family in a Madras park during his lunch break, 1961 (©Ted Polumbaum / Newseum collection).

of nearly two million (since grown to five million), they would take turns riding atop the empty wagon.

Vedachalam lived in a close-knit settlement of cartpullers and their families, down a narrow mud alley leading off a courtyard by the park. Home for his family of five was a hut of unfired bricks plastered with mud and roofed with orange tiles, enclosing a single dirt-floored room, with a cooking porch in front. Similar shelters lined both sides of the alley. The huts had neither electricity nor plumbing. The courtyard had streetlamps, a water tap, and latrines. Like most of the men, for space as well as security, Vedachalam usually slept in the open yard, rather than in his cramped hovel.

Nagarathnam, 19, was Vedachalam's second wife. His first wife had died, leaving him a son, now 16. With Nagarathnam, he had a daughter, 4, and another son, 18 months old. Nagarathnam cooked lentils and rice and vegetable pancakes, fragrant with cumin and cardamom, making three meals a day when her husband had enough work, two if work was scarce. Sometimes they took the noon meal to the park. Vedachalam drank neither tea nor coffee; they were too costly. Betel—the ubiquitous, red-juiced narcotic seed of a kind of palm tree—was cheap, and he chewed it throughout the day.

Their community's tidy, organized, dignified spirit was no accident; these cartpullers belonged to a union, headed by a burly man named Arya Sankaran. In English, he called himself the "Brahmin-Destroyer"—Sankaran being a Tamil name for Lord Shiva, destroyer of evil. He was an articulate and belligerent advocate for the untouchables, although his complexion was lighter and his caste origins mysterious. As secretary of the Union of Employees and Labourers in the Hides and Skins Firms of Madras, he negotiated money matters, pursued grievances, represented union members in court, and defended them from harassment by police, merchants, landlords, and officials. He also put out a small weekly paper in Tamil, eponymously named *The Destroyer*. When he walked along the streets of the leather district, men rose to their feet and saluted him.

Sankaran's office and sleeping quarters opened onto the same courtyard. His authority ensured that neighbors worked together to keep their homes and alleys clean, and that children were cared for and well behaved. He insisted that unemployed youths be neat and cleanshaven, and saw to it that they had clean clothes. The union held its meetings in the courtyard; and the cartpullers, who traditionally had their own theater troupe, entertained in that same space several nights a year. Their boisterous performances by kerosene lamp lasted from 10 p.m. until dawn: stories from mythology and folktales, sketches on the hardships of contemporary life, flamboyant dances and raucous songs, with males taking all the roles, including dancing girls.

Vedachalam, who read and wrote Tamil, was a member of the union committee and Sankaran's trusted friend. Sankaran translated as Ted asked the cartpuller what he thought about as he trudged through the streets, drenched in sweat, his hands to the crossbar. "I think," Vedachalam said, "why has God done this to me?"

He had aspirations for his little son, Mhanakaran. Even in decent years, Vedachalam's earnings barely reached the poverty line, set at 240 rupees annually in 1960. Still, with painstaking frugality, the family managed to put away 20 or 30 rupees a year, worth about four to six US dollars. Only education could raise an untouchable above the level of a beast of burden, and the money would help free the boy for as much schooling as possible. Mhanakaran must not become a cart puller, his father said.

Later, reviewing his pictures with thoughts of a book, Ted reflected on the Western tendency to view Indian poverty with both fascination and repulsion, until shock and

anger give way to a kind of habituation. "After awhile, the visitor gets used to it; he does not see, and if he sees he does not think about it," he wrote. "The essential quality of the people recedes from his consciousness, and all these bedraggled creatures, in the folds and tatters of their drab garments, become mere objects in an alien landscape, faceless properties cluttering a dismal stage."

Photographs in most books about India had this same character, he thought: a curiously lifeless impersonality, pictorial clichés "whose subjects appear to us so grotesque that we cannot possibly identify with them." He hoped to present a different view. "If we go into the street itself and look closely, there is the shock of recognition. We see human beings, warm and alive. Their mode of life, so different and depressing to the Western eye, cannot obliterate their essential identity with us. The true image must be humanity asserting itself, now feebly, now boisterously, against a background of chaos and desperation. In their eyes you can see defiance and pride, pain and durability."

Such a book did not materialize; the concept was a hard sell, and Ted was busy enough with magazine assignments. Like much of my father's strongest work, most of his India pictures were never published. But those images kept our strange and mysterious journey vivid for me.

For the longest time, I thought of India mainly in black and white. Swatches of color returned on rare occasions, as when I recalled elephants romping across hills and spraying water at a nature reserve in Kerala. Even then, the hues were subdued. Viewed from our boat in the middle of a lake, one herd was distinctly brown, another herd distinctly grey, the hillsides yellowish green, the water a dusky amber.

Not until the winter of 1997–98, when I returned to India with a university group for a couple of weeks, did I realize how deficient my memories were. From textiles to lentils, from movie billboards to temple idols, from landscapes to food, India is a brilliant riot of color. Yet the power of my father's photography, perhaps in combination with my malleable childhood brain, overrides what I know as an adult. The India imprinted on my mind remains the black-and-white version.

16

Assignment: Afterimage

With art comes empathy. It allows us to look through someone else's eyes
and know their strivings and struggles. It expands the moral imagination
and makes it impossible to accept the dehumanization of others.
> —Dave Eggers, "A cultural vacuum in Trump's White House,"
> *The New York Times*, June 29, 2018

In our break from Delhi's sweltering summer, Kashmir seemed a heavenly respite.
The Indo-Pakistani conflicts over the Himalayan region had yet to reach the intensity
that deters travelers today. Nyna and Miki and I gamboled at the maharaja's palace until
Ted returned from his Indochina assignment. Then we all moved to the houseboat.

When the owner of our floating abode smashed his hand while securing the craft
before a storm, he invited Ted to accompany him to consult a traditional healer. In the
ancient city of Srinagar, with its temples and shamans, they joined a cluster of pilgrims

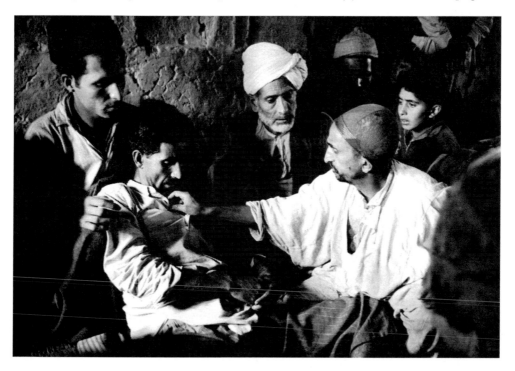

The bone priest of Srinagar, healing through touch, 1961 (©Ted Polumbaum / Newseum
collection).

seeking help from a bone priest. There, Ted captured a scene of the laying on of hands, a scene in which viewers ever since have discerned a kind of purity and rapture. The healer is reaching toward the patient, a man deep in shadow, curled into himself, supported by another man, as a turbaned elder and a young boy look on. The faces express tentative mixtures of worry and hope, except that of the healer, who looks serene and confident. Any facile assumptions one might bring to the viewing—say, of benighted peoples mired in superstition or prey to quackery—dissolve in the depths of belief and emotion.

This image went on to become a favorite of family and friends, likened to an Old Master. And, as timeless pictures will, this one came to resonate far beyond its moment and place of origin. Among the admirers was Dr. Bernard Lown, a world-renowned cardiologist, Harvard School of Public Health professor, recipient of the Nobel Peace Prize as a cofounder of International Physicians for the Prevention of Nuclear War, and one of Ted's closest friends. With compassion, connection, fierce concentration, and the laying on of hands, the bone priest's demeanor distilled what Dr. Lown espoused his entire career: the need to retrieve what he called "the lost art of healing" as an essential counterpart to the science of modern medicine. No wonder he loved this photograph.

So when Dr. Lown's practice moved into new offices, Ted gave him a framed print of the Kashmiri healer. Whereupon the ranks of admirers grew further among Dr. Lown's patients, who included famed actress Jessica Tandy.

Knowing she was nearing the end of her life, Ms. Tandy arrived one day for what would be her final appointment with her cardiologist. As Dr. Lown related it, she told him: "Don't get a swelled head, Lown. I'm not here to see you—I just wanted to see the Rembrandt one more time."

17

Up the Cool Potomac

It was Mr. Moody's idea to have parents put names on our clothing with indelible ink. In the event of a nuclear attack, he explained, children may be separated from their families. My mother anxiously scrawled our surname all over my shirt collars as though by some medieval necromancy it might shield me from a twenty-megaton blast.
—Jeff Porter, *Oppenheimer Is Watching Me: A Memoir*

Some of us postwar kids missed out on an important rite of passage, the duck-and-cover drills of the 1950s and early 1960s. I recall plenty of fire drills from my elementary years, but no practice in cowering from atomic bombs. My sister, whose uncanny memory makes her the family custodian of factoids, has no such recollection either. Neither do childhood friends I've asked. We have no explanation for the uncommon sanity of the public school authorities in Lincoln, Massachusetts.

Not that my hometown was immune from the panic. The adults engaged in lengthy debate over whether to build civil defense shelters. Those in favor thought holing up in well-stocked underground bunkers was a viable method to survive nuclear war. Opponents argued that such a war would doom humanity, the only route to survival being abolition of atomic arsenals. My parents were in the latter camp, which won out; although a few families and businesses dug their own fallout shelters, town meeting voted against investing public funds in such ventures.

Even without duck-and-cover reminders, anxiety about the bomb was omnipresent, instilling dread in the children of Lincoln as well. My fears arose whenever I heard the sound of a plane flying overhead, certain this was the one bringing the attack. My mother, meanwhile, took heed of evidence that atmospheric testing of nuclear weapons had poisoned the environment and the food chain. The tests dispersed Strontium-90 that was ingested by grazing cows and excreted with their milk. For a good year, Mom halted our fresh milk delivery and bought powdered skim milk that never quite dissolved. My sister and I found the watery mixture repulsive.

Ike was still in office, his portrait hanging over a fireplace on the set of *The Big Brother Show* on Boston's WBZ-TV. George Orwell's *1984* had been out for a decade, but there were no indications that the name of this lauded children's program was meant ironically. In every episode, the host, Big Brother Bob Emery, would lift a glass of milk from the mantel and drink a toast to President Eisenhower to the accompaniment of "Hail to the Chief." No doubt it was real milk, not the nasty substitute.

As my president from infancy into primary grades, Eisenhower seemed a distant, benign character. He was hugely popular, if sometimes denigrated as a lightweight chiefly devoted to golfing. But during his eight years in office, I now realize, he was a major force

in shaping the country in which I grew up. General in charge of Allied forces in Europe during World War II, then chief of staff of the Army, briefly presiding over Columbia University as a thank-you position, inaugural commander of NATO forces, he was adamant about keeping postwar America strong. Even as he lay the groundwork for the interstate highway system that has conducted me back and forth across the country too many times to count, he was fortifying the very military-industrial complex whose exorbitant power he would warn against in his famous farewell speech from the Oval Office.

Nor did he buck the Red Scare. While helping to usher out the brash excesses of McCarthyism, Ike acquiesced to continuing inquisitions, albeit with slightly more decorum. Joe McCarthy had overstepped by ranting and raving and investigating the Army, and was little more than an embarrassment by the time the Senate censured him in 1954. Congress outlawed the Communist Party in the US that same year.

Also that year, with Ike's backing, Congress added the phrase "under God" to the Pledge of Allegiance. A congenital atheist, I always performed my patriotic recitation warily, wondering if someone might notice how my lips stilled during those two words.

Eisenhower's vacation home near the Newport Country Club in Rhode Island had become his summer White House, and Ted photographed Ike on the golf course, reporting back to Nyna that the president was great at turning on the smile for the camera, but cranky off-camera. Ted also took pictures of Ike campaigning for reelection in New England, Vice President Nixon at his side. My only recollection from that election cycle, when I was 3, is my parents' renewed support for Adlai Stevenson, the Democratic presidential candidate; having been defeated by celebrated war hero Ike in 1952, Stevenson was headed for the same fate in 1956. I have no impression at all of the presidential race that followed, although I know it well from the history books. Ted and Nyna surely voted for JFK over Nixon in 1960, even if the Kennedy name never dazzled them as it did most of Massachusetts, and eventually much of the country.

Alarm over the growth of the permanent war economy and the nuclear arms race was fueling a peace movement in Lincoln. The desire for nuclear disarmament was at the center of the first political campaign I do remember—H. Stuart Hughes's attempt on the US Senate. When John F. Kennedy attained the White House, a special election to fill his Senate seat was set for 1962. Hughes, a Harvard historian, was the peace candidate, running as an Independent against Democrat Edward Moore Kennedy and Republican George Cabot Lodge.

JFK's youngest sibling had been expelled from Harvard for cheating, avoided getting sent to Korea during an abbreviated US Army stint, reentered and finished Harvard with mediocre grades, and earned a University of Virginia law degree. Just shy of 30, minimum age for the US Senate, Ted Kennedy had been handed a placeholder job as an assistant district attorney for Suffolk County, centered in Boston—a post that commoners like my hardworking brother Ian, who prosecutes domestic violence, sexual assault, and homicide cases for that same office, have to earn.

Lodge also had gone to Harvard, graduating with honors, then serving two years in the Navy. He was the scion of an august Boston WASP clan; his father, another former senator from Massachusetts, would become the Johnson administration's ambassador to South Vietnam.

Professor Hughes, a World War II veteran, had distinguished provenance as well; his grandfather, Charles Evans Hughes, had been governor of New York, Republican presidential nominee (losing to Woodrow Wilson), secretary of state (under Calvin

Coolidge), and chief justice of the US Supreme Court. Grandson Stuart, Harvard PhD, was an authority on European intellectual and cultural history; he'd published six books by 1962, and would author eight more. Elimination of nuclear arms and an end to war were the core issues of his campaign.

Yet another influential political family figured briefly in this contest. Edward McCormack, Jr., attorney general of Massachusetts, was challenging Kennedy in the Democratic primary. Edward Sr., known as "Knocko," was a notorious Boston fixer, and Uncle John was speaker of the US House of Representatives. Teddy trounced Eddie by a two-to-one margin in the preliminaries.

For the general vote, the *Harvard Crimson* editorialized on behalf of dark horse Hughes, eliding his lineage, deeming him preferable to two "family candidates" who possessed neither qualifications nor principles. Of Ted Kennedy, the campus paper said: "His immaturity, inexperience, disinclination to debate with his opponents or to run on any platform save his brother's are by now obvious facts." In a straw poll of Harvard students, more supported Hughes than Kennedy.

A group of peaceniks inspired to electoral activism had been meeting around my parents' dining table, where my dad masterminded a rewrite of Hoagy Carmichael's lyrics to "Lazy River." The new version ridiculed Kennedy's entitlement and extolled Hughes's virtues. Fragments are entrenched in my mind:

> *Up the cool Potomac in November-time,*
> *That cool cool cool Potomac River seat will soon be mine*
> *Blue skies up above, there'll be no more love,*
> *Unless the people wise up, a man of peace they choo-ooose,*
> *Up the cool Potomac with Hughes—he's in-de-pen-dent!*
> *Vote for brains, for peace, for Stuart Hughes.*

The *Crimson* predicted, correctly, that Kennedy would win, although nobody could foresee that he would become a highly competent, dedicated liberal, known as "the lion of the Senate," and hold his seat for 47 years, until his death in 2009.

The peace movement never expected a Hughes triumph, but hoped he might rack up 100,000 votes or more in symbolic victory. Just before the election, Hughes helped pack a Harvard University auditorium for a protest against the US blockade of Cuba. He accused JFK of acting hastily, bypassing the United Nations, and needlessly stirring up an atmosphere of national emergency. That position is thought to have cost Hughes thousands of votes. He got about 50,000, just over 2 percent of ballots cast. Lodge got 42 percent, Kennedy 55 percent.

Satirist-songwriter-math professor Tom Lehrer had a good deal to say about this era, and I absorbed it all, committing to memory every number in his now classic purple-jacketed LP *1964: That Was the Year That Was*. His paean to militant folksingers pointed out, in reference to the loyalists in the Spanish Civil War, that you can lose the battles even if you have the best songs. His scenario for World War Three began, "So long Mom, I'm off to drop the bomb…," and ended, "I'll look for you when the war is over, an hour and a half from now."

Still, the Hughes crusade left a legacy, forming the basis for a strong statewide peace movement, creating a localized campaign strategy, and advancing a progressive agenda that shapes the Massachusetts congressional delegation to this day. This tide would send people like Father Robert Drinan, Michael Harrington, Barney Frank, John Kerry, and, yes, repeatedly, Ted Kennedy to Washington, D.C. More recent officeholders, such as

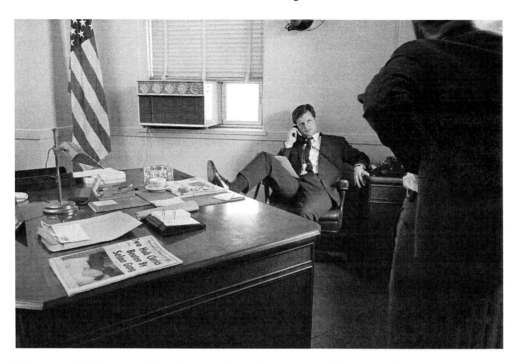

First-term US Senator Edward Kennedy in his Boston office, 1965 (©Ted Polumbaum / Newseum collection).

Senators Edward Markey and Elizabeth Warren and erstwhile Representative Joseph Kennedy III (grandson of RFK, Peace Corps alumnus, fluent Spanish speaker, former assistant district attorney, and teetotaler), also owed their electoral successes in part to Hughes.

That 1962 contest that put Teddy Kennedy in the Senate also opened my parents' eyes to *LIFE*'s singular clout. To be deputized by *LIFE* meant not only unparalleled access, but also unusual allowances.

The campaigning Kennedy was visiting a succession of private homes, on calls of courtesy or consultation or consolation, and *LIFE* assigned Ted to follow along. Ted and Nyna planned to drive to New York that evening, so she accompanied him, and they took her car, a Hillman Minx—a British import now forgotten to all but collectors. My father avoided anything, signals of political opinion above all, that might draw attention on the job. My mother, with no such constraint, had affixed a green Stuart Hughes sticker to the rear bumper. She dutifully peeled it off before they set out.

At each stop, Nyna hung around outside, while Kennedy went in with his driver, Jack Crimmins, trailed by photographer Ted. The crusty Crimmins, a South Boston native and war veteran who knew all the local roads and power brokers, would remain Teddy's steadfast guide and chauffeur until 1977, when Teddy delivered the eulogy at his loyal attendant's funeral.

Partway through the schedule, Kennedy said he needed to enter a home by himself, so the others stayed outside. Noticing a bit of green still stuck to my parents' bumper, obviously a remnant from the competition, Crimmins began to glower. When Kennedy emerged, Crimmins intercepted him, visibly fulminating, no doubt about the rats in their midst. Ted and Nyna watched from a distance as Kennedy gradually calmed the man down. At the next stop, Crimmins, now excessively friendly, invited Nyna to go out back

with him and see some nifty exotic chickens. Regardless of their electoral preferences, my parents had to respect Ted Kennedy's mediation skills.

Early in Kennedy's tenure, for reasons unclear to my parents, a group of progressive Democrats invited them to sit in on a meeting in a hotel room with the new senator. Curious, they went. Kennedy acknowledged them amiably, noted that photographer Ted hadn't brought his cameras, and proceeded to field questions on national and international affairs. My parents, who said nothing, thought his responses clumsy and uninformed. The next day, Kennedy's chief of staff called my father at home, and said, "Teddy wants to know how you think he did." Not great, my father said, and proceeded to explain why. Again, my dad could not help but be impressed at Ted Kennedy's desire to listen and learn.

Peace, civil rights, social and economic justice, self-determination for communities and nations, opposition to US intervention abroad—these big issues, winding through the second half of the twentieth century, also were threaded through our daily lives. My parents not only cared about these causes; they spoke up and took action on them. They hosted civil rights meetings and Indochina history seminars in our home. They organized fundraisers for Southern freedom projects. They turned my sister and me into truants; I still have the diploma from our day of Freedom School at a church in Roxbury, Boston's main Black neighborhood.

We attended many a protest march, sometimes in a delegation from our town, sometimes in the town itself. One year, our antiwar contingent in Lincoln's July Fourth parade wore sandwich boards sporting logos of corporations complicit in war profiteering. For a national moratorium day against the Vietnam War, my parents helped transform

A mock Vietnamese village goes up in flames in "Peace Park" as part of nationwide antiwar activities, Lincoln, Massachusetts, 1969 (©Ted Polumbaum / Newseum collection).

Lincoln's bucolic Pierce Park into Peace Park, complete with a mock Vietnamese village that was doused in fuel and torched after sunset. The thatched-roof creation exploded upward in a fireball, as the town fire department patrolled the perimeter to protect the adjacent forest.

So how did Ted Polumbaum square his political involvements with his work as a photojournalist? How did he get by working for prestigious national news organizations in an era when "objectivity" was trumpeted as the lodestone of American journalism?

To the extent possible, Ted separated his livelihood from his opinions. Carrying cameras, he was either photographer-on-assignment or photographer-for-himself. On assignment, he was a keen, alert observer, with specific tasks to fulfill. As himself, with or without cameras, he could be an interested party, an affected soul, a participant.

Later, when the heyday of the big picture magazines was over, and Ted's income came to depend on illustrating glossy annual reports for stalwarts of the military-industrial complex, such as Raytheon Corp., the separation seemed even clearer: Inflated compensation from corporate jobs supported his more worthwhile personal projects. That didn't exactly satisfy friends who accused him of being a sellout, but it satisfied him.

On the job, Ted could be genuinely friendly even to people who espoused ideas and policies he despised. He got on famously with Louise Day Hicks, Boston School Committee member, mayoral candidate, and standard-bearer for racists opposing school integration in the name of "local control" during the late 1960s. When a friend gleefully remarked that a *LIFE* photographer had the opportunity to make Hicks look monstrous, Ted replied that her words and actions could speak for themselves. He would depict demagogues and their followers as people. The same held for former Alabama Gov. George Wallace, who was running for president against Nixon and Humphrey on his history as a southern bigot, and thought my father would appreciate a tie clip with the legend "Wallace for President in '72." Ted doctored the year to read '48, in reference to Henry Wallace, and wore it as a lark off the job.

Conventional wisdom about photography and photographers further buffered Ted's work from his politics. From its inception in the nineteenth century, photography presented itself as fact. Even before the digital age, people recognized that images could lie or distort, and at best were but partial truths. Still, in the prime of the picture magazines, photos retained an aura of authenticity. The camera was a mechanical device for capturing reality. The photographer was a kind of machine as well. The vocation required a competent eye, a steady hand, and sometimes fleet feet, but perhaps not much of a brain. A photographer's thoughts or opinions were of no consequence.

The backing of the world's most successful magazine company may have been the best insulation of all. Working for *LIFE*, at photography's apex, immunized Ted from the sort of paranoia that had cost him his newswriting job. The magazine tolerated the large personalities and idiosyncrasies of its superstar photographers, the prime example being W. Eugene Smith. Others were expected simply to get the pictures and pass on the raw materials, and that's what Ted did. *LIFE* simply wanted the job done, and applied no political litmus tests.

The volatile Gene Smith was Ted's favorite photographer of all time. In his obsessive desire for control, Smith ultimately had quit his *LIFE* staff position over arguments with the picture editors. My father never met Smith, and could hardly have been more different in temperament. But Ted admired Smith's intense humanism, emulated his preference

for strong contrast in printing, and concurred with his general philosophy of photography. "I have tried to let the truth be my prejudice," Smith once wrote.

Ted also understood Smith's tenacious attachment to the products of his work. As an early member of the ASMP, the American Society of Magazine (later Media) Photographers, my father long advocated for fair compensation and copyright protection. Nevertheless, when it came to proprietary emotions about his own output, he was a soft touch; he could let his pictures go, and gave a lot of them away.

In today's gig economy, with work-for-hire contracts that typically claim all rights, independent creators are hard pressed to keep control of their work. In my father's day, the situation was not so dire, although vigilance was still required. As a freelancer, Dad made sure he retained the rights to his pictures, even those taken for major national publications. If he saw his photos used without permission, he would send letters alerting the scofflaws that they owed him money or credit or both, which sometimes worked. Time Inc., which held many of his negatives, contact sheets, and prints, was always dutiful about forwarding any royalties; and when my mother requested Ted's materials back after his death, they complied right away (minus some of the JFK family images, which tended to mysteriously disappear).

The regime at *Look* was not as conscientious. When that magazine shut down, its photo files were scattered, and my father rediscovered some of his own work only by accident.

In one memorable *Look* assignment, Ted followed poet Anne Sexton around for several days in 1968. Sexton had gained attention in 1960 with her first book, poems arising from her psychiatric struggles, and won a Pulitzer Prize in 1967 for a subsequent collection. At her home in Weston, Massachusetts, another small town bordering our town of Lincoln, my father photographed her having coffee with her husband, relaxing with her daughters, walking in the woods, and swimming in her backyard pool. Elsewhere, he showed her with students in a classroom, accepting a Phi Beta Kappa key at Harvard, and attending a cocktail party.

The long-troubled Sexton killed herself in 1974. Sixteen years later, as Ted perused a new best-seller, Stanford scholar Diane Middlebrook's biography of Sexton, he came upon his picture of the poet clinging to the edge of her swimming pool, an alluring smile on her face. The photo was credited to the Library of Congress, which had cherry-picked the *Look* archives.

When Ted contacted Middlebrook, she told him she'd get proper credit into the paperback edition. The Library of Congress also added catalog credit to what turned out to be a substantial collection of Ted's pictures, part of a 1971 gift from *Look* parent company Cowles Communication. But the institution refused to return the prints or negatives to their creator, deeming possession a hundred percent of the law. It was the nation's library, after all, and Dad gave up.

Assignment: Teen Rockers

Their contagious good vibrations excited mamas, papas and other adults in
the audience, as well as the kids.
— "Battle of the bands," *LIFE* magazine, September 29, 1967

At its height, the far-flung collaborative system developed by Henry Luce churned
out a wealth of picture stories for consideration each week. Emanating from the floors of
editors, writers, researchers, and other staffers at *Time-LIFE* headquarters in New York's
Rockefeller Center, the machinery extended to a network of bureaus across the country
and correspondents worldwide. Typically, a photographer and a reporter would be dis-
patched together to the front lines, and Ted got to know the Boston-based journalists
well.

One was China Altman. Appropriate to her birth in the deep South, her given name
was Mary Helen. At age 16, with ambitions to be a serious journalist, and designs to
confuse male editors inclined to consign a girl to the women's pages, she had it legally
changed to China. After completing college at Georgia Southern University, she arrived
in Boston to work for United Press International. Her ascent at UPI was meteoric, hur-
tling her to posts in London, Rome, and Budapest. She covered Jackie Kennedy's visit
to Greece, and JFK's report to the nation after his meetings with de Gaulle in Paris and
Khrushchev in Vienna.

Ted met China in Boston in the 1960s. She'd returned to the city that felt like home
and, like him, was now a regular New England stringer for *LIFE*. The two freelancers
were often a team. Ted would drive from his home in Lincoln, that hamlet of woods and
fields west of the city, to pick her up downtown. En route to wherever they were going,
they'd gab, lively conversation inevitably spiraling into spirited argument. Ted would
make some sort of declarative statement, China would challenge him, he'd retort clev-
erly, she'd light into him, and if she really wanted to annoy him she'd call him a preten-
tious Ivy League guy. Then they'd get to their destination and switch it off. It was all part
of the relationship.

"Unless you were dead, you couldn't not notice that he had this very very hand-
some long-legged body and grace," China said of Ted. She, for that matter, was quite the
femme fatale. But her coquetry with Ted was pure talk. My father was highly appreciative
of intelligence and wit in women, yet oddly oblivious to flirting. He seemed permanently
smitten with my mother, and my mother alone, a condition my mother found amusing,
but never in doubt. China had met Nyna at the house in Lincoln. Beholding the flour-
ishing, if unruly, garden, she'd asked her hostess about an intensely purple groundcover,
learned its name, and forever after associated my mother with the vivid personality of the

ajuga flower. No romantic designs on my father could compete with that. Friendship, on the other hand, was warmly embraced.

"In those days, you dressed," China recalled. Ted had a definite "Ted Polumbaum style" of attire: khakis, or sometimes corduroys, always with ample pockets for stowing film and a dependable supply of Kleenex, button-down shirt and jacket, tie if absolutely necessary. On one assignment, China took umbrage when a couple of jokesters made fun of Ted's sports coat, which was an unusual shade of green. Without hesitation, she countered: "I don't know what you're talking about, I think this is one of the most handsome sports coats I've ever seen." On their drive back to Boston, Ted said, "I can't believe you stood up for me!"

Unlike some of the more famous, and sometimes petulant and self-important, staffers from *LIFE*, freelancers were obliged to get along with everyone, and China admired Ted's good manners and people skills. She also saw him as uniquely intellectual among the many photographers she knew. She knew he wasn't the elitist phony she teased him about being.

They thought of themselves as journeymen—Ted in images, China in words—representing *LIFE* magazine in a respected and significant way, but without airs. They knew how to cover a story, and went about it with intense focus; whatever they were working on was the most important story in the world.

The most luminous experience of their partnership would turn out to be an assignment they made fun of all the way there—a contest to find the best teenaged rock 'n' rollers in the nation. For three deafening days, 29 amateur bands that had risen to the top of competitions in as many states were playing before a panel of judges at an arena in Braintree, Massachusetts. As the reporter and photographer headed to the final day of what China would call "rhythmic holocaust," she and Ted expected little more than noise from a bunch of immature wannabes. Esteemed as *LIFE* might be, the magazine also was known for indulging goofiness—how many frat boys could pack into a phone booth, how the Hula-Hoop craze was taking hold, the rising hems of miniskirts, and the like. Surely this was another one of those inconsequential missions.

The choice of location itself did not suggest high culture. Braintree was a center of shoe manufacturing. The Braintree of 1967 also was home to one of the busiest establishments in an East Coast restaurant chain, Valle's Steak House, with a dining room seating 600, banquet rooms for 1,000, and parking for 700 cars.

Awaiting the pair of cynics was the absolute antithesis of their assumptions. The electronic music was electrifying—vital, vibrant, different from anything they had ever heard.

The winners were a combo called the Gents, from Provo, Utah. The five young men, ages 14 to 17, wore high-necked white shirts with ruffles, dark jackets, light pants, and slightly longish hair. Their instrumentation included guitar, organ, piano, saxophone, drums, and an electronic violin. Their music, mostly original, wove classical strains into hard rock.

Ted and China not only were won over; they were ecstatic—stirred by the young musicians' fervor, dazzled by the novelty, astonished by the artistry. They spent the return drive wowing and whooping with excitement.

Looking back half a century, their enthusiasm seems quaint: two relative oldsters awakening to sounds that young people already knew and embraced. Listening back, the music itself sounds even more quaint. YouTube yields audio files from a 45 RPM record

Drumming with abandon at a battle of the bands competition, Braintree, Massachusetts, 1967 (©Ted Polumbaum / Newseum collection).

by the Gents, evidently their only release. One side features a grungy song titled "I Wonder Why," with much cymbal-crashing; the other, an instrumental of "Moonlight Sonata," heavy on the amplified violin. The production values are charmingly antiquated, the effect at once cacophonic and sweet.

Yet somehow, Ted produced imagery that resurrects the experience, conjuring up the feelings of those performances in a way the outmoded music itself fails to do. *LIFE*'s two-page spread opened with the figure of a hard-driving drummer, viewed from behind, streaks flaring from the stage lights as if in sync with the frenzied beat. A study in light and dark, the image embodies the power of black-and-white photography. Ted later made China a large print of this picture, writing on the back, "For China, who was there when it all began."

19

Freedom Is Never Free

The Nation has not yet found peace from its sins; the freedman has not yet found in freedom his promised land.
—W.E.B. DuBois, *The Souls of Black Folk*

Dad met Harry Belafonte on assignment, photographing the singer in concert at Boston Garden in 1958. As they talked afterwards, Belafonte picked up on Ted's interest in civil rights, and invited him to his Manhattan apartment to meet a special guest. Soon thereafter, on an October day, my parents drove down to New York to meet the Rev. Martin Luther King, Jr.

Already in the national spotlight, King had just been released from Harlem Hospital. A mentally deranged Black woman had plunged a letter opener into his chest during a book signing at a department store; only luck and hours of surgery saved his life. Belafonte was hosting him to solicit support for civil rights actions in the South. Arrayed around King were his adviser Bayard Rustin, film star Sidney Poitier, Lorraine Hansberry, whose play *A Raisin in the Sun* would open on Broadway the following year, and other Black activists and artists, as well as Oscar-winning actress Shelley Winters and a few other whites.

Somebody asked King whether he carried a gun. My mother was struck by his reply. "I used to," he said, "but it didn't make me feel safer."

Sidney Poitier gave my mother his phone number and urged her to call with any ideas for fundraisers to help King. She followed up, hoping to arrange a concert at a high school, an event that might appeal to liberals in the Boston suburbs. Poitier said he would send a fabulous troupe of African drummers and dancers.

Few knew the name Olatunji in 1959, although the release of the LP *Drums of Passion* the following year would make the Nigerian musician and social activist famous; the first recording to popularize African music in the West, it sold more than five million copies.

That breakout was yet to come. The Lexington High auditorium was only half full. The no-shows, those who contributed by buying tickets they didn't intend to use to see performers they'd never heard of, would later rue their absence, for the show was a rousing success, and its aftermath entered local legend.

In our adjacent town of Lincoln, a physician and his homemaker wife opened their large house for an after-party, a gesture that would turn the wife into a lifelong civil rights activist. In the middle of the night, the revelers saw the troupe off at the Route 128 train station, the drummers drumming, the dancers and townspeople dancing on the platform in a misty drizzle, until the train arrived from downtown Boston to carry the performers

back to New York. The proceeds went to a fund set up by Belafonte after that gathering in his apartment.

On his sorties on familiar ground, in and out of Boston, around New England and the Northeast, Ted could always return to the comforts of home. Plunging into the deep South was another matter.

Encouraged as usual by my mother, whose outrage over injustice typically bested any apprehensions about danger, my father convinced himself that the story of idealistic young northerners heading into a hostile Mississippi in the summer of 1964 was a story he had to cover.

Freedom Summer, a concerted effort by major civil rights organizations to draw media attention to racial discrimination in the South, depended on volunteers recruited largely from college campuses in the North. The strategy was to send young, privileged, predominantly white volunteers into the most hidebound state of all, Mississippi, to set up community centers, run programs for Black children, and help Black adults register to vote.

LIFE had covered civil rights extensively for years, bringing images of marches and boycotts, police dogs and fire hoses, arrests and beatings to a nationwide audience. Luce's flagship magazine already would have Freedom Summer well staffed. So Ted asked for, and got, the assignment from *Time*.

At that time, in that place, the idea of bearing witness without getting involved was impossible. Southern law enforcement and white segregationists counted the Northern press among the enemy. Ted's mere presence as *Time*'s correspondent put him on the side of the movement, as at heart he was.

During the month he spent with civil rights volunteers and their courageous Black hosts, visiting shacks of sharecroppers and descendants of slaves, watching stoic Black citizens in voter registration lines that didn't move, at courthouse protests, with arrest wagons waiting, while brawny sheriff's deputies and taunting white supremacists stood by, my father sometimes wondered why he'd sought the assignment. Never had Ted felt so frightened. Not as a young draftee under Japanese bombs in the Pacific. Not before the US congressmen determined to disgrace him in public. Mississippi in 1964, he always said, was by far the scariest place he'd ever been.

America's defense industries, expanding rapidly to fight the Second World War, had drawn surges of African American labor to jobs in the heartland and along the coasts. In the postwar years, the perils and hardships of life in the Jim Crow South continued to drive Blacks north and west—beckoned, as author Isabel Wilkerson so eloquently puts it in her chronicle of the nation's epic racial migrations, by "the warmth of other suns." Yet close to a million Black citizens still lived in Mississippi, nearly half the state's population. They earned one-quarter the income of white people, experienced twice the infant mortality rate, and had far lower rates of schooling in an intractably segregated system.

Freedom Summer was a joint project of several organizations acting as the Congress of Racial Equality, or CORE. At the forefront was the Student Nonviolent Coordinating Committee, SNCC, led by young Black activists who already were veterans of the risky work of promoting voter registration. If enough students—enough white college students from the North—flooded down to help, the thinking went, then the nation's news media, and ultimately Congress and the executive branch, would be forced to pay heed and take action.

Mobilized from college campuses throughout New England, New York, the West Coast, and the Midwest, more than a thousand students signed on to spend the summer

working for the SNCC-led coalition. Recruiters did not hide the dangers: Several local Black men had been killed already in the effort to expand voting rights in Mississippi. But most of the young people joining the movement, many raised in 1950s suburbia, were fairly sanguine, unaware how transformative two months in Mississippi would be for them personally, if not for the country at large.

Before heading to their posts in Mississippi, the summer volunteers reported for orientation on the grounds of the Western College for Women in Oxford, Ohio. There were two successive training sessions, each lasting a week, and Ted arrived with his cameras to document the first.

On the Ohio campus, veteran organizers tried to steel the neophytes for their perilous journey into the unknown. Warned that Southern law enforcement held sway and the federal government could not offer protection, told to be prepared for jail, beatings, even death, the volunteers rehearsed nonviolent self-defense techniques and learned the rules of non-engagement. Rules such as: Know the local highways and byways; travel before nightfall; beware of vehicles without plates or officers without badges. Don't wear contact lenses that might get knocked out; wear sturdy shoes rather than sandals; carry a jacket to wrap around your head if you're attacked. Avoid giving a sniper a target by standing in a lighted window or doorway.

Before that week was out, three of those in attendance—one fresh volunteer, along with two experienced civil rights fieldworkers who had come to assist with the orientation—had disappeared after leaving the training site early to investigate the firebombing of a Black church in the rural outskirts of Philadelphia, Mississippi. James Chaney, a native of Meridian, Mississippi, was Black; Andrew Goodman and Michael Schwerner

Freedom Summer volunteers prepare to head south at the conclusion of orientation, Oxford, Ohio, June 1964 (©Ted Polumbaum / Newseum collection).

were white northerners. Their fates would transfix the nation, tragically validating the premise that placing whites in harm's way would raise the alarm. Six weeks on, the three men's remains would be unearthed from farmland a few miles outside Philadelphia.

What is probably Ted's most-reproduced Freedom Summer photograph shows a line of the volunteers, Black and white, arms linked, singing "We Shall Overcome" alongside the buses that would carry them to Mississippi. Ted flew down, rented a car, and checked into a centrally located hotel in Jackson. His first days in the state were focused on the earliest, futile search for the three missing men. Discovery of their burned-out station wagon solidified the assumptions of abduction and murder. Schwerner's wife Rita identified the incinerated hulk of the car.

Ted found driving back alone at night in his rental car to the white part of town harrowing, so he moved to a motel in a Black neighborhood, and felt safer. Turning on the television each morning, he would rise to the prayer from the white establishment that opened the day's broadcast schedule on an ominously hollow note: "We thank thee, Oh Lord, for our freedom and our noble Christian heritage. We thank thee, Oh Lord, for living in a land that exalts righteousness and truth." Then he would set out to join the young people trying to break through the shell of a closed society.

Always mindful of the ongoing hunt for their vanished colleagues, couriers for civil rights went to work throughout the state, in smaller cities and hamlets where the gutsiest of local residents and activists were prepared to host them. At the home of a middle-aged Black woman providing room and board to a couple of the young white outsiders, Ted took note of the rifle hanging on the wall beside portraits of JFK and Jesus.

Some of the volunteers fanned out with clipboards and packets of voting information, visiting Black homes along rural roads. Others set up community centers and

Civil rights workers escorted by locals set out with voter registration materials, Hattiesburg area, Mississippi, July 1964 (©Ted Polumbaum / Newseum collection).

Freedom Schools in town, offering lessons in Black history and literature for kids, and helping adults with literacy. Black children in the Mississippi Delta had a "split session" year, going to school in the hottest months because plantation bosses needed their field labor in spring and fall. The students would make for the Freedom Schools after regular classes let out.

Federal civil rights laws of 1957 and 1960, prohibiting interference with attempts to vote or register to vote, were of little use in these parts. Mounting pressure from the movement led to a new milestone on July 2, 1964, when President Lyndon B. Johnson signed a stronger Civil Rights Act, barring discrimination at "public accommodations" such as restaurants, theaters, and recreation facilities. The segregationists quickly responded with subterfuge: Rather than admit Blacks, many businesses and tax-funded facilities closed, or overnight became private clubs open only to whites.

Another of my father's photos shows a young Black woman being dragged by an arm across brick paving, shouting as her back scrapes the ground. It was taken July 16, 1964, in Greenwood, Mississippi, on the city's third "Freedom Day" of the year, when would-be voters and their advocates assembled at the Leflore County courthouse. About 35 African Americans, mostly elderly and middle-aged, waited patiently in line. They would wait in the hot sun all day; a favorite ruse to prevent Blacks from registering was simply to shut the office. Khaki-clad lawmen, some chewing tobacco, milled casually on the courthouse steps. Nearby, voting-rights supporters marching with picket signs chanted and sang. More than a hundred protesters were arrested and hauled off in converted school buses repainted black.

A PBS documentary marking the fiftieth anniversary of Freedom Summer, aired in

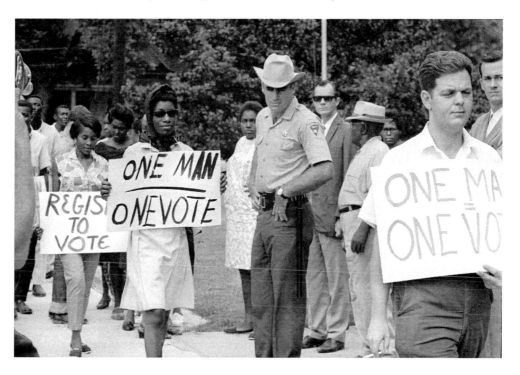

Voting rights demonstrators in Greenwood, Mississippi, July 1964 (©Ted Polumbaum / Newseum collection).

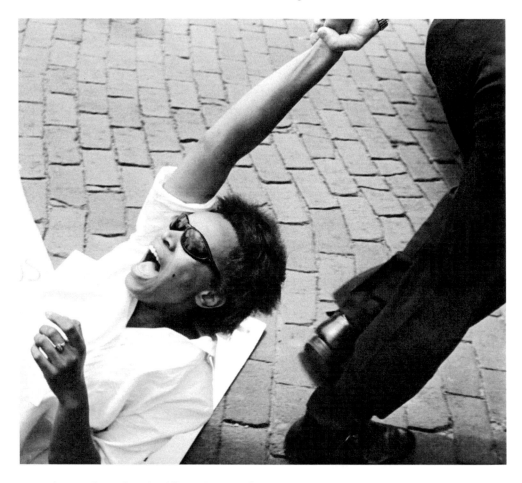

One of more than a hundred "Freedom Day" voting rights demonstrators arrested in Greenwood, Mississippi, July 1964 (©Ted Polumbaum / Newseum collection).

June 2014 as part of the *American Experience* series, resurrects that day in Greenwood. Recovered TV footage reveals the same scene my father saw, of the young Black woman being hauled over the bricks. But the scene has been shot from the opposite side. Beyond the demonstrator's contorted body and the officer who has seized her by the wrist, my skinny father, his hair shorn to a crew cut, a Leica around his neck and another camera in hand, is briefly visible. One glimpse, and of course I ordered the DVD.

Otherwise, Ted Polumbaum left few imprints in Mississippi. The main clues for tracking his activities come from his photographs. He phoned my mother occasionally, not relaying much, downplaying his fears because he didn't want to worry her. She remembers little of their conversations, understandable since she was busy with a new baby, my brother Ian, who was not quite eight months old.

Although Ted took copious notes on Freedom Summer, he recorded almost nothing about his own doings. Rather, he homed in on the feelings and experiences of the volunteers, asking about their paths into the civil rights movement, probing their devotion to a mission greater than themselves. My father was intensely curious about what motivated them, undoubtedly wondering whether he himself would have had the nerve to walk into the hazards that quickly were turning from admonitions into realities. Back at his lodging

each evening, he would type up his interviews, knowing that if too much time elapsed, even he wouldn't be able to decipher his insufferable scrawl.

Madeline, a schoolteacher, at 26 a bit on the older side among the white volunteers, told Ted: "My approach is humanitarian, not political; I have this great faith in people." Devoutly Catholic, she'd considered becoming a missionary. Her parish priest had warned her, "Leave those niggers alone." Her mother had changed the locks to keep her from returning home. But her pastor at college held a special mass to bless the traveler.

Ira, 25, another teacher, also white, worked with New York City kids who'd been labeled incorrigible. He hoped to help influence the country's attitude toward Mississippi, building pressure for federal intervention to ensure voter registration. "When I ask myself why I came," he said, "I come up with unsatisfactory answers. I can only rationalize that my skills will be useful. It's a personal challenge, but down here it's not your personal measure that's important. You're very preoccupied with day-to-day work, so any fishy subjective reasons evaporate."

Another white volunteer, Nancy, 23, recalled the terrifying trip south, when the integrated bus she rode got turned away from food stops and menaced by Memphis police in helmets. At one stopover, police interrupted a meeting in a Black church, ordered the visitors to the station, took names and mug shots, and played them a recording of the district attorney ranting that Negroes would sexually assault the girls and, anyway, they had no business there.

Yet Nancy, granddaughter of two ministers, said the civil rights cause brought her the closest she'd ever come to a sacred experience. "I examined my motives. Was I doing this for my own gratification? To be a great savior?" She drew affirmation from the woman she was staying with, who worked as a maid for a white family. "When she said how much she loved us and would do anything for us, we cried. I talk to her when I need encouragement. I'm not ashamed now to expose myself, share happiness and joy and not think of consequences."

Her parents had told her, "You'll look back in fifteen years and see how silly you were." Her forecast: "I don't think so."

Many of Ted's photos follow volunteers to dilapidated wooden homes, where they stand on rickety porches, explaining the voter registration process to Black residents. In one series, a young white visitor has a sizable bandage on the crown of his head, over a patch of shaved scalp.

David Owen, 19, an Oberlin College student from Pasadena, had just gotten a gash on his head stitched up. He was working in and around Hattiesburg, where civil rights workers often faced threats of violence. He'd been accompanying a visiting ally, Rabbi Arthur J. Lelyveld, 51, head of a Reform temple in Cleveland and longtime advocate for social justice, when a couple of men emerged from a pickup brandishing pipes, yelling, "We're gonna' get you nigger lovers." The assailants chased and beat Lelyveld, David, and another volunteer, badly enough to send them to the hospital with lacerations and contusions.

"My first impulse was to get away," David told Ted. "Then I saw the rabbi standing there, and I couldn't leave him alone; we'd been trained never to abandon one another. I saw it was just an old man attacking me, so I thought I could defend myself with karate. Then I remembered I was pledged to nonviolence, and if the rabbi didn't defend himself, I couldn't. I fell down in curled-up position, with hands over my head."

In this context, man-beats-man was an unremarkable phenomenon, seldom rising

A beating by white supremacists has landed Rabbi Arthur Lelyveld in the hospital, Hatties-burg, Mississippi, July 1964 (©Ted Polumbaum / Newseum collection).

to the man-bites-dog level of newsworthiness. Brazen but nonfatal attacks on civil rights workers rarely got national coverage. This instance drew unusual attention. Lelyveld had arrived early that week, on behalf of the National Council of Churches, to assist with voter registration and embolden local Jews (he found few) to support the cause. Given his prominence, *The New York Times* (where Lelyveld's son Joseph already worked, and would become a noted foreign correspondent and eventually executive editor) reported the assault in a small item on page 22.

"I guess I'm one of the younger generation looking for purpose," David said. "It's clear to me that we're doing something Negroes want, and may fear to do alone: Get the right to vote. We must change a system where 42 percent of the population doesn't believe what it's told but has to live as it's told."

Among white volunteers, my father found persistent idealism, tempered by the implacable southern white racism they now were encountering up close. Among young African Americans with longer involvement in the movement, some starting very early, he found remarkable determination, tough realism, and clear aspirations.

Douglas, 17, a Black staffer with SNCC, had been thrown out of high school for activism that began when he joined a lunch counter sit-in at age 13. He'd since been arrested fourteen times, and twice received beatings in jail. "I believe in one man, one vote, and self-defense," he told Ted. "The most important thing is to keep trying to educate the Negro into political organization so he'll have some say in government."

Gwen Robinson, 19, came from the Black bourgeois tradition. At Spelman College, where the girls were destined to marry Morehouse men, her mind opened up. After her sophomore year, the college president grilled her about alleged communist affiliations,

asked if she really believed in the ideals of America, and pressured her to leave the school. If she agreed to drop out quietly, he promised, there would be no demerit on her record. She did leave, quite happily, to work for SNCC, joining the executive committee.

"The SNCC office was alive," Gwen said. "They were having an impact on the world, not worrying about what to wear. I loved everybody there. Now it's my life.

"Whenever I was arrested I'd talk to the Negro cops: When you arrest me, you're arresting your sister, your mother. They were so gentle with Black girls that white cops had to take over. I was attacked only once, hit on the head."

After seven years with SNCC, in three southern states, Gwen would go on to a distinguished academic career. Gwendolyn Zoharah Simmons, as she is known today, became a professor of religion and expert on Islamic feminism.

"We can only make people aware," she told Ted back in 1964. "The people here will be the officeholders of tomorrow. It will be the volunteers who will return home changed. Kids are here for a lot of motives: Some of the whites want to dramatize their opposition to segregationist parents; some couldn't fit in, but most of them have a vision of a better world. I think the leaders also have this vision. They really believe in the blessed society— heaven on earth—and doing away with divisions among human beings. This is religion to me."

The challenges of civil rights work sometimes came from unexpected sources. Dad wrote that Mitchell, 11, attending a Freedom School class, refused to believe what the white teacher, Denise, was saying about ancient African kingdoms. The boy answered back: "All colored people can do is play Tarzan in the movies. Colored people couldn't build those buildings."

Denise asked the other children if they thought white people were better than colored. They all said yes. Mitchell insisted: "Colored people don't look no good because they're Black as midnight. The Sunday school teacher and Denise say those things just to make us feel good. They don't tell the truth. Colored people be doing all them dances on TV. You don't see white people doing those dances." Flailing his arms and legs, he frantically demonstrated this rendition of Blackness, until Denise succeeded in calming and comforting him.

My father got home safe, shaken, reflective, uplifted. He continued to support and cover civil rights, mostly around New England, occasionally venturing further afield.

Boston had plenty of race issues of its own, affecting everything from housing, education, and employment to entertainment and the arts. On or off the job, my dad welcomed opportunities to chronicle local struggles against segregation and discrimination, to draw attention to racial progress, and to donate pictures and expertise toward good causes. For posterity as well as publication, he photographed civil rights marches in the streets, rallies in churches, militants on college campuses, and Black athletes at the highest levels of their sports.

During the prolonged controversy over court-ordered busing to desegregate Boston public schools, Ted's pictures revealed the virulence of resistant whites, and the grandstanding of their demagogic leaders. He covered Edward Brooke, who represented Massachusetts in the US Senate from 1967 to 1979, the first African American voted into that body since Reconstruction (and the first Republican in the Senate to call for Nixon's resignation amidst the Watergate scandal). As Harvard University gradually addressed demands for serious attention to Black culture and history, Ted photographed resolute students with Black-is-beautiful Afros; political scientist Martin Kilson, the first

African American promoted to full professor at Harvard; and, when Harvard created a full-fledged Department of Afro-American Studies, its first chair, lawyer and labor leader Ewart Guinier (father of Lani Guinier, who became the first woman of color to get tenure at Harvard Law School, and later was portrayed as a wild radical by Republicans blocking her nomination to a Justice Department post).

Ted was smitten with Elma Lewis, a native Bostonian just a few years his elder, who ran a school of the arts for African American children and youth in Boston's mostly Black district of Roxbury, as well as a theater program for incarcerated men. She cut a disarming figure, short and stout, but with the graceful comportment of a dancer, propelled by a forceful personality. My father would do just about anything she asked. He helped her get national publicity in magazine stories, and provided photos for an anthology she edited of writings by Black convicts. Ultimately, she would earn recognition as one of the earliest recipients of a MacArthur "genius" award.

For a while, collaborating with a Roxbury activist named Carnell Eaton, Ted tutored young men in picture-taking and darkroom work. I went along once or twice, meeting the warm, expressive Eaton, who was then a young father. He and others had founded a community organization that helped calm the area after Martin Luther King's assassination in the spring of 1968. Later that year, in a perplexing incident that police called an attempted robbery, the 33-year-old Eaton and two others would be shot and killed. Three men tried for their murders the following year were acquitted.

I accompanied my father to Eaton's wake. The first lifeless body I had ever beheld was laid out in a small whitewashed storefront. A coil of stunned mourners unwound slowly through the little room. We were the only white people there.

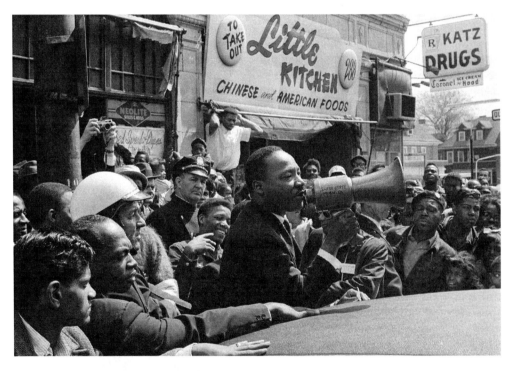

Rev. Martin Luther King, Jr., in Boston to lead a march for equal jobs and housing, April 1965 (©Ted Polumbaum / Newseum collection).

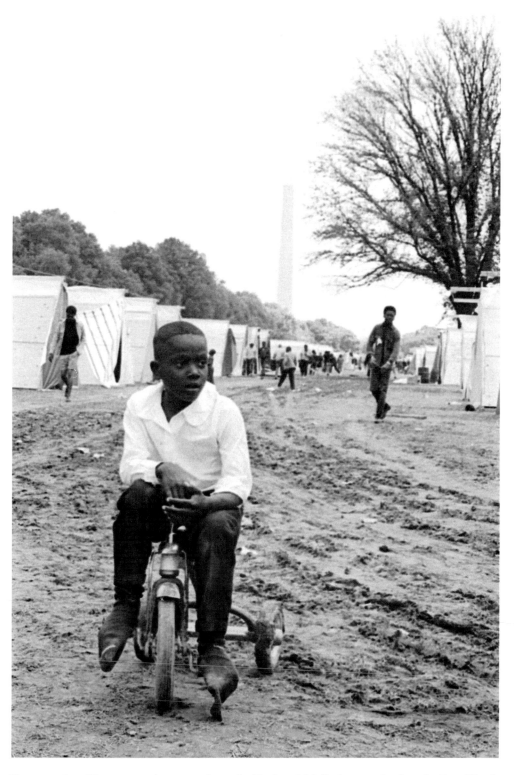

Resurrection City, a tent city erected on the National Mall the month after the Rev. King's assassination, May 1968 (©Ted Polumbaum / Newseum collection).

Martin Luther King had lived in Boston for five years, earning a doctorate in theology from Boston University in 1955. When King returned in 1965 to lead a civil rights march from Boston's Chinatown to Boston Common, Ted was on the job, taking pictures.

After King's assassination in April 1968, Dad briefly went back to the South to track caravans on the Poor People's March, bound for the nation's capital. King had been planning this campaign for economic justice when he was killed. Unveiling the project, he'd linked its objectives with an end to the Vietnam War, saying, "We believe the highest patriotism demands the ending of the war and the opening of a bloodless war to final victory over racism and poverty."

The Poor People's March convoys, some incorporating covered wagons pulled by horses and mules, culminated in construction of a shantytown, Resurrection City, on the National Mall. The encampment of shacks and tents lasted six weeks in the spring of 1968, inundated by downpours, largely ignored by politicians, with media attention perfunctory at best. When Dad took me along on a photo trip there, it was a muddy, messy, demoralized place. Unattended kids buzzed around with nothing to do; someone produced a children's book, and I read aloud to a few of them. Ralph Abernathy, heading the campaign since King's death, led a disordered entourage into a tent, spoke to a fidgety crush of people, and departed.

What seemed like eons had elapsed, and much had happened, since that long-ago meeting my parents attended at Belafonte's apartment, on the fifth floor of a stately building on the Upper West Side (Belafonte had bought the entire thirteen-story building when the landlord refused to rent to him). On that occasion, as Dr. King spoke solemnly about the challenges in the South, Ted was as close to the civil rights icon as he would ever be, not to mention surrounded by other luminaries of the movement and Black culture.

No images would emerge from that encounter. My father had left his cameras in the trunk of the car, feeling they might be inappropriate. I doubt he ever questioned that instinct. My mother always regretted it.

20

Assignment: The Station Wagon

"The interior of the car was burned, the upholstery was burned, the seats were completely burned out and the windows were melted, and the station wagon, with the exception of a small area on the driver's side, had all the paint burned off of it."

—FBI special agent John H. Proctor, Jr., testimony in *United States v. Price et al.*, 1967

It was a 1963 Ford Fairlane station wagon, license plate H25 503. It was still smoldering when discovered amidst thickets of sweetgum and blackberry off Highway 21 in Neshoba County, Mississippi, just outside the county seat of Philadelphia. Its last known occupants, James Chaney, Andrew Goodman, and Michael Schwerner, had been reported missing two days before.

Mickey Schwerner—dubbed "Goatee" by local whites, and especially loathed as a race traitor, a Yankee, and a Jew—was known to be on a hit list. He and his wife Rita, organizers with the Congress of Racial Equality, had arrived in Mississippi in early 1964 to run a community center in Meridian.

Jim Chaney, a young Black man, eldest of five children, lived with his mother and little brother in Meridian. He had joined the civil rights movement as a teen, and had been suspended from school for wearing an NAACP badge made out of paper. As a volunteer at the CORE office in his hometown, he became a trusted guide, able to go places white organizers couldn't go. When the Schwerners arrived to manage the center, they arranged for him to join the fulltime staff.

Andy Goodman, a Queens College student from New York City, was in the first group of mostly white northern volunteers heading south for the Mississippi Summer Project.

The three men had left the Freedom Summer orientation program in Oxford, Ohio, to investigate the firebombing of a Black church in rural Neshoba County. Arriving a few days after Klansmen assaulted church leaders and burned down the building, they learned that the white mob was hunting for "Goatee."

The three hadn't been heard from since Sunday, June 21. Civil rights organizers were sure they were dead. Discovery of the station wagon fortified this certainty.

In Ohio, the first group of Freedom Summer volunteers boarded buses to go south as the second group arrived for training. Reminded that they were free to return home, very few did.

A sequence of events was soon established. On their way back to Meridian after inspecting an incinerated Black church, the three civil rights workers were arrested by a deputy sheriff on a speeding charge, and held into the evening in the Neshoba County

Jail. Late at night, they paid a fine, were released, and resumed their drive. Local law enforcement surely would have alerted Klan members to the whereabouts of likely prey. Not a few officers of the law themselves were in the Klan.

Mickey's wife Rita remained stoic and unsentimental, determined to avoid the grieving widow label. Returning to Mississippi, she confronted Neshoba County's top cop, Sheriff Lawrence Rainey, and insisted on viewing the destroyed vehicle. She and a colleague, accompanied by a lawyer, were given five minutes at Stokes Auto Body Shop in Philadelphia, where the station wagon had been towed. When they drove away, a caravan of jeering locals followed, lobbing bottles and rocks at their car.

As Rita Schwerner and others observed, it was the involvement of white people that drew national attention; had Chaney alone disappeared, nobody would have devoted resources to looking for another lynched Black man. FBI agents, joined by about a hundred cadets from a nearby naval station, continued to comb the area's woods, fields, rivers, and swamps for traces of the missing three. After six weeks, their decomposed bodies were excavated from an earthen dam on Old Jolly Farm, owned by a Klansman. Meanwhile, the search unearthed eight other corpses, all African American men, findings seldom mentioned in press or historical accounts of the case.

To spur a federal investigation, US Attorney General Robert F. Kennedy had invoked the "Lindberg law," enacted after the 1932 kidnapping of aeronautics hero Charles Lindberg's baby. The parents of Goodman and Schwerner were meeting with President Johnson at the White House when they learned the burned-out station wagon had been found.

Andy Goodman (center, in black t-shirt), listens as SNCC executive secretary James Forman (standing at left) speaks to Freedom Summer volunteers, Oxford, Ohio, June 1964 (©Ted Polumbaum / Newseum collection).

Rita Schwerner identifies the car that last carried her husband and two colleagues, Philadelphia, Mississippi, June 1964 (©Ted Polumbaum / Newseum collection).

Black comedian and activist Dick Gregory, cutting short an international tour to go to Mississippi, announced a $25,000 reward for information on the location of the three civil rights workers, and the FBI offered another $30,000. A tip from an informer, later identified as a highway patrol officer, led to discovery of the bodies on August 4.

The state declined to press murder charges. Federal prosecutors relied on a Reconstruction-era statute to indict eighteen Klansmen and law officers for conspiring to deprive the murdered men of their civil rights. In a 1967 trial, seven defendants were found guilty, including the Imperial Wizard of Mississippi's White Knights of the Ku Klux Klan. Sentences ranged from three to ten years, although none served more than six years. Among those acquitted was Edgar Ray Killen, a sawmill operator and part-time preacher, whose role in organizing the killing party was common knowledge. Reopening the case more than three decades later, the state tried Killen for murder in 2005. A jury convicted him on the lesser charge of manslaughter. He was sentenced to three consecutive twenty-year terms, and died in prison in January 2018.

Andy Goodman appears in some of Ted Polumbaum's photographs from the Mississippi Summer training program on the peaceful, sunny campus of the Western College for Women in Oxford, Ohio. Goodman is visible in the second row of an auditorium where speakers are detailing the dangers the volunteers will face. In another image, he sits among a group on a lawn, listening intently at a workshop on nonviolent resistance. In another, he stands on the lawn, the Romanesque Revival stone buildings in the background, focusing on comments from James Forman, one of the young Black leaders of the summer project.

An anthropology major, Goodman also studied theater. In another photo, he jeers at a simulated brawl on the lawn, playing the role of a white racist, as volunteers practicing

non-violent defense curl up on the grass in the fetal position to prepare for an imminent beating.

In one auditorium presentation, John Doar, deputy chief of the civil rights division of the US Justice Department, is saying he is sorry, but the federal government cannot protect the hundreds of northern students wandering through rural Mississippi that summer; they will be at the mercy of local police. The young Black director of the summer project, soft-spoken Bob Moses, already a veteran of many beatings and often likened to a saint, attempts to explain the dark territory into which the volunteers are heading. Somewhere in the crowd is the shy Jim Chaney. Toward the back, Rita Schwerner sits by an aisle beside her husband Mickey, their heads tilted toward each other in concentration.

Ted has captured some of the final poignant images of lives cut short. Michael Schwerner is 24, James Chaney 21, Andrew Goodman 20. Forever young.

Now they are gone. Rita Schwerner, in a paisley shift, is at Stokes Auto Body Shop to view the station wagon.

Fissures in the
American Century

Defenseless villages are bombarded from the air, the inhabitants driven out into the countryside, the cattle machine-gunned, the huts set on fire with incendiary bullets: this is called *pacification*.
—George Orwell, "Politics and the English language"

I grew up without much consciousness of the world war that had shaped my parents' generation, and with scant understanding of the power vacuum that my own country would rush to fill. The British Empire was shrinking into nothingness; soon after the Second World War ended, in the space of one February week of 1947, Great Britain relinquished responsibility for Palestine, announced that India would be granted independence, and withdrew patronage propping up the governments of Greece and Turkey. While the UK ceded its dominion as the world's preeminent military, political, and cultural power, the US was expanding its reach. The noble appeal to global leadership that Henry Luce had proclaimed in his 1941 *LIFE* essay on "The American Century" seemed more credible than ever.

Baby boomers would benefit from America's rise, sharing in the postwar certainty of our grand destiny, largely ignorant of how we got there. As far as we knew, the Soviet Union and China were never our friends; those wartime alliances had broken down as our parents were bringing us into being. As far as we were concerned, Communism was always the American bugaboo; the Red Scare, ignited by the Bolshevik revolution decades before, was rekindling as the first of our numbers arrived. The Cold War, fueled by the notion that the diabolical Soviets would conquer the globe if the Americans failed to hold them at bay, would be the context of our lives into middle age.

In time, of course, our imperial role would have grave domestic repercussions, helping to set off the political and cultural rebellions of the 1960s. While much of the Cold War was conducted by proxy, far removed from our shores, the specter of a Red tide swelling across Asia had direct consequences for Americans, draft-eligible young men above all. The Communists had come to nationwide victory in China in 1949, sending the US-supported Nationalists fleeing to Taiwan, and US troops were soon at war in Korea. The Korean armistice of July 27, 1953—signed two days before my birth—halted fighting between North and South without really ending the war; two separate Koreas still occupied (and still do) approximately the same territory as when the war began. The enveloping contest among the larger powers raged on. And the stage for America's fiasco in Vietnam was set.

My parents gained premature knowledge of US involvement in Vietnam in the

spring of 1961, during our India sojourn, when Time Inc. dispatched Ted on his side trip to Southeast Asia. His main mission was to take pictures for a new Time Life Books series about different regions of the world. Few back home even knew of the existence of small countries like Vietnam, Laos, and Cambodia, let alone of the region's historic and developing conflicts. Hardly anyone was aware that the US government had bankrolled the late stages of France's colonial war against Vietnam's independence movement; or that after the French defeat at Dien Bien Phu in 1954, leaving a divided Vietnam awaiting democratic elections that were never held, US military aid, equipment, and expertise had continued to flow to the South. Few knew that the US was adopting the ill-fated French strategy of "pacification," so bitterly described by George Orwell. Nobody realized the extremes to which America, in the guise of a mission of salvation, would take its project of destruction.

President Truman had offered mounting financial support for the French colonial regime, and in 1950 dispatched the first US troops to Vietnam—a few dozen, to accompany military equipment. After the French withdrawal, far from subsiding, the US military presence steadily escalated. Eisenhower sent a handful of emissaries in 1955 to help train the South Vietnamese Army in its efforts to repel the Communist-led North. Kennedy added more in ostensibly non-combat roles; the number of US military advisers in Vietnam had grown to some 1,500 by the time of my father's visit. Johnson would put boots on the ground.

Saigon in 1961 was a beautiful, seemingly peaceful city. But the troubles were closing in. Escorted in and around the southern capital by a colonel from the US Military Assistance and Advisory Group, MAAG for short, Ted and a *Time* correspondent visited a South Vietnamese prison camp, set up to weed out suspected Communists. To Ted, the 800 or so prisoners held there looked to be the cream of the youth of Vietnam: most in their teens or 20s, some in their 30s, including women cradling babies. Camp officials with microphones would order large batches of them into rows, and lecture them all day on the evils of Communism. Prisoners laughed when they saw the Americans watching; they obviously viewed the entire show as a futile farce.

From the rooftop of their hotel, the visiting writer and photographer could hear gunfire and see explosions in the distance. Their US military guides said the Viet Cong (the American term for the National Liberation Front, forces backed by the North that were fighting against the US-backed regime in the South) controlled 55 or 60 percent of the population by daytime. But at night, the advisors said, those figures are classified, so we can't even begin to tell you how bad it is. They clearly thought they were backing a losing proposition.

Vietnam took up occupation in Dad's mind. Rejoining us in Kashmir, he woke from a nightmare imagining that my mom, with her high-necked pajamas, was Viet Cong.

Once we got home that fall, my parents were ready to apply themselves as peaceniks. The first task, as they saw it, was to help people inform themselves. My father came up with the notion of living room meetings, with discussions around shared readings moderated by upstanding members of the community, ideally individuals of conservative bent. My mother thought the idea unlikely to work but worth a try. Remarkably, these sessions did change minds, turning not a few hawks into doves—and quite early, when disengagement from Vietnam was still an unpopular cause.

President John F. Kennedy continued to send men, machinery, and money to South Vietnam; by the time of his assassination, the advisory corps had grown tenfold, to about

16,000. Despite historical speculation about how JFK might have proceeded differently from his successors, his decisions and statements show he anticipated greater military involvement, not less.

Highly exaggerated accounts of North Vietnamese attacks on US ships in August 1964 gave President Lyndon B. Johnson the pretext he needed to justify colossal escalation. With only one representative and two senators objecting, Congress handed him what amounted to a blank check, in the form of the Tonkin Gulf Resolution. Soon, hundreds of thousands of US draftees were headed to Southeast Asia, and America was deep into an undeclared war.

LBJ's commitment of combat troops in Vietnam reached 580,000 at its peak, as carpet-bombing of the South spread into the North. Nixon further expanded the bombing into neighboring Laos and Cambodia, illegal incursions that he and his national security adviser (later secretary of state), Henry Kissinger, went to great lengths to try to keep secret.

By 1975, when South Vietnam fell to the North, and the last Americans left, the Vietnam War had claimed some two million Vietnamese civilian lives, more than a million North Vietnamese and Viet Cong combatants, a quarter of a million South Vietnamese soldiers, and more than 58,000 US troops. America's aerial bombardment of Southeast Asia delivered three times the total tonnage dropped in World War II.

Ted made the antiwar movement a photographic project as well as a personal cause, sometimes on assignment, often on his own. Boston, with its revolutionary heritage, a concentration of young people on college campuses, and the informed outrage of academics such as linguist Noam Chomsky of MIT and historian Howard Zinn at Boston University, was at the leading edge. Through much of the 1960s, peace demonstrations were small, and usually disrupted by hecklers. By decade's end, objection to the war was widespread, and protest as much a part of the daily news as the war itself.

My father dated the most marked change to the Tet Offensive in early 1968, when the Viet Cong launched dozens of simultaneous strikes throughout the South during Vietnam's most important holiday season, the Lunar New Year. Even though the insurgents suffered tremendous casualties, and the US military claimed victory in terms of body count, the scope and audacity of the coordinated attacks transformed the American mood.

Most *LIFE* photographers and reporters Ted knew favored the war. Nevertheless, even they played an important role in changing minds. With no desire to go anywhere near military combat, Ted greatly admired the journalists and photojournalists who did bear witness to its results. US Army combat photographer John Olson, later a *LIFE* staffer, was only 20 when his devastating pictures of American casualties from the Tet Offensive appeared in *Stars and Stripes* newspaper and *LIFE* magazine. Ted found Olson's terrible, unflinching images—the stillness of the dead, the agony of the dying and wounded, the desperation of those trying to save them, the palette of flesh and blood, camo and mud—hauntingly beautiful. Such coverage, impossible to ignore, helped to persuade the country that the bloodletting was not worth it.

Most importantly, in Ted's analysis, the mounting cost of the carnage changed the mood of Americans in high places. He never subscribed to the widespread view that mass protest brought the military effort to its knees. Only when those holding the levers of power changed their views, my father maintained, did an effective consensus against the war emerge.

"This is my own theory, and I'm not a political scientist or historian," my father told an interviewer in 1995 for an oral history project on the peace movement in the Boston area. "A real debate occurred ... not because there was a popular revulsion against it, but because there was a revulsion at the top, among our political, economic and media leaders. That may be a cynical point of view, but I think that Americans are just as susceptible to becoming implicated in war crimes as any other population, including the Germans, the Japanese, you name them. Sorry to say."

The power elites came around, my father believed, out of recognition of their own best interests. He'd heard as much from the head of Arthur D. Little, a Boston consulting firm that was one of his earliest corporate clients. Company President James Gavin, a World War II lieutenant general and paratrooper hero, had told Ted that millionaire politician Nelson Rockefeller (then governor of New York State, later vice president under Gerald Ford) and his friends would bring our entanglements in Vietnam to an end, that it was not a good war, and we had to cut our losses and leave.

William Fulbright, Democrat from Arkansas, chair of the Senate Foreign Relations Committee, and a vocal opponent of the Vietnam War, had opened hearings on Vietnam in 1966, two years before the Tet Offensive. Now he had a chorus, as other senators and representatives called for US withdrawal. My parents' friend Charlie Whipple, a *Boston Globe* editorial writer, had earned attention in 1967 as author of the first editorial at a major US newspaper to oppose the war. Now other prominent papers turned against it.

Only half-joking, Dad would say that many friends and neighbors and relatives, and certainly his more conservative tennis pals, developed amnesia around this time. They'd always been in favor of human rights and civil rights. They'd always been peaceniks. They forgot that they'd ever been racists and jingoists.

Resistance to the draft became a flash point of antiwar efforts, with Boston a conspicuous crucible. In the spring of 1966, four young men burned their draft cards on the steps of the South Boston courthouse. FBI agents who were present rescued them from attack by neighborhood thugs. Under a 1965 amendment to the Selective Service Act criminalizing deliberate destruction of a draft card, the ringleader of the card-burners was tried, convicted, and sentenced to six years, with the verdict later upheld by the US Supreme Court.

By the fall of 1967, when protesters from throughout New England turned out for a "Call to Resist" rally on Boston Common, hundreds of young men were openly rejecting the draft. Addressing the rally, Professor Howard Zinn chastised policymakers for trying to "save" people from Communism, "whether the people want to be saved or not, and even if they have to kill them to save them." At nearby Arlington Street Church, following sermons against the war, more than 200 men turned in their draft cards, and nearly 70 burned theirs.

A few days later, at a draft resistance gathering in Washington, D.C., famed pediatrician Benjamin Spock collected nearly a thousand draft cards in his briefcase. The following spring, Spock and four other seasoned peace activists went on trial in Boston's federal court, charged with conspiracy to counsel, aid, and abet young men to evade the draft. Spock and three others were found guilty. An appeals court later overturned the convictions.

Untold numbers avoided the draft privately. Some went into hiding, or to Canada. Some found ways to stymie the induction process. A fellow my parents knew took the route of deception. Owen, small and wiry, with a halo of curly hair and aspirations to

be a photographer, had lost his student deferment when he graduated from MIT. (His younger brother, who would become a well-known comedian, was still at Harvard.) He asked my parents if he could hunker down at our home for a couple of weeks. Already scrawny, he was planning a starvation diet, ensuring he'd be sufficiently underweight to flunk the Army induction physical.

Owen's scheme worked. To thank those who'd helped him, he invited my parents and others to dinner at a Chinese restaurant, then presented his honored guests with their shares of the bill.

Owen wished to hang around Lincoln awhile longer. My parents referred him to our delightful new neighbor, Victor, who was happy to rent him a room. A young widower, founder of a computing service in Cambridge long before the PC days, Victor had bought the house across the street from us. His hyperactive son Daniel quickly became my rapscallion brother Ian's best buddy. A taciturn young woman who helped with childcare and worked on cars in the driveway also lived there.

In his next demonstration of generosity, Owen offered homemade brownies to his new household. Everyone but him got violently ill; he'd neglected to tell them the brownies were laced with hashish.

My parents never saw nor heard from him again, although we know Owen did stick with photography, sometimes documenting his famous, smart, politically liberal brother's doings. The brother went into politics, only to resign when an embarrassing snapshot from a USO tour surfaced. Owen was on that trip, but told reporters he hadn't taken that particular picture.

My hometown did figure in a more inspiring example of individual resistance to the draft, the case of John Sisson, whose sister Wendy was one of my sister's nicer classmates in the Lincoln public schools. John refused induction on the grounds that he considered the Vietnam War illegal and immoral; he was acting as a conscientious objector to this war specifically, not to war in general. A federal judge accepted his reasoning, and the case ultimately reached the US Supreme Court, which let the original ruling stand.

The Boston area also became known for offering safe haven to draft resisters. The pastor of Lincoln's First Parish Church even proposed holding a sanctuary in our town, with a good deal of support from the congregation, although a majority turned down the idea. My father would have relished such a visually appealing opportunity so close to home. He didn't have to go far, however, when a group of theology students sheltered an Army deserter at Boston University's Marsh Chapel in October 1968.

Ray Kroll, an 18-year-old private, had gone AWOL from Fort Benning in Georgia. Dismayed that his unit was being trained for riot and crowd control, he'd decided that he could not square his moral convictions with military service. Dad drove into the city to photograph the BU sanctuary for days on end and some nights, bringing me along a couple of times. Hundreds of supporters, mostly students, came and went, replenishing a protective crowd of up to 1,500 around the clock. There were teach-ins, speeches, singing, and an open microphone. It was wall-to-wall people, deep in discussion alongside giant woodcarvings of the Apostles, making endless bologna sandwiches beneath soaring Gothic buttresses, illuminated by daylight through stained glass windows, and by chandeliers after dark.

The place was easily infiltrated. Dad used to say you could identify undercover operatives at antiwar demonstrations by their shiny shoes. This was different; to get in, the observers had to blend in. Still, my father recognized one cop posing as a student. Ted

had met him while covering a drug raid for *LIFE*; the other cops called him Baby Face, for his youthful looks. The narcotics team had first knocked down the wrong apartment door, only to encounter young people studying; then they hit the intended place, where druggies were sleeping on dirty mattresses. Now, in Marsh Chapel, Baby Face scurried off as Dad's eyes met his.

No doubt there were other police and government agents. The authorities were making diagrams of the layout of the church, and preparing to strike. At 5:30 a.m. on October 6, as the fifth day of the sanctuary dawned, about a hundred federal marshals, under the direction of an FBI crew, entered and gave the occupiers fifteen seconds to clear the aisles. My father was there. As Kroll attempted to go limp, Dad heard one agent say, "Stand up or we'll kill you, you bastard." They dragged Kroll out and arrested him. My father got outside in time to capture two burly marshals manhandling their captive down the steep flight of concrete steps at the chapel entrance.

Kroll would get three months at hard labor. A graduate student organizer of the sanctuary was expelled from BU's School of Theology. Yet most participants saw the event as helping the antiwar cause. "The most we can do, if we don't liberate the world, is to liberate the ground on which we stand," said Howard Zinn, the outspoken BU history professor, the day after the bust. "We can find victory in the act of struggling for what we know is right."

The Vietnam War was the overriding issue of the 1968 Democratic presidential campaign. Eugene McCarthy, US senator from Minnesota, brought his antiwar platform to the primaries, nearly upsetting Lyndon Johnson in New Hampshire. Days later, Robert Kennedy entered the race, also calling for an end to the war. LBJ, headed for a shellacking,

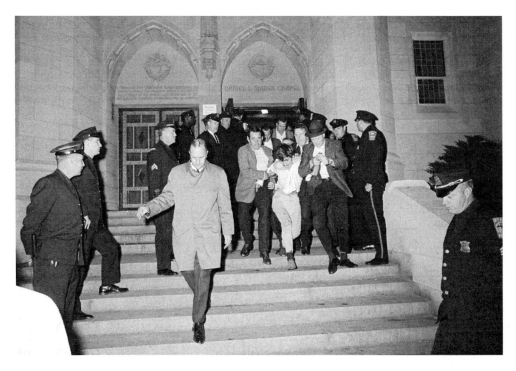

AWOL soldier Ray Kroll's forced predawn march from Boston University's Marsh Chapel, October 1968 (©Ted Polumbaum / Newseum collection).

dropped out. Martin Luther King, who had characterized the Vietnam War as "destroying the soul of our nation," was assassinated. Bobby Kennedy was assassinated. The Democratic establishment selected Hubert Humphrey, claimant to just over 2 percent of primary votes, as its candidate. He lost to Richard Nixon, who had promised to achieve "peace with honor" in Vietnam. (Half a century later, historians finally found proof of what they'd long suspected: Nixon's campaign had tried to sabotage Johnson's fledgling efforts at peace talks, which could have helped Humphrey's candidacy.)

Nixon quickly sought to deflate the antiwar movement. Under the policy of "Vietnamization," with responsibility for the war's direction allegedly shifted to the South Vietnamese government, he began US troop withdrawals. At his instigation, Congress changed the selective service to a lottery system, and reduced the window during which young men were eligible to be drafted from seven years to one. Yet the aerial warfare over Indochina intensified and spread. And the swell of returning Vietnam veterans provided a new source of antiwar dynamism.

A nationally coordinated Moratorium Day against the war took place in October 1969. More protests reverberated across the land throughout that fall. At one rally on Boston Common, which Ted covered for *LIFE*, a more militant group of several hundred, carrying Viet Cong flags to chants of "Ho-Ho-Ho Chi Minh, the NLF [National Liberation Front] is going to win," broke off on a separate march. My father walked along with them, crossing the Charles River into Cambridge, all the way to Harvard Square, where the marchers sat down in the street, chanting, "The streets belong to the people! The streets belong to the people!" Dad found it all rather endearing, until he realized that a large contingent of Cambridge cops had materialized, and were closing ranks and tapping their clubs in the gathering dusk.

Pretty soon, a few demonstrators were smashing windows of the Harvard Coop and setting fires in trash cans. Ted had no doubt that some of these agitators were police or FBI infiltrators, deliberately inciting violence to discredit the peace movement. Others were really crazy kids, and some were high on weed. In any case, the cops now had their provocation, "and they attacked indiscriminately," my father recalled for the oral history project. "They attacked women, children, everybody. I mean, they pursued people. People were fleeing into cafeterias and stores nearby, and the cops would pursue them and beat them up inside."

To law enforcement in this theater of town-and-gown tensions, the young protesters represented affronts to religion and patriotism, lax morals, lack of respect. Ted could even identify a bit; youthful activists' contempt for straitlaced older specimens sometimes came his way, which amused rather than angered him. The brutality he now witnessed seemed a highly overwrought response.

Overcoming his amazement to focus on taking pictures, he felt a sudden blow. A cop had just swung a four-foot baton at him, cracking his camera lens and wrecking his electronic flash unit.

Ted produced his press credentials. The cop smiled, and directed another whack that sent the meddlesome photographer sprawling, cushioned only slightly by his thick jacket. My father's shoulder hurt for weeks after. "I guess he was very skilled, because he could have broken my shoulder, but he didn't," Ted told the oral history interviewer. "I just sort of quit right there."

At least a dozen other cameramen had been similarly roughed up, Ted learned, including a United Press photographer, who was calling his office when the cops pulled

him out of a phone booth, took off the precautionary helmet he was wearing, and hit him in the head. Despite plenty of reliable testimony, the media lodged no concerted complaints. When Ted reported the damage of his strobe and lens to *Time-LIFE* headquarters, he was told: "Have your insurance cover it. We assume you're carrying insurance." He was, but that wasn't the point.

"How do you ask a man to be the last man to die in Vietnam?" A former Navy lieutenant named John Kerry posed that question in the spring of 1971. "How do you ask a man to be the last man to die for a 'mistake'?"

Kerry—Yale alumnus, Purple Heart recipient, future US senator, presidential candidate, and secretary of state—was testifying to the Senate Foreign Relations Committee on behalf of Vietnam Veterans Against the War. The emergence of VVAW had lent new resolve and legitimacy to the peace movement. Founded by half a dozen vets who'd met at a demonstration in New York City in early 1967, the organization would grow to an estimated 25,000 to 30,000 members in all 50 states.

In late April 1971, more than a thousand Vietnam veterans, joined by Gold Star mothers of dead comrades, converged on Washington, D.C., for a week of actions against the war. The outpouring of opposition from the ranks of those who'd served overseas as cannon fodder, clad in their military-issue fatigues, seized the nation's attention.

Deftly adapting the language of battle, Kerry told senators that VVAW was determined to complete "one last mission—to search out and destroy the last vestige of this barbaric war, to pacify our own hearts, to conquer the hate and fear that have driven this country these last ten years and more."

The next day, more than 800 veterans threw medals, ribbons, discharge papers, and

John Kerry (second from left), future US senator and secretary of state, with Vietnam Veterans Against the War on Lexington Green, May 1971 (©Ted Polumbaum / Newseum collection).

other mementoes of the war they despised over a temporary fence erected at the steps of the US Capitol building.

The following month, VVAW mounted a spectacle designed to evoke Boston's revolutionary past. During Memorial Day weekend at the end of May, hundreds of veterans, many with plastic rifles slung over their shoulders, convened for a march that would trace Paul Revere's ride in reverse, from Concord to Lexington to Boston Common. On horseback, Paul Revere had alerted local militias that the Redcoats were coming. On foot, returnees from Vietnam were decrying the country's wasteful and immoral sacrifice.

My father fell in with the trek on the leg from Concord to Lexington, as soldiers and supporters passed through our in-between town of Lincoln. Dad remembered the event for both its gravity and its levity—seriously against the war, but also great fun. The weather was good, the companionship abundant, spirits high, participants engrossed in meaningful conversation. The tall John Kerry could not be missed, a reserved but charismatic leader, destined to go places. Unlike many of the VVAW riffraff, who looked like pot-smoking hippies in rumpled olive green, Kerry always appeared clean-cut. Even his fatigues were clean. "He seemed to have a great future; maybe he would run for president or at least senator," my father mused in his oral history interview.

Having camped out on national parkland in Concord the previous night, with appropriate clearance, the veterans intended to do the same on Lexington's Battle Green the second night. To everyone's outrage, the town's elected Board of Selectmen denied them permission. The vets proceeded to the Green anyway, where they threw down their toy guns, set up camp, and listened to speeches into the evening. The crowd ignored instructions to disperse. Then the arrests began.

It was all very cordial; protesters smiled as they were led to buses by exceedingly polite officers of the Lexington Police Department. The veterans availed themselves of the symbolic opportunity, putting their hands behind their heads like prisoners of war. Vets in wheelchairs were lifted and carried aboard. Locals who had stayed on in solidarity happily went along with the roundup. Times had changed; large segments of the most respectable sectors of society had turned against the war. Nobody resisted, nobody got rough.

My father figured he would stay and photograph for a while, and then get arrested, too. My mother had been arrested once, at a peace demonstration at Hanscom Air Force Base, which sat like a little foreign kingdom on the north edge of Lincoln. Ted had always escaped, with the excuse that he was recording the event at hand. This time, however, he wasn't on assignment. Around 3 in the morning, bleary-eyed, he thought, okay, he was ready. He and a dozen or so others who were still hanging around offered themselves up to the police. Who said, "No, go home, we've had enough." So Ted never did get arrested.

The total haul amounted to 458, the biggest mass arrest in Massachusetts history. Offenders were taken first to a public works facility for processing, then to Concord District Court. Later that morning, a judge fined them five dollars each. A VVAW bail fund and local donations covered the fines, and the veterans, some ferried by local residents in cars, made it to Boston by that afternoon.

Historians continue to debate whether the American Century ever existed. It was an "illusion," according to Cornell University's Walter LaFeber, a "myopic view" of our country's place in the world. It justified American "hyperpower," according to David M. Kennedy of Stanford University. It produced "unforeseen, unintended, and even perverse

consequences," writes Andrew Bacevich of Boston University, who edited a volume of essays on the topic.

Ted would agree with all that: The American Century was conjured from hubris and hypocrisy. But he'd probably say it existed, at least as a set of ideas that helped generate the Cold War consensus against Communism, sanctioned the growth and extension of US military might, bolstered faith in the superiority of American capitalism, and spread the gospel of mass consumerism worldwide.

He'd also say the American Century sowed the seeds of its own destruction, and he'd bid it good riddance. The 1950s were years of firm belief in the family, the country, and authority. The 1960s generated mistrust for all those institutions. The public's conviction that our government was great, that our leaders told the truth, and that our national causes were inevitably just was shaken, maybe permanently. Ultimately, the veil would drop from virtually every hallowed institution in American life—the military itself, the Church, the news media, even sports. My father would have commended all that.

Dad would have been dismayed, of course, at the conservative dismantling of the progressive impetus. He'd already recognized the onset of a backlash in the 1980s, as the country entered a period of reaction during the Reagan administration, but wouldn't live to see how far it went. I could only imagine how he might analyze the reactionary populist swell that culminated in the election of an autocratic narcissist as president in 2016, an election he was no longer around for. I know he would have been heartened, however, as right-wing extremism began to encounter renewed activism, incorporating youth and grass-roots resistance, even generating the sort of establishment political pushback that my father deemed a requisite for effective change. He would have cheered the emerging united front against the misogyny, xenophobia, and white supremacy personified in the White House. He'd be delighted that ideas once dismissed as "radical"—universal health coverage, wealth taxes, green energy, pot legalization, protection for immigrants, criminal justice reform—were issues of central concern to the Democrats vying for the 2020 presidential nomination.

Political oscillations notwithstanding, Ted felt confident that the cultural revolution of the 1960s had remade US society forever. "People changed the way they dressed, changed the way they ate, changed the way they smoked, changed the way they talked, changed their sexual habits. All this came about, I think, because of the disillusionment with authority," he observed for the oral history project. "I was brought up in Westchester County in the fifties [*sic—Ted's metaphorical dating; actually it was in the thirties*] to believe in the family and the government and our country and authority. And this changed."

My father was glad about all that, even if he and my mother remained somewhat prudish in their own personal proclivities. My parents viewed the broadening acceptance of varied lifestyles as a tremendous leap forward. So what if the celebration of difference was quickly co-opted by advertisers and marketers; this only proved that tolerance was going mainstream.

As Ted Polumbaum saw things, tolerance, along with liberty, equality, fairness, iconoclasm, dissidence, the right to rebel, and so forth, represented the best of America; and my father was quintessentially American in many ways. He saw America as a marvelous, albeit deeply flawed, tapestry of humanity—if not a melting pot, then a beautiful patchwork quilt. He relished America's variety. He believed in the promise of openness and

opportunity that, even during inhospitable times, continues to draw immigrants and refugees to this land.

Dad especially loved the Revolutionary War ambiance of the part of the country where we lived, not out of any affection for war itself, but for that history's galvanizing and democratizing dynamics—the mobilization of small farmers, the articulation of ringing ideals.

Of course, he also recognized the wealthy, white, male privilege behind the revolutionary impetus, the momentum for independence built on the subjugation of Native Americans and West Africans, the complicity with the slave trade that fueled global commerce between the colonies and Europe, the striving for freedom motivated largely by the desire to make money free from British hindrance.

He was taken as well with the sorrows and ambiguities of the uprising against the British Crown. On the approach to Concord's Old North Bridge, where we routinely brought houseguests, he'd always point out the grave of two fallen British soldiers, and the plaque inscribed with lines from US poet James Russell Lowell: "They came three thousand miles and died, to keep the past upon its throne."

My father was a patriot, no doubt about it. His patriotism had nothing to do with bigotry, chauvinism, superiority, or domination. His loyalties lay in conscience, and in willingness to go against conventional wisdom when conscience dictated. At the same time, people who subscribed to the ugliest strains of the American symphony, those who waved the flag in homage to militarism, racism, sectarianism, or exclusion, intrigued him. He did his utmost to understand what motivated them, and to see them as fellow human beings.

My mother had no patience for those flag-wavers, no interest in trying to fathom how narrow-minded, knee-jerk bigots got that way. Nyna sometimes said she could see herself moving to Canada, a more civilized place. She knew it was idle reverie. Ted was an American through and through, and would never leave.

22

Assignment: Conversion

Not at Harvard, they had said in deep-leather clubs and in book-lined studies, not at Harvard, it couldn't happen there.
—"Academic calm of centuries broken by a rampage,"
LIFE magazine, April 25, 1969

Even future leaders of the free world were defying authority. Students opposed to the escalating Vietnam War had tacked a list of demands on the door of Harvard President Nathan Pusey's home. Foremost was the call for Harvard to end the Reserve Officer Training Corps program. The next day, protesters occupied University Hall, the grand white granite administration building with the statue of John Harvard out front. They ejected deans and staff, chained the entryway shut from the inside, and debated into the evening about what to do next. Additional students and faculty gathered outside, and the protest expanded as word of the takeover spread.

For the first time in history, Harvard administrators invited city and state police onto campus. The cops were happy to handle these privileged children who didn't recognize how good they had it. Over a period of ten hours, two deans and the mayor of Cambridge issued warnings, including a five-minute countdown to the bust. Shortly before dawn, the increasingly impatient officers finally advanced across the hallowed greens, swinging batons and spraying Mace. One contingent cleared the steps of the occupied building, smashed the doors with a battering ram, and charged inside, while others dealt with supporters outside. What one observer called "a fast and violent action" took about twenty minutes.

Ted Polumbaum was there with cameras, Colin Leinster with notebook and pen, teamed up on assignment for *LIFE*. Born in the north of England, Colin had come to the United States in his mid–20s for travel and adventure, and ended up working for the magazine. He had just returned after two years of reporting from Saigon, where he'd dodged rockets and snipers and tried parachute jumping. He was a big fan of American military involvement in Vietnam. Peacenik Ted had tried to talk him around, to no avail.

In disbelief, onlookers watched the blue-helmeted state troopers and their Cambridge brethren on a tear, clubbing their way through the throngs, manhandling students, dragging captives off to waiting police wagons. Even those critical of the protesters were outraged at the intrusion. Close to 200 students, including women from Radcliffe and the graduate schools, were taken to jail and charged with criminal trespass; scores of students and a handful of officers were injured.

Amidst the havoc, Ted had lost track of Colin. He trained a long lens over the yard

Crowds, and a casualty, after state troopers and local police storm Harvard Yard to break up antiwar protests, April 1969 (©Ted Polumbaum / Newseum collection).

and panned across the remaining observers, who had fallen silent while a few downed students still writhed on the ground. The sun was about to rise.

Suddenly, the intrepid Brit appeared in his viewfinder. Blood trickled down Colin's forehead, and he was holding up a hand in a V sign. "Instant conversion," Ted called it.

Colin called the cops "brutal." He'd been slugged on the back of the head, knocked down, kicked, and hit some more, even as he protested that he was a reporter. A nightstick had split his forehead. Ted drove him to Cambridge City Hospital for six stitches. Then they returned to Harvard Yard to wrap up the reporting.

Later that morning, student activists called a three-day class stoppage. Posters around campus exhorted: "Strike because you hate cops. Strike because your roommate was clubbed. Strike to stop expansion. Strike to seize control of your life. Strike to become more human. Strike because there's no poetry in your lectures. Strike because they are trying to squeeze the life out of you." Thousands rallied in Harvard Stadium and extended the walkout for another three days. Six weeks later, a university disciplinary committee expelled a batch of students, put others on a kind of probation with deferred suspensions, and issued warnings to a hundred or so more.

The academic year was almost over; among the graduating seniors was future Vice President Al Gore, who had not taken part in the protests. Returning 25 years later as a commencement speaker, he said, "I left Harvard in 1969 disillusioned by what I saw happening in our country, and certain of only one thing about my future: I would never, ever go into politics."

23

Lost and Found

We shall not cease from exploration
And the end of all our exploring
Will be to arrive where we started
And know the place for the first time.
—T. S. Eliot, "Little Gidding"

For a few years, it was my turn to cause my parents a good deal of grief. The troubles began the summer after ninth grade. My sister was going to an arts camp, to study voice. For lack of other plans, my parents sent me to the same camp, where I did modern dance every day under the tutelage of a rangy, commanding, flamboyantly gay choreographer associated with the experimental performance crowd at Judson Church in Greenwich Village.

The camp was full of talented and assertive New York kids. Girls in my bunk had considerable breasts, wore lacy push-up bras, and talked about foregoing dessert for the sake of their figures. I simply stopped eating. Between studio lessons and rehearsals, often evading mealtimes, I would wriggle into an orange-and-pink striped cotton bikini swimsuit with a 32A underwire top that more than covered what little there was to obscure, swim laps in the pool to exhaustion, then sunbathe to excess, as was customary back then. When my parents arrived for visiting day, they were horrified to see my blue jeans sliding off my hips.

Once I was home, rounds of medical consultations began. I had something called *anorexia nervosa*, another syndrome nobody had heard of which, like autism, has since become a household term. When my parents looked into possible treatment at the area's fancy mental hospital, McLean, they were shocked to be told that I might have to stay for months. Instead, they checked me into a state mental health center in Boston's tough Mission Hill neighborhood. What they thought would be a shorter stay turned out to be even longer. I missed the second half of tenth grade and was hospitalized through that summer, although with "privileges" that allowed me to take far-ranging walks and make occasional visits home.

Group therapy and individual sessions were part of my treatment, but no revelations emerged about why I was doing this to myself. Nor do I know what brought me out of it. One late summer day in the street outside the hospital, as my mother was about to drive away, I told her through the car window that I'd be home soon. I was, and returned to school that autumn.

With my father's encouragement, I spent a good deal of my last two years of high school behind a camera and in the darkroom. I was editor of my senior yearbook. The

summer after graduation, I supervised three kids two days a week in exchange for a tiny suite off the family's townhouse on Beacon Hill, from where I would walk diagonally across Boston Common to my other job, clerking at an antiquarian bookshop. I saved up money into the fall, then embarked on a journey through Latin America, solo but seldom alone, usually among serendipitous company encountered along the way.

It was a journey of discovery: the discovery of myself. The experience tested my stamina and nerve and adaptability, and found them quite okay. It affirmed the likelihood that the tentative girl I was might someday grow into a free-standing adult. It validated what would become my maxim for living, that I should always attempt what I most feared.

It never occurred to me that my parents also were enduring severe testing. I was barely 18 when I took off. Kind people I met along my route marveled that parents would allow their daughter to travel haphazardly on her own. I'd explain that my parents had no say in the matter; I was no longer a minor and was using my own money. In any case, given their own feckless history of uprooting my sister and me from our blithe child-hoods to gallivant around the world, they could hardly have forbidden me.

Of course, my undertaking caused them great worry. They saw me as competent and resilient, but still a kid, only recently emerged from prolonged distress. Geographic distance and unwieldy communications probably protected all of us, since they learned about my weirdest adventures after considerable delay. Still, my journey was their jour-ney, too—of trepidation, imagined horrors, long waits for updates, and, in spite of them-selves, pride in my evident self-sufficiency. They warrant neither credit nor blame for my doings; nevertheless, my pluck, my choices, my recklessness, my resourcefulness, all reflected upon my mom and dad. Someday, I would find my way into my separate exis-tence; until then, we were living a shared story.

That story transpired as follows:

After six weeks of intensive Spanish language lessons in Cuernavaca, Mexico, I spent Christmas of 1971 in the lively market town of Oaxaca, lodging at the cheapest place I could find, a tiny windowless room off a beautiful courtyard with lush flower gardens and a parrot in a cage. The shower was a cold-water nozzle in another dark cell. During the day, I hung around with a friend from language studies, whose parents and sisters were visiting from Wyoming, and whose family temporarily adopted me.

Meeting a trio of gringos going south in a van, I was welcomed aboard, and we headed down the Pan American Highway and into the new year. At the entry to Gua-temala from Mexico, the border guards had a good thing going with the barbershop around the corner, where they sent the guys for haircuts before granting us visas. When we stopped for a meal in Managua, Nicaragua, the driver's briefcase got swiped from the locked van; we had to stay overnight, the time it took for the US Embassy to replace his passport. A year later, an earthquake would wreck the shabbily elegant downtown hotel where we slept.

I rode with the van crew as far as San José, Costa Rica. There, I ventured up a dor-mant volcano with three more Americans, two men and a woman. It soon emerged that they were making their way south on the revolving proceeds of a scam, claiming they'd lost their travelers checks and repeatedly getting replacements. Not wishing to bear wit-ness to the hocus pocus, I bid them adieu to make a detour across the Caribbean Sea.

A short plane ride later, I was on San Andrés Isla, an island free port belonging to Colombia, fringed by fine sand and brimming with coconut and banana palms. Its few streets were chockablock with duty-free shops selling Crest toothpaste and French

perfume, its tiny township populated by Black and mixed-race residents who spoke a musical Spanish-French-English creole. Learning I'd spent my first night on the beach, a maternal local woman put me up in the room her daughter had vacated. From there I sought boat passage to the Colombian mainland.

My parents knew approximately where I was, and occasionally sent me letters care of American Express offices (I was an honest user of travelers checks). Somehow, we had arranged that I would call them collect when I reached Bogotá, capital of Colombia.

Nearly a week elapsed beyond the time they expected to hear from me. Back in Lincoln, Massachusetts, looking across the breakfast table one morning, Nyna saw Ted blanching over the open *New York Times*. With home delivery unavailable in New England, the paper came by mail, usually a day late. In those pre-computer times of manual typesetting, when unanticipated blank spaces arose on pages being readied for the press, the "bus plunge" story was a common filler—a sentence or two about random deaths in some developing country that otherwise got no attention. My father had come across an item about a bus plunging off a mountain road in northern Colombia, quite possibly on my route.

Their panic rising, Ted and Nyna attempted to rouse the US State Department. They called DC for three days running, reaching a different "officer of the day" each time. Apparently, the individual on duty's main role was to deflect inquiries from unduly concerned citizens like my meddlesome parents, whose willful child undoubtedly had no desire to be found.

In fact, I was okay, merely delayed. The cargo ship on which I'd bought a berth from San Andrés Island to Cartagena, an ancient fortified city, had run out of gas in the middle of the Caribbean. Inexplicably, the captain's father, in charge of fueling, had neglected to fill up.

At the start of the voyage, I'd been sitting out in the open air chatting with the handful of other passengers, scoffing at warnings about seasickness. Within hours, I was crumpled on my narrow bunk behind the cockpit, my entire body churning, certain I was dying. I finally arose a day and a half later, around the time we were due at our destination. Instead, we were bobbing in mid-ocean, the engines quiet.

We were stranded at sea for five days, the generators occasionally turned on for brief periods, radio contact made with an airplane whose pilot, speaking English with an American accent, couldn't discern us through the cloud cover. The galley cook continued to serve rice and potatoes, and hot coffee with lots of milk and sugar, supplemented by fresh catch as we floated over dense schools of fish. Members of the crew had a pitched battle with a shark, which they ultimately pulled in, filleted, and dried on deck. At last, we got close enough to shore to chug into a small port for refueling. Next came a search for the local authority to sign us out, followed by an attempt to leave, aborted when our big vessel chopped through a line anchoring a small boat to the dock; then an even more frantic hunt for a frogman to dive under the keel and untangle rope from the ship's propeller. Finally, we powered through one more night to reach Cartagena.

It was dawn. The market was coming alive. Passengers were ushered off and told to come back in a bit for luggage; only now was it divulged that the ship, transporting oil barrels, was not authorized to transport us. I returned, and got sent away again; port officials evidently were searching the vessel for contraband TVs. Meandering into a gift shop that turned out to be owned by an American, who had come as a Peace Corps volunteer and stayed, I related my tale of woe. His shop assistant, a local woman around my age, helped me retrieve my canvas carryall, get to the long-distance terminal, and purchase my fare to Medellín, where I would buy another ticket to Bogotá.

Two long winding bus rides over treacherous mountain roads later, with stops at roadside stands in the middle of the night for *tinto*, highly sweetened coffee dosed with cinnamon and cloves and served in tiny cups, I arrived in the capital. In yet another example of the astonishing hospitality I encountered throughout my travels in Latin America, a sister and brother returning from Medellín to Bogotá on the same bus befriended me and took me to stay at their cramped apartment. My folks were much relieved to get my collect phone call; fortunately, they had not yet alerted Sen. Edward Kennedy's famously responsive constituent services.

Chile was now at the center of my parents' attentions. Ted first visited toward the end of 1970, to photograph the inauguration of President Salvador Allende for *The New York Times Magazine*. An otherwise obscure country suddenly was of interest to international media because Allende, a leftist physician and longtime politician, was Latin America's first avowed Marxist to attain a nation's highest office through democratic elections. In fact, Chile already was of interest to the Central Intelligence Agency, which would help wreak havoc there, leading to a military coup and nearly two decades of brutality and terror. But during the three years of Allende's presidency, my parents were drawn into documenting a movement to build a new society. This new system was to serve the interests of ordinary working people, from coal miners to peasants to shantytown dwellers. From his initial trip there, Ted felt compelled to go back.

In the spring of 1972, my father made his third visit to Chile, my mother following for her second. It would be my first, and the final stage of my South America expedition. Dad was changing planes in Lima, Peru, where I met him at the airport for the flight to Chile's capital, Santiago. I have no idea how we managed the logistics, long before e-mail and cell phones, but we did. In Santiago, we rented an apartment that was ready when my mother joined us.

Ted had revisited his long-ago Spanish lessons, the large softbound textbook from World War II Army Specialized Training finally proving useful. I proved even more useful, my recently acquired Spanish surpassing his rusty skills. Nyna's Spanish was negligible. For the next six weeks, I played primary interpreter as the three of us toured slums, farms, and factories.

Toward the end of our stay, I fell ill, leaving Dad to manage conversation on his own. The key turned out to be Chilean wine, which was cheap, very good, and as yet undiscovered up north. One evening, as I lay on a mattress in the apartment, wracked with fever and rattled with chills, I could hear Dad becoming increasingly fluent in Spanish, as he and Mom and Chilean friends followed up dinner and wine with hours of talk about politics, over more wine.

My mother got the name of a doctor, and we reported to his dark office, which was adorned with a crucifix and a gloomy portrait of Jesus. I described my symptoms. Without examining me, he said I had typhoid. Mom was skeptical. She sought a second opinion from a physician on call for an international trade meeting, surely more qualified. He ordered a blood test. Results showed the first doctor was not too far off: I had paratyphoid B. The second doctor prescribed pills, and within days my symptoms abated.

I was still on the prescription when we flew home. Our family doctor ordered an immediate halt, since the drug was known to damage red blood cells. Apparently good enough for Latin Americans, it had been banned in the United States.

24

Their September Eleventh

Make the economy scream....
—Richard Helms's handwritten notes from
declassified CIA document, "Meeting with
the president on Chile," September 15, 1970

The peaceful road to socialism. That was Dr. Salvador Allende's intent. My idealistic father was hopeful, but dubious, about the proposition. The problem lay not with those dreaming of social justice, who had chosen this Marxist physician and Socialist Party member as Chile's new president in the fall of 1970, but rather with those opposing threats to the status quo. Would the opposition eschew violence? Unlikely. Would the United States refrain from its longstanding support, via methods overt and covert, for the forces of reaction in Latin America? Highly improbable.

As Allende prepared to take office, even as the US government was conspiring to undermine Chilean democracy, most North Americans had little awareness of that long, narrow strip of a country, hemmed between the Andes to the east and the Pacific Ocean to the west. Few knew that Chile had produced two Nobel-winning poets, Gabriela Mistral and Pablo Neruda; that most of the world's copper came from multinational mining operations in Chile; that Daniel Defoe's novel *Robinson Crusoe* was inspired by a true story of a Scottish castaway on an island belonging to Chile; that the time Charles Darwin spent in Central Chile while exploring the world on the ship *Beagle* was crucial to his work on the origin of species. To the extent they might look southward, toward a region better associated with tyranny and tumult, few North Americans had any idea of Chile's long record of stable democracy and respect for constitutional procedure.

Allende had won the presidency on his fourth try, propelled by a coalition of leftist parties called the Popular Unity. He'd pledged to nationalize key industries, including the giant multinational copper mines, and to bring housing, jobs, education, and better lives to the poor. He'd won a plurality, not a majority, in the three-way race. The opposition could not be underestimated.

Ted's fears were realized almost immediately. Two weeks before the president-elect was to be sworn in, the chief of the armed forces, René Schneider, a constitutionalist, was assassinated. Thugs led by an ex-general, hoping to inspire a coup before Allende could assume office, had killed Schneider in a botched kidnapping attempt. The CIA had supplied money and weapons for the plot. My father arrived in Santiago in time to photograph the somber ranks of mourners lining the streets, among them Allende and the outgoing president, Eduardo Frei, a Christian Democrat, standing side by side as Schneider's funeral cortege passed.

The rogue general was jailed, Chile's Congress ratified Allende's victory, and the inauguration went forth. As the new head of state rode through cheering crowds, the atmosphere was ebullient, yet tense. Wearing the presidential sash, standing erect in an open car, Allende is nearly lost in Ted's emblematic photo of the inaugural parade. In the background, ecstatic onlookers mob the sidewalks and fill the windows and doorways, waving and saluting, the air awash with confetti. In the foreground are three layers of nervous protectors—a cordon of uniformed national police, the Carabineros; plainclothes officers from the widely disliked Investigaciones bureau; and on the outside, a line of young men in business attire, their handsome faces grimly vigilant. This last line of defense consists of members of Chile's Revolutionary Leftist Movement, or MIR, the most militant component of the Popular Unity coalition, beyond the Communists, Socialists, Radicals, Social Democrats, and other conventional left and left-liberal parties. MIR stalwarts served as Allende's self-appointed personal bodyguards because they didn't trust the others.

On that first visit, Ted consciously looked for contrasts, promises of peace and civility juxtaposed with menacing representations of state power. In one photo, two small children peer around a uniformed torso, the officer's utility belt equipped with a long nightstick. In another, an armed policeman stands sentry during Allende's inaugural address, against the gorgeous backdrop of a mural depicting oversized faces and hands and flowers. The art is the work of the Ramona Parra brigade, named after a young protester shot to death during a general strike in the 1940s. The mural painters, enthusiastic propagandists for the Popular Unity, would race along walls under cover of night, a vanguard making a first pass with bold black outlines, others following to fill in the colors.

Cordons of protection at the inaugural parade of Chile's new president, Salvador Allende, Santiago, November 1970 (©Ted Polumbaum / Newseum collection).

On this trip and subsequent ones, Ted sought out grassroots leaders and ordinary people trying to build better lives for themselves and their communities. In the slums that ringed the cities, he photographed new construction replacing hovels; in urban factories, workers meeting around conference tables to run newly nationalized enterprises; in the countryside, peasants laboring on cooperative farms; at coal pits, miners putting in a day of voluntary labor in support for their government of the people. My parents gathered a range of perspectives on prospects for this new regime, from old-school Communist Party confidence and cautious labor movement faith to wary MIR skepticism.

As the US-backed vise tightened, they encountered growing disillusionment among people of moderate means, many frantically stockpiling toilet paper. Resistance from small business owners spread; truck drivers bankrolled by the CIA impeded flows of basic goods. In a period of raucous press freedom, Allende never stooped to suppress opposition voices; powerful right-wing media persisted in sounding the drumbeat for elites determined to recover their privileges. Throughout, Ted never set aside his worries that the whole thing could come apart.

In the end, sadly, the MIR proved to have made the most accurate political analysis: Allende's most radical adherents never quite believed that plans for peaceful transition could work. Chile's aristocracy would never give up without a fight. The middle classes were fickle. And the political and economic priorities of the much greater power to the north remained clear. The US government would do its utmost to cripple the new government with an economic blockade, denying aid for civilian pursuits while continuing to funnel assistance to the military. The CIA would maintain its surreptitious channels to foment disruption.

This prognosis might have seemed like a feverish conspiracy rant, but all these things turned out to be true—aired in US Congressional hearings, disclosed in hundreds of thousands of pages of declassified documents, now baldly admitted on the CIA's own website. Attempts to deny Allende the presidency, and to throw the country into turmoil when those plans were foiled, had been approved at the highest levels of the US government, by President Richard Nixon and Secretary of State Henry Kissinger themselves.

With such robust American complicity, the grand social experiment ended with a military takeover in the fall of 1973—on September 11, to be precise. That date thus signified tragedy for Chile decades before the United States would claim it as our own marker of heartbreak.

As the Chilean air force bombed the presidential palace, Allende delivered one last address to the nation, then shot himself. General Augusto Pinochet assumed power, suspending constitutional procedures and safeguards. For weeks afterwards, the military rounded up Allende supporters, alleged subversives, working people, students, intellectuals, government functionaries, anyone in the wrong place at the wrong time. Those detained were corralled in sports stadiums, sent to concentration camps, tortured, executed, made to disappear. The bodies of two young American men who'd been working and studying in Chile turned up in morgues, the US Embassy thoroughly recalcitrant about finding them or helping their families—later the topic of the movie *Missing*, starring Jack Lemmon and Sissy Spacek.

For months, stretching to years, the state-sponsored violence continued. It found its way to Washington, D.C., where a Chilean agent planted a car bomb that killed exiled Chilean diplomat Orlando Letelier and a US colleague, Ronni Moffett. Nationalized companies were returned to their former owners, confiscated estates to their former

landlords. The copper mines remained state-owned, the multinationals placated with large compensation packages. Chile became a US darling: largesse toward the military more bountiful than ever, economic assistance that had been withheld for three years now flowing as well.

My father's fascination with Chile, germinated by that initial trip on behalf of *The New York Times Magazine*, had evolved into an extended odyssey, one which drew in my mother, then me, and later my brother, whose Spanish was the best of all.

Before the coup, Ted and Nyna were hoping to publish a book. With prototype in hand, Nyna found herself welcomed into New York City's major publishing houses, where top editors fawned over the pictures. Unfortunately, they determined that the volume my parents envisioned wouldn't pay for the paper it was printed on; nobody cared about Chile. After the coup, publishers were more interested, but now many of the people in my father's photographs were in danger. Chile's main establishment newspaper, the rabidly reactionary *El Mercurio*, had cheered the putsch with immediate publication of a front-page "Find and Detain" poster of wanted Popular Unity leaders. My parents feared that a photographic guide to the movement would similarly be used to assist arrest, torture, and murder. The project was on hold.

Only after General Pinochet lost a plebiscite in 1988, resulting in the restoration of democratic elections, did Ted and Nyna return twice more to explore the aftermath of seventeen years of military dictatorship. Their prolonged venture at last culminated in a visually stunning, poignantly written, excruciatingly sorrowful book, *Today Is Not Like Yesterday: A Chilean Journey*, self-published in 1992, with Ted's photos and Nyna's text.

In the interim, my parents hosted a continuous stream of Chileans in exile, most in

Ian (center), Ted and Nyna's youngest, serving as interpreter in late 1989, when restored democratic elections are in full swing in Santiago (© Ted Polumbaum / Newseum collection).

limbo while seeking political asylum or more stable status elsewhere. I remember best the two who stayed the longest, for several months—avuncular Mario Planet, head of the journalism school at the University of Chile, who'd been exceedingly helpful to my dad; and dashing Leonardo Díaz, long-limbed, tousle-haired, whose father had been Allende's ambassador to Canada. Leonardo spoke perfect English with the slightest Latin inflection; he was the perfect gentleman as well, although to me quite the heartthrob—he was in his 30s, I was 20. Mario, a stocky, smiling man, spoke excellent English also, with more of an accent. He eventually returned to Chile. We lost track of Leonardo.

Another favorite visitor was Federico García, a droll, dreamy, prematurely gray philosopher who'd grown up in Tierra del Fuego, the fragmented southern tail of the country that points toward Antarctica. He and his wife, Cynthia, had been in hiding with their infant daughter, preoccupied with keeping the baby from crying. Boston University helped them out by giving Federico a fellowship in theology. The family later moved to Costa Rica, and then to Mexico.

Ted pitched a story to *People* magazine about a young American woman yearning for her Chilean lover, waiting with their toddler in the US while he was confined in a Santiago detention camp. René Castro, a small, wiry artist whom my parents had come to know well in Chile, would send letters out of the camp festooned with drawings. The text accompanying my father's photos in *People* identified the pining "Yankee lass" as the artist's wife; the editors later were miffed at Ted for not mentioning that the couple wasn't formally married. After his release, René made it to Boston, where he surprised our friend Federico—the two had known each other in Chile, and Federico thought René was dead. The artist joined a vibrant Latino arts scene in San Francisco, gaining renown as founder of a design workshop and creator of powerful political work, including community murals.

As for all those beautiful photographs from the early 1970s, Dad donated images for posters, album covers, note cards, and other informational and fundraising uses. My parents gave slide shows about Allende's Chile and the coup, and turned the presentation into a film. In solidarity with the people of Chile, my mother masterminded the creation of a large plywood mural on Boston Common.

Then as now, Canada took in political outcasts more readily than the US. At McGill University in Montreal, where I'd just begun my sophomore year when the coup occurred, students helped welcome refugees from Chile. We held a big Chile solidarity day. My friend Laura Fox cooked chicken wings for hundreds of people.

In the summer of 2001, barely half a year since my father's death, I accompanied my mother on a nostalgic return to Chile. It was ski season in the Southern hemisphere, and we shared a Santiago hotel breakfast room with foreign tourists toting alpine gear, headed for the Andes.

Corpses no longer surfaced in the Mapocho River; people no longer vanished in the night; elections were held with regularity, and the judicial system was operating. But the reckoning with the wreckage of the dictatorship was still underway.

Pinochet was back in the news. He'd expected to remain immune from prosecution, until British police detained him in a London medical clinic on a warrant from a Spanish court. The general finally had been extradited back to Chile, where courts stripped him of his immunity, but accepted his defense that he was too demented to stand trial. He would hang on several more years, dying at Santiago's military hospital in 2006. The general's sequestration in London had given rise to a semi-satirical tabloid titled (in English)

The Clinic, started as a lark by a group of young people in Santiago, hugely popular by the time Mom and I went back. Published twice weekly, it had a circulation of 40,000, with a much larger pass-on readership.

In their book, my parents had picked up trails of friends from the Allende period and tracked their experiences and fates—prison, exile, a few murdered by the military. Nyna and I now sought out a few we could locate.

We had a joyous reunion with one friend from a shantytown, Cecilia Bernál, who'd gone to Canada after the coup. Missing her homeland terribly, she'd left behind her husband, along with the comfort and benefits accorded those granted refuge in Canada, to return to relative penury in Chile. She now ran a refreshment and sundries shop on a plaza outside Santiago's main railway station.

On a day trip to the seaside city of Valparaíso, south of the capital, we visited another friend, Frida Agosín, still elegant in her late years, whose late husband Manuel had been the rare man of wealth resolutely supportive of Allende.

We also met with journalist Patricia Verdugo, at her home in a wooded Santiago neighborhood. Her father, a mild-mannered union officer with no political ambitions, had been abducted and murdered in 1976. As opposition to the dictatorship grew, she'd begun to investigate human rights abuses, and published a succession of books. The most influential documented what became known as the "Caravan of Death," describing a spree of extrajudicial killings overseen by a team of military officers from the central command, led by a Pinochet special envoy. Traveling in a Puma helicopter that touched down in five Chilean cities five weeks after the coup, the expedition left 75 summary executions in its wake.

Among much else, the coup destroyed a vibrant cultural scene that had blossomed to celebrate the aspirations of Chile's commoners. The Andean musical group Inti-Illimani, known for its rousing Popular Unity anthems and bewitching folkloric arrangements, was on a European tour when the military seized power. That trip turned into a seventeen-year absence.

They were home, and performing at a theater in Santiago. We got tickets.

The beloved ensemble offered many old favorites, leavened by strains of jazz and world music picked up during those long years abroad. It was an especially rousing and poignant occasion; Inti's longtime musical director had announced his retirement, and old friends took to the stage for the sendoff. The audience coaxed three encores from the group.

After midnight, as the concert was winding down, spectators began chanting the mantra of Allende's Popular Unity coalition: "*El pueblo unido jamás será vencido!*" (The people united will never be defeated!) They wanted to hear the period's most politically charged song.

The musicians did not comply, making it clear that, despite the long shadows history still cast upon the present, they did not dwell in the past.

25

Assignment:
Finding Armando

Tyranny cuts off the singer's head,
but the voice from the bottom of the well
returns to the secret springs of the earth
and rises out of nowhere through the mouths of the people.
—Pablo Neruda, translation by Alistair Reid

The Mapuches are descendants of the Araucanos, the only indigenous population whose fierce resistance against the Spanish Crown lasted centuries. Ultimately decimated, enslaved in gold mines, herded onto reserves and driven into subsistence farming, the Mapuches became the downtrodden of Chile. Concentrated in Cautín province, some 400 miles south of Santiago, they were the poorest and most impatient of the Chilean

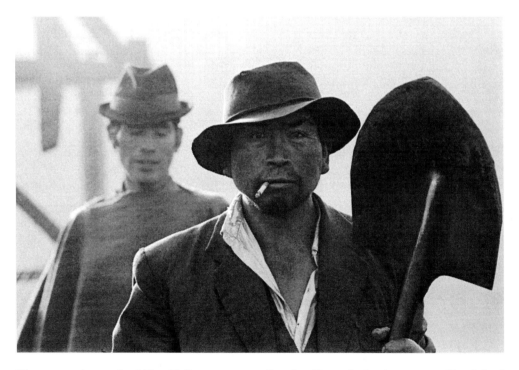

The young Armando Ailio, Chilean peasant of native Mapuche heritage, on collectivized estate, Temuco area, 1971 (©Ted Polumbaum / Newseum collection).

peasantry. Many were tenant farmworkers. Emboldened by the election of Allende, who had pledged to redistribute land, they began to take over landed estates without waiting for official niceties.

Mom was visiting Chile for the first time, accompanying Dad on his second visit, in 1971. A local fellow in Temuco, provincial capital of Cautín, offered to escort them to one of these *tomas*, or seized properties (from the Spanish *tomar*, to take). When they disembarked from a bus at the shore of the broad Imperial River, the guide shouted and waved and jumped until a small skinny boy in a boat appeared, coming toward them in the water. The farm, called Rucalán, was on the opposite side.

Peasants received them at the gate, where rough letters painted on a board read, in Spanish, "Mapuches: Recover your usurped land." Laborers initially had taken over the estate with the help of a revolutionary rural organization. Two months later, on Christmas Eve, the former owners led a counterattack, pouring bullets from the hillsides for hours, wounding two men, and forcing women and children to flee in the dark. Their efforts were foiled, however, when the Allende government formally expropriated the land and turned it over to the farmers to work collectively.

A young Mapuche man awaiting his work assignment caught Ted's attention. His name was Armando Ailio. A cigarette dangled from the corner of his mouth, and a floppy broad hat shaded a smooth, broad face tapering to a valentine chin. He held a spade, almost regally, blade up. The shape of the blade and the shape of the face were inverted versions of each other. After the coup, this striking image would end up on Chile solidarity posters and a record jacket.

Ted and Nyna returned to the area in 1991, learned that Armando was still alive, and

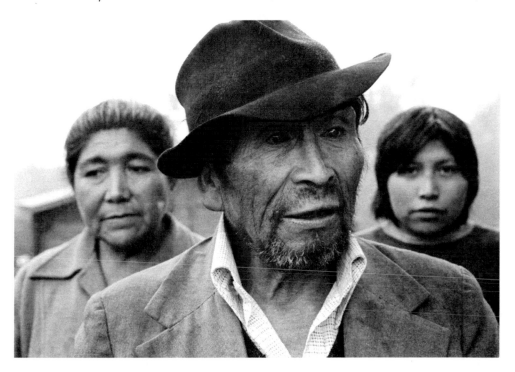

The older Armando, two decades later, again a landless farmworker, Temuco, 1991 (©Ted Polumbaum / Newseum collection).

found their way to his house, where one of his daughters recognized the photographs they had brought of her younger father. He soon returned from working on a farm some distance away. His face was now craggy and lined, his cheeks bewhiskered.

After the coup, large landowners and military officers had celebrated Allende's death, and Rucalán's old proprietors, accompanied by police, retook the farm. Armando went to prison for six years; his family survived by begging. Now, once again, they were renting and laboring on others' farms. For them, the return to democracy had yet to bring improvements. "They won," said Armando, "and we lost."

26

Varieties of Departure

There is a time for departure, even when there is no certain place to go.
—Tennessee Williams, Lord Byron's monologue in *Camino Real*

I was almost 10, my sister 13, when Mom and Dad sat us down to convey sad news: Uncle Bobby, Ted's younger brother, had fallen ill and died unexpectedly.

A decade later, when I was home on a college break, enjoying routine familial chit-chat in my parents' living room, my mother made reference to "Bobby's suicide."

I rose to object: What was she talking about? Bobby had died of a sudden illness.

"Didn't we ever tell you?" my mother said.

No, they never had.

Every family has its secrets, but this one seems to have been inadvertent: Protecting our young sensibilities turned into forgetting to tell us the truth once we could take it.

The record remained clouded, in any case. Before Ted even learned of his brother's death, via elder sister Peggy, their father Phil had gotten the body cremated. No funeral was held. No explanation was forthcoming.

My parents knew Bobby was sensitive. As the youngest of Phil and Minnie Polumbaum's children, the one still at home while their mother lay dying, his sister at college, his brother off to war, Bobby had long struggled to distance himself from their overbearing father. But he seemed to be finding his way. He'd finished medical school and was doing a residency in Philadelphia, working with troubled children. He'd married a nurse, Harriet, whom I recall as dainty and indifferent. My parents disliked her, but if Bobby loved her, so be it.

Theories floated among the relatives: depression, alienation, conjugal difficulties. According to my mother, Bobby's supervisor at the children's center had criticized him as too emotionally wrought over his young patients' tribulations. A cousin said there were marital problems. Another cousin recalled that, as a medical student, Bobby often showed up at their place on weekends and vacations, avoiding his own father and stepmother. Word had it that Peggy's husband Gerry had interrupted an earlier suicide attempt.

I finally sent off for the death certificate. Bobby was 34 when he killed himself. The cause of death, as certified by the Pennsylvania medical examiner on April 2, 1963, was acute barbiturate poisoning. Pills a physician easily obtained.

Sweet, affectionate Bobby had been the quiet uncle. Ted's brother-in-law Gerry was the garrulous, riotous one. As a big man on campus at the University of Michigan, varsity tennis player, radical agitator, warm and spontaneous, he'd swept the demure, well-mannered Peggy off her feet. Their improbable marriage produced my first cousins,

two daughters possessed of their mother's poise and their father's liveliness, whose fashionable hand-me-downs clothed my sister and me for many years. To me, these older Schaflander girls, with hair just so, makeup on their dressing tables, and pictures of teen boy idols on their bedroom walls in their Queens apartment, represented distant paragons of female adolescence.

In that family, Aunt Peggy held the fort as an employee of Ma Bell. With long-distance calls costly then, she dialed up Ted about once a month to talk for free. We never knew quite what Uncle Gerry was up to—usually on the order of running a political campaign that would change the world, subverting the minds of college students with his sociology courses, organizing in poor neighborhoods. Whatever the current cause, he was charming, brilliant, and utterly persuasive, a magnificent orator, purveyor of important knowledge whose authoritative sources he cited chapter and verse.

Yet intimations surfaced of troubles beneath—something about Phil paying unspecified fines on Gerry's behalf, tales of missed payments and bad checks. Ultimately, the disturbances of Gerry's disordered mind became impossible to ignore.

My parents got their first glimpse of Gerry's manic tendencies early on. He had spent World War II in the Army Air Corps, finishing at the rank of lieutenant with a comfortable office assignment in Florida. He and Peggy then moved to Pennsylvania, where he worked for the Progressive Party and Henry Wallace's 1948 presidential campaign. Ted and Nyna landed in the same state, my father writing for the daily newspaper in York, Pennsylvania. Gerry showed up at their apartment one night in a panic, saying his enemies were after him, displaying a dent in the roof of his car as proof. Fond as they were of Gerry, my parents found his story implausible.

Phil had always loathed Gerry's political views, staying mum about all the rest. But even my admiring father gradually grew resistant to Gerry's magnetism. On the eve of Ted's appearance before HUAC, Peggy asked him to check Gerry into a private psychiatric facility in Connecticut. As far as we know, that was his only spell of treatment. For the most part, Peggy was stoic. Eventually, the rollercoaster of a marriage ended in divorce.

Meanwhile, Gerry's frenzies generated a succession of grand schemes that came to naught, or worse. He once trumpeted a plan to manufacture benign cigarettes, the tobacco replaced by lettuce leaves. Ted was still a smoker; declining an invitation to invest, he tried a sample and found it disgusting. Decades later, Gerry coaxed loans from hundreds of people in exchange for stock in an alternative energy company. Millions of dollars went into his main project, a solar array in the Arizona desert that purportedly yielded nonpolluting hydrogen fuel to power converted automobiles. His efforts inspired an adulatory report in *The Nation* magazine, and suspicion on the part of the FBI and the US Postal Service. Tried and convicted of mail fraud in 1982, Gerry served four years in prison.

While dodging the get-rich offers and discounting the tales of persecution, Ted nevertheless endeavored to stay on good terms with his brother-in-law. From my perspective, Uncle Gerry was always loads of fun—until he wasn't. On his last visit to us that I remember, he and Ted played tennis on the Lincoln town courts, while I climbed a mighty pine tree just outside the fence, and shouted gleeful greetings to them from my high perch. I was probably in junior high, happy and proud about my tomboyish daring. Afterwards, fuming, my uncle accused me of deliberately distracting him to make him lose the match. My father was unable to persuade him of my innocence. Gerry then accused Ted of complicity.

Gerry moved out West, remarried, and died in California in 1996 at age 76.

Five years on, also at 76, my father died.

As Ted was declining, so was his sister Peggy. She died two months after Ted, closing the sibling circle.

Bobby was long departed. In one of those perversions of natural order, the youngest had gone first, the eldest last.

Where death seems arbitrary, Mao Zedong offers a measure of assessment. In his famous eulogy for Dr. Norman Bethune, he called for learning from the doctor's spirit of selflessness and internationalism. Bethune, a Canadian physician who developed mobile medical services for the Republican side in the Spanish Civil War, then took his system of portable surgery and blood transfusion units to assist the Communist forces in China's resistance against Japan, contracted blood poisoning while operating on Chinese soldiers, dying in Hebei Province in November 1939. Paying tribute to the weight of Bethune's legacy, Chairman Mao quoted Han Dynasty historian Sima Qian: "Though death befalls all men alike, it may be heavy as Mount Tai or light as a feather."

This adage comes to mind when I reflect on what I know of the departures of two grandfathers—my mother's father, Lazer, whom I hardly knew because he wasn't there, and my father's father, Phil, whom I hardly knew because he didn't care. As a statement on their lives, and on the manner of their deaths, the contrast between heavy and light is apropos.

My mother loved Lazer in a deep and visceral way. She also loved her stepfather, Murray, but rationally, by way of appreciation more than instinct. My father saw Lazer as the antidote to his own patrilineage—warm, funny, giving, the opposite of the chilly and imperious Phil in nearly every respect.

Even Ted's younger brother, Bobby, viewed Lazer as far superior to Phil. As the third child, left behind when Peggy defected with her iconoclastic husband and Ted went off to college and war, Bobby had tried to resist the patriarch in his own gentle way. Heading to medical school, he managed to infuriate Phil by spurning an institution his father had blessed with a large donation, attending a less prestigious place instead. Far from becoming a high-powered doctor to the stars, Bobby was counseling disturbed kids.

Herein, perhaps, lie clues to some of the psychic torment behind Bobby's suicide. "If I'd had a father like that," he once told Ted and Nyna, in reference to Lazer, "my life would have been so different."

Ultimately, Lazer's life and death sustained the weight of mountains, while Phil's life and death floated away like a feather. One might say that Lazer died in living color, suffused by an otherworldly glow, never entirely disappearing, while Phil died in mottled black and white, fading to gray, then to nothingness.

I was a toddler when Lazer died. I have only a shadow of a memory of him, possibly a mere artifact of photographs. But my parents spoke of him so often, and so effusively, that his adroit, goofy, passionate personality was richly impressed upon my mind.

My mom had no animus about her parents splitting up before she got to high school; much as she cherished them both, she knew Ruth Amdur and Lazer Israel were somewhat mismatched.

In days when men wore fedoras over slicked hair, Lazer let his springy red-gold crop grow longer than was considered proper, and went hatless. Along with linen sports shirts he made for himself out of Macy's upholstery fabric, he further defied fashion by wearing shorts, cut down from old trousers and finished with natty cuffs. With little formal

education, he nevertheless was steeped in classical music, literature, and the joys of the Yiddish vernacular. He turned heads by singing arias aloud on the streets of Manhattan. One day, when schools were closed after an ice storm, he laced up skates and took little Nyna gliding over the sidewalk, all the way to the public library.

The carefree Lazer believed in enjoying life and not worrying about tomorrow. An accomplished cloakmaker, he never had difficulty getting a job, and never remained at any workplace more than a season or two. Seeking a change of scene, he would leave one shop floor bereft of his songs, stories, revolutionary rhetoric, and hilarious imitations of the bosses, to bestow his entertaining repertoire on the next group of factory comrades.

Ruth was the responsible one, forthright and plucky, but far better behaved. She longed for a bit of security, and found a much more predictable partner in Morris Zweiban. Thanks to transcontinental air travel, Ruthy and Murray remained the closest of all our relations. In 1960, considerably ahead of the retirement surge, they left Brooklyn for the southwest, the dry heat easier on Murray's bad back. Through the decades, they managed apartment buildings in Tucson, Arizona. Both are buried there.

Had he lived longer, Lazer surely would have been prominent in our lives as well. I was 3, my sister 6, when he visited us for the last time, climbing a wooded hill, with some effort, to view the newly laid foundation of our house in Lincoln, Massachusetts.

As my mother tells it, her father treated the approach of death as a kind of mirthful challenge. Although his marriage to Jean had slowed him down slightly, he still sang and danced, clowned around, and played the mandolin, until he became very ill. As when Ted's mother Minnie lay on her deathbed a decade earlier, the word "cancer" was never mentioned. It took him some months to expire, in a veteran's hospital in New York City. When a rabbi arrived to offer spiritual sustenance, Lazer instead engaged his visitor in debate. Proudly, he could report to Nyna that he'd resisted the temptation of a deathbed conversion. He died at 62, a scrappy, irreverent atheist to the end.

My mother, his only child, forevermore felt his vivid presence. She never grieved, she told me, because he'd led such a full life and brought joy to so many.

For the elders on my father's side, the grim reaper came in properly bleak guise. I was in high school when Phil's second wife, Mildred, had an accident involving an electric shaver and bathwater. She soon developed dementia. By then, Ted's father and stepmother had moved from West End Avenue in Manhattan to Long Island. On the only visit I recall to that smaller, gloomy apartment, its pastel walls dimly lit with chandeliers, Mildred tried to scratch out my little brother Ian's eyes.

Retired from the tobacco company he had served for 40 years, with a five-year pension, amid rumors of a parting quarrel whose details he never divulged, Phil still had plenty of wealth in investments. When it came to our wing of the family, he was as tight-fisted as ever: His greatest largesse, if he saw us around the holidays or a birthday, might be to slip my sister or me a ten-dollar bill. For Mildred, though, he sought the best doctors, hired attendants, and exhausted what had once been a fortune. When she died in 1971, at age 74, he had little left.

In an improbable act of charity, Phil's African American maid took him in. Mary had worked for Phil and Mildred for years, shifting her commute when they left Manhattan for Long Island. She lived in Queens with her boyfriend. She continued to call Phil "Boss." She sheltered him for two years, until one night when friends were over, playing cards and drinking, and Phil emerged in his pajamas to demand that the guests clear out. After that scene, Mary told him he would have to leave.

Phil decamped to a boarding house, taking one room equipped with a hotplate, also in Queens. Daughter Peggy visited frequently, son Ted occasionally. On a November day in 1974, having agreed to go into an assisted living facility, the diminished potentate headed to the post office to fill out a change-of-address form. On the post office steps, he had a fatal stroke. He was 83.

The rich man died a pauper, with something like six hundred dollars in the bank. Ted told Peggy to take any money; he'd take the cremains. He and Ian scattered them behind the house in Lincoln, in the scrubby oak woods at the bottom of the hill. When I asked my father how it felt to dump those ashes and chunks of bone among downed branches and dead leaves, he said he didn't feel sad—didn't feel anything, as a matter of fact.

27

Wanderings
and Wonderings

Sit at home, and you won't tear your shoes.
—Timeworn proverb, *A Treasury of Jewish Folklore*

There comes a tipping point in the shared lives of parents and progeny, when the axis of the relationship shifts. I have felt this happen with my own sons, as their stories disentangle from mine. In time, they come to thoroughly claim their own narratives, quite separate from mine, known to me only in glimpses they wish to divulge. And whenever I reenter their lives in real time, I am the guest. They are the hosts, giving me the gifts of themselves that I once fancied I possessed.

Ted and Nyna might have felt the separation, too, but as the daughter disentangling from their ambit, I recognize this recalibration of our connection only in retrospect. The process occurred mainly during the 1980s, into the 1990s. I had gone off to China to teach, fallen in love with a Chinese man, returned with him to start a family on the West Coast, and taken a teaching post in the Midwest.

With a ten-year delay, something analogous took place with my brother Ian, who repurposed his skills as a newspaper reporter to become a prosecutor, handling heinous cases of domestic abuse, sexual assault, and murder with brilliance and rectitude. He married a woman from India, and they started their family in close proximity to our parents—upstairs in the very house in Cambridge where my parents moved when I struck out for China, the house where Ian lived during high school.

Those were the same years my father's livelihood receded from photojournalism to depend largely on commercial work, typically illustrations for glossy annual reports. Dad called this "corporate propaganda," and approached these shoots in a detached, focused manner, as if playing a superficially serious game—capturing elaborately lit laboratory simulations, shiny machines on gussied-up factory floors, scripted non-events, and countless executive portraits. He relished the opportunity to see new parts of the US and the world, and grew fond of the enterprising young assistants he hired to haul equipment and set up lights. Several consider him a valued mentor in life, quite apart from anything they learned about photography. Most important, corporate America's vastly inflated payscale supported Ted's personal documentary projects, as well as additional travel, sometimes purely for enjoyment.

From the start, as a freelancer needing to support a household, Ted took jobs from business clients along with the photojournalism work he preferred. Essentially public relations, these jobs sometimes enabled a kind of artfulness he avoided with news and

documentary work. When Massachusetts General Hospital hired him to help mark its 150th anniversary in 1961, the results were exhibited at the deCordova Museum in Lincoln, where he'd won that contest a decade before that helped launch his career.

In the late 1960s, between magazine assignments, Ted started working with an art director named Sid Herman. Sid contracted with companies to design annual reports, and needed pictures. "I was looking for graphic images," Sid recalled. "Ted was looking for information, content, and I think it was a good melding." They got along well, became good friends, and would work together through the 1980s.

Clients included United Shoe, Polaroid, and Kendall Corp., manufacturer of textiles for industrial and medical use. A big one was Raytheon. Even as Dad decried the military-industrial complex, and its criminal role in the Vietnam War, he was helping to make Raytheon look good to its stockholders. Ted would tell Sid, "Look, you're working for multinational corporations, and they're making bombs," and Sid would tell Ted, "You're shooting the picture," and Ted would comply. The subject might be missile guidance systems, radar jamming systems, or microwave ovens. Once, they arrived at Los Alamos, only to learn they needed some sort of security clearance. It didn't come through.

In 1971, a job took Sid and Ted to England. In London, my father insisted on going to Karl Marx's grave. He photographed Sid beside the tombstone, Marx's massive head atop a pedestal inscribed with WORKERS OF ALL LANDS UNITE, and had Sid do the same for him.

Another time, in Zurich, someone told them they had to try a traditional Swiss restaurant. Ted and Sid both were tall and lanky, but evidently only my dad had the hollow leg. "You know your father loved to eat," Sid recalled. "He would sit there and eat and eat." The Zurich establishment proffered course after course, including a fish cooked right at the table, "and finally you're eating the fish and food is coming out of your ears and now they're going to bring the main course," Sid said. "Ted was happy."

By the late 1980s, as desktop publishing emerged, and simpler financial reports replaced glitzy annual brochures, less work went to independent art agencies. Sid downsized to an office over his garage. Dad continued to drum up business on his own, and sometimes through an agent working on commission.

One of his last big annual report packages was for an Arizona bank. The assistant who accompanied him to Tucson—also a chance to visit my grandparents, Ruthy and Murray—remembers the trip well. "We really had a blast," he recalled. "We went out to Saguaro National Monument to get the desert ambiance, and discovered Ted was really good at left and right, and I was really good at north and south; I could figure out directions, and he was good about knowing where to turn." He remembers Ted well, too: "He had such a goofy sense of humor. He was playful and funny. He loved to laugh."

Sid's former partner, John Lees, introduced Ted to one of his odder jobs. John had a rugby friend named Billy—William Koch, twin of the late David Koch. Their oldest brother was Frederick, a collector and anglophile; the next oldest was Charles, chairman and CEO of Koch Industries. This was before Charles and David, right-wing libertarians, became widely known as the politically influential Koch brothers. Few had heard of their far-flung, privately held company.

Billy Koch was a bit of a gadfly: yachtsman, aficionado of marine memorabilia, wine connoisseur, ladies' man. In concert with Frederick, he'd later sue the other brothers and leave the family company with a settlement. Before the falling-out, Billy aspired to document the company's expansive holdings—mammoth gas and oil refineries, picturesque

sheep and horse ranches—and create a fabulous coffee-table book. On his buddy's refer-
ral, he sent Ted all over the place. The last stop was Wichita, Kansas, to photograph exec-
utives at company headquarters. This was the first Charles heard of the plan. The boss
put the kibosh on the whole thing. Billy loved my father's work, and never returned most
of the lush color transparencies; but we do have the images of a cowboy in a pink shirt,
amidst a swirl of horses on a Wyoming ranch.

My father was hyperaware of his service to corporate America, and happy to dis-
cuss it with friends who accused him of hypocrisy and selling out. The accusations never
seemed to wound him. Yes, he was taking money from the dark side. But he was recy-
cling it for better causes. I think that was his view. He was not arrogant, nor even terribly
self-confident, but neither did he suffer guilt.

Now charting my own adult path, I saved my parents money and fuss by marry-
ing abroad with little to-do, beyond the stress of a year awaiting the permissions that the
Chinese system then required. Mom and Dad wouldn't have begrudged money or fuss;
on the other hand, they didn't mind my disregard for ceremony and convention. "I never
thought you would marry a nice Jewish doctor," my mother said.

Instead, my parents got a dreamy, poetic son-in-law from a rural revolutionary fam-
ily, a child of New China who'd come of age during the Cultural Revolution, driven an
army truck, and studied engineering and journalism. He would chronicle his childhood
and adolescence in the book *Born Red*, published by Stanford University Press in 1987,
still in print after all these decades.

Once he and I obtained proper letters of introduction, the formalities of matrimony
went smoothly. Three days before Christmas of 1980, we reported to a shack purporting
to be a Beijing district civil affairs office. On Christmas Eve, we returned for our marriage
certificates, with their pink-hued background of factories, farms, trains and planes and
an atomic bomb; the phrase "four modernizations" was a bit outworn, but the paper stock
hadn't changed.

From there, we proceeded directly to a holiday party hosted by the US ambassador,
former labor leader Leonard Woodcock. Back then, the grounds of the embassy residence
could accommodate all the Americans in town, and all were invited. I flashed my pass-
port at the People's Liberation Army sentry, along with a nod and the colloquial Chinese
word for spouse (*airen*, literally "lover"), and we were in.

Woodcock and his wife greeted each arrival warmly. "I know your story," my hus-
band said, eliciting grins. Woodcock was in the process of a divorce when he arrived in
China as US liaison officer (upgraded to ambassador after normalization of relations).
He'd fallen in love with the mission's foreign service nurse.

The following spring, my parents and brother arrived to join my husband and me for
what we dubbed a delayed honeymoon. That visit, I see now, illuminated the shift in my
position as a daughter. My parents were getting used to life without me. I was carrying on
without them, and could invite them back in.

We were an unusual crew for those days, foreigners consorting with Chinese rel-
atives and friends and roaming around without official escorts. We Americans needed
travel permits from Chinese public security authorities for every place we planned to go.
Despite China's new openness, any Chinese person in our company was mildly suspect.
My dad, poking about with his cameras and standing half a head taller than most Chi-
nese men, usually won over even the wariest of onlookers with his gregariousness and
curiosity.

In Anhui Province, China, a child peeks from under his mother's traditional hat, 1981 (©Ted Polumbaum / Newseum collection).

The scene in Bao's village that led to the hat picture, Anhui Province, 1981 (Gao Yuan / family collection).

My husband negotiated passage by train, boat, cars and buses, and one alarming ride in a small propeller plane to see the terracotta warriors in Xian, as well as all the lodgings, restaurant orders, and so on. One of his graduate school classmates, a genial beanstalk of a fellow who'd grown up in rural Anhui Province, accompanied us for part of the trip. We called him simply by his family name, Bao.

Anhui, in central China, was where our travels would peak, both literally and figuratively, with pilgrimages to two mountains. In between, in a region closed to foreigners that we were supposed to glide through in our hired cars without a glance, we stopped amid fields of yellow-blossoming rapeseed, and crossed a river on foot to reach Bao's home village. His father was the village chief. All the inhabitants, perhaps a hundred people, turned out to welcome us. It was raining, and only a few in the enfolding crowd carried umbrellas. Some wore big conical hats. The giddy children were soaking wet.

We'd spent the previous days navigating the peaks of Huangshan, or Yellow Mountain, probably China's most famous natural landmark, renowned for its breathtaking crags, twisted trees, clear springs, and seas of clouds. The ethereal magic of traditional Chinese landscape painting may look unreal, but its sources indeed exist. We'd beaten the onset of the tourist season, when the paths and flights of stone steps become overrun and the mountain slopes turn into campgrounds at night. But we could not evade the weather, and early spring is rainy season. So, over two days, we'd ascended through the upper atmosphere, unable to see most of the breathtaking views. Periodically, gnarled pines atop pinnacles loomed up from the mist. At an especially steep and twisty section, we had to shelter under rock overhangs from a torrential downpour.

The first night, we stopped at a clammy guest house, and slept fitfully. The second night, we reached a hotel where Deng Xiaoping had stayed, and toasted our socks over

A porter hauling cotton batting for quilts up scenic Huangshan mountain, Anhui Province, 1981 (©Ted Polumbaum / Newseum collection).

Buddhist abbot at the holy mountain of Jiuhuashan, Anhui Province, 1981 (©Ted Polumbaum / Newseum collection).

charcoal braziers. Only on the third day, when we descended the other side, did the skies clear. There were no trams or roads to the top then; provisions for the lodgings arrived by human transport. Porters filed up both front and back of the mountain, laden with all manner of supplies, from furniture to fruit to flour, and, yes, charcoal.

My parents were in their late 50s, and although Ted was athletic, Nyna was not. After a long period closed off to outside influences, China was opening up to the rest of the world, and Bao's proud new knowledge of American popular trivia helped energize our climb. Whenever my mother's strength flagged, Bao would strike a resolute pose somewhere above her, brandish his bamboo staff, and shout, "You've come a long way, baby!"

Having conquered the beautiful beast, and made our surreptitious visit to Bao's village, we arrived at Jiuhuashan, literally "nine glorious mountains," one of China's four sacred Buddhist mountains. During the Cultural Revolution, 1966–76, when religion was suppressed, monks had hidden the relics, doffed their robes, and returned to their villages. Now, monasteries and temples were coming alive again. Monks chanted, meditated, read scripture, and received visitors. Pilgrims burned incense, kowtowed, and left piles of fruit at the altars.

At the largest temple, the abbot and other elders described how they had protected their sacred site from political opportunists and thieves. They'd buried their most important relic, a mummified holy man, in a barrel deep in the ground. The mummy, in all his regalia, was back in his glass case.

One of the monks conversed with Ted, my husband interpreting: Your daughter and son-in-law will have a son who will become a great man, perhaps a head of state, he confided. Ted and the monk both brought their palms together, and bowed their heads together.

Arguably great in their chosen fields, certainly great in the minds of their family and friends, no son of mine has become, or seems to be on the way to becoming, a head of state.

Not that he put much stock in the exalted prediction, but my dad nevertheless was delighted.

That evening, he announced an epiphany: Buddhism, he said, was the highest stage of Marxism!

Dad would repeat that revelation frequently, as the period historians call the "short American century" was winding down. The Soviet Union disintegrated, the economies of the former Soviet satellites collapsed, and the market-fueled Chinese economy took off. Meanwhile, social and economic inequalities widened. Poverty and squalor were returning even to rich developed countries like the United States of America, where a long stretch of rising living standards for working people was coming to an end. The environment was under unsustainable strain. A world that seemed to have stabilized and grown more prosperous through most of my parents' adulthood was sundering again. Neither communism nor capitalism was the answer. Buddhism, or the little Ted had seen of it, seemed nice.

Not that Dad ever blamed the disappointments of socialism and communism on Marx himself. *Das Kapital* remained, in his view, a monumental work of genius.

Ted and Ian joined a group tour to Nicaragua in 1984, five years after the Sandinistas came to power. The rebels had ousted dictator Anastasio Somoza, whose family had controlled the country for more than four decades. The tour felt somewhat canned, the atmosphere uncertain, the shadows of intervention lengthening; indeed, the US already was backing the Contras in their effort to overthrow the new regime, and the bloody war would continue for another ten years. Dad took remarkably few pictures. What seemed to impress him most was his near-death experience in an ocean riptide at night. Ian had pulled him out, so the son he'd considered incorrigible as a teen was now his savior.

When Ted turned 65, Nyna persuaded him to take Social Security. She urged him to work less for money and more for himself. He took writing courses at the Cambridge Center for Adult Education—fiction, playwriting, poetry. He fooled around with photographing brick walls, but wasn't that talented at depicting inanimate objects. He played with a little half-frame Canon, joined an early computer group to get an e-mail address, did some digital scanning, toyed a bit with Photoshop. (My mother was the real pro with that program, adapting it to digital printmaking.)

Nyna took some overseas trips on her own in the mid–1980s, in connection with an international exhibition she curated to oppose the specter of nuclear annihilation. "Save Life on Earth" was the legend printed beneath an open white circle on a grass-green background; artists from all over the world filled in the circle with original art.

International Physicians for the Prevention of Nuclear War, winner of the 1985 Nobel Peace Prize, cofounded by my parents' close friend Bernard Lown and a Russian cardiologist, subsidized the project. In his introduction to the catalog, Bert wrote: "Intellectual grasp of the problem does not suffice. Only art and poetry can help us grasp the dimensions of the tragedy threatening a beleaguered planet." Author John Hersey, of *Hiroshima* fame, contributed an essay on bluefish. Writing of his sense of "the chains of life on earth," Hersey continued, "We are not alone. We cannot live without others. There are rules of mortality and survival which we dare not break, else all living things up and down the links of interdependence perish."

Together, my parents attended the IPPNW fifth annual congress, held in Budapest,

Hungary, in the summer of 1985, my father working as a volunteer photographer. In their final statement, the gathering of physicians unanimously called for a moratorium on all nuclear explosions as their "medical prescription" for the coming year.

Together, my parents made a trip to the peculiar town of Mir, in Belarus, where Nyna's mother, Ruthy, had started out. Mom was retracing the paths trod by Ruthy and her siblings—seven children orphaned in a typhoid epidemic who'd ended up scattered all over the world. Back in her studio, my mother transformed that family history into a stunning series of large digital prints, incorporating archival and modern-day photographs, computer-generated imagery, drawing, painting, collage, and text. Part of her huge archive of unexhibited work, the results still rest in flat files.

My parents took an Elderhostel trip to Hawaii, clambering up dormant volcanoes with cranky oldsters, cavorting with parrots, happy for the company of an informative young guide.

My brother would have two weddings! Recompense for my lack of one? The first was at Lincoln's Pierce Park, with its wide rolling field, two ponds, and giant trees arrayed around a yellow colonial mansion, bequeathed by its owners to our hometown. The second was in India. He and his wife, Nalina, soon moved into the top of my parents' Cambridge house, where my mother had designed them an apartment, cleverly carved out of the third floor and part of the second. Renovations were underway when the earliest inklings of my father's health problems appeared.

Ted obtained small grants to complete what would be his last two personal projects—"TRASH! Workers of the Works," focusing on city garbage collectors in Cambridge, Massachusetts, and "Rank and File," photos of Boston area labor activists and union members.

"The Works," stenciled on the garbage trucks that rolled down my parents' street weekly, referred to the Cambridge Department of Public Works. Dad photographed sanitation workers gathering and hauling refuse, and followed several home to capture them with their families in their Sunday best. To get another angle, he hopped into the fetid maw of a truck, and directed the guys to throw the trash right at him. For the second project, he followed other laborers, on the job and off, including to rallies called by the organization Jobs with Justice. Both projects led to exhibitions at community centers. Departing a bit from straight photojournalism, Dad played with color alterations using Photoshop in some of the prints. As things turned out, his experiments with early digital technology would go no further.

Until near the end of his life, Ted remained a voracious reader. He periodically returned to classic fiction, and was a maven of both vintage and contemporary poetry. But mostly he read nonfiction: history and biography, politics and philosophy, works of social, natural, and biological science, art criticism and current affairs. He was always open to new knowledge, and receptive to reassessing his views.

When I saw a copy of *The Origins of Consciousness in the Breakdown of the Bicameral Mind*, by psychologist Julian Jaynes, in a used bookstore, I knew immediately that Dad would like it. I never could have guessed how much.

Instant favorite, right up there with *Das Kapital* and *The Brothers Karamazov*.

Dad liked dense books, books that prompted thought. This one prompted thought about thinking! About eternal questions: What is consciousness? Where did it come from, and why? Alone among all species, humans try to understand themselves and the world. Humans have a sense of their inner selves. How to account for that?

Upon its 1976 publication, Jaynes's book had made an enormous splash. In the 1980s, the author visited the University of Iowa for a symposium on the mind, but that was some years before I got there. Twenty years or so behind the times, Dad and I were just catching up. Jaynes had barely published anything since the book, and his tour de force had lost its luster amidst a growing deluge of works on the mind, emotion, sensation, consciousness, and the like. To my father, however, *Origins of Consciousness* struck with brand new splendor.

Jaynes analyzed the brain in a manner that indeed was novel for its time, integrating findings from the natural and medical sciences with insights from the social sciences and humanities—anthropology, theology, literature, and more. He concluded that human consciousness did not come down to biology alone; the mind was more than neurons and neurotransmitters. Although subsequent scientists and science popularizers might take issue with his specific claims, virtually everyone has come to accept his pioneering approach, insistent on the interplay of a myriad of factors.

Jaynes described consciousness as the ability to imagine the self as a protagonist in the narrative of life, and to excerpt parts from experience to evoke the whole. Our primeval ancestors lacked such awareness, he argued, due to their "bicameral" brain structure. In the early human brain, each hemisphere had its own operating system. One side went about its autonomic business; the other side was the source of voices and visions. Only through evolution did the two sides learn to communicate and coordinate, making consciousness possible.

The bicameral mind has obvious remnants, according to Jaynes, in the "voices" everyone hears. It is recapitulated in schizophrenia, when voices in the mind are believed and obeyed. As in bicameral times, schizophrenics recognize imagined speakers "as gods, angels, devils, enemies, or a particular person or relative," he writes.

These ideas, presented with elegant intricacy in fluid, engaging prose, made perfect sense to Ted. They helped explain what happens when we dream—the source of the dream is within us, but the impression of the dream is of something happening outside us. They helped explain the adolescent mind—all those inchoate feelings teenagers grapple with. They might explain something of the aging brain, when connections between feelings and intellect cut off again. They could explain how poetry arises unbidden from who knows where.

Dad raved about *The Origins of Consciousness in the Breakdown of the Bicameral Mind*. The title alone was fabulous! No matter that he'd discovered the book two decades after its publication. My father became Julian Jaynes's greatest fan.

Ian and I had worked at summer camps, and later at newspapers, in Vermont. Between leaving journalism and attending law school, my brother spent a winter at a Vermont ski resort, skiing by day, operating snowmaking machinery at night. We fantasized about someday finding our own Vermont getaway.

In their seventh decade, my parents hijacked our whim and acted on it, buying a former ashram up a winding road in the wooded hills of central Vermont. Centered on a geodesic dome house, the property included a large garage with a studio above, two cozy guest cabins, huge trees, and expanses of unruly grass. For a couple of summers, Mom gardened, while Dad motored merrily around on a lawn tractor. The rest of the family and friends came and went.

The place was a gorgeous sinkhole, demanding major repairs and constant upkeep. Other than one year when Ian studied there for the Vermont bar exam and stayed on

for a lonely winter, it served little practical purpose. In the summer of 2000, when my father was seriously ill, my mother put their retreat back on the market, and finally unloaded it, at a loss. In late 2001, old listings drew a flurry of inquiries from New Yorkers in search of sanctuary after September 11, chasing traces of a retreat that no longer beckoned.

28

Assignment:
Human Landscapes

Souls dance undressed / together / and like loiterers / on the fringes of a
fair / we ogle the unobtainable / imagined mystery / Yet away around on
the far side / like the stage door of a circus tent / is a wide vent in the battle-
ments / where even elephants / waltz thru
 —Lawrence Ferlinghetti, *A Coney Island of the Mind*

Ted, his professional life centered in New England, was not in the least nostal-
gic about his upbringing. Nyna, on the other hand, child of Brooklyn and Manhattan,
remained something of a New York City chauvinist. Even as her children put down firm
roots in our woodsy home west of Boston, she clung to her identity as a product of what
she deemed the world's greatest metropolis.

She finally acknowledged that she wasn't moving back around the time I was a
sojourner in her home city, living in a shared apartment on the Upper West Side while
attending journalism school. Wealth had not yet driven poverty into the outer bor-
oughs; Manhattan's majestic neighborhoods still alternated with trash-strewn blocks.
I found the grime, the crime, the narrow line between comfort and distress, too offen-
sive to contemplate staying permanently. My mom wasn't put off by all that; she recalled
worse slums from her childhood. Rather, she was facing facts: Long settled in a place
that could never match New York City (no place could match it), she would settle for
inferior climes.

Until Nyna's mother and stepfather, Ruth and Murray, left Brooklyn for Tucson in
1960, we visited New York frequently. My parents would gain a few child-free days by
depositing my sister and me with our grandparents, while Miki and I gained a few days of
total indulgence. Our favorite diversion was the Coney Island boardwalk—past its prime,
yet still offering junk food, dizzying contraptions, and tacky games. Murray would put
Miki on the roller coaster, which she loved, screaming her way through the thrilling ups
and downs. I preferred the sedate merry-go-round. Most of all, I wanted to win a huge
stuffed animal. Murray would buy me a few futile turns tossing rings at bottles or darts at
balloons, then assuage my dashed hopes with cotton candy.

Later, my father found himself intrigued by Coney Island's seedy ambiance in win-
ter, with its vacant amusement parks, vagabonds and con artists, sunbathers defying the
cold, vestigial carnival booths and rides persisting through the slow season. On one of
his visits to Time Inc. headquarters in Rockefeller Center to pitch stories in person, he
proposed his Coney Island idea to Dick Pollard, then *LIFE*'s photo editor. Pollard was
amused. No assignment, but he would subsidize Ted's infatuation. He handed my dad two

cellophane-wrapped bricks, 20 rolls each, of pricey Kodachrome slide film, along with a wad of petty cash, and wished him a good time.

In its swinging heyday, Coney Island had shocked Russian writer Maxim Gorki, who saw the place as hellish and depraved. "Everything rocks and roars and bellows and turns the heads of the people," he wrote of a 1907 visit. More than half a century later, Mario Puzo, author of *The Godfather*, lamented Coney Island's decline, writing, "It breaks your heart to see what a slothful, bedraggled harridan it has become." The amusement areas had shrunk, the carnival lights dimmed, the crazies and muggers moved in.

Accessible by horse-drawn carriage and steam railroad from the 1860s on, then by automobile in the early 1900s, this stretch of oceanfront along Brooklyn's southern shore once constituted a somewhat disreputable summer playground for bluebloods and high rollers. Racetracks, gambling dens, and bordellos flourished. As the middle classes acquired cars, the clientele grew, attracted by a new two-and-a-half-mile board-walk and three wondrous amusement parks. Zealous reformers drove out the shadier enterprises.

Finally, in 1920, completion of a new subway line with a nickel fare brought hordes of immigrants and working people to Coney Island. Vacationers and weekenders flocked to the carousels, the majestic Ferris wheel, the sensational Cyclone. The boardwalk was lined with food stalls, shooting galleries, Turkish baths and freak shows. Nathan's hot dogs expanded from a nickel stand to a large emporium on Surf Avenue. A summer Sunday during a heat wave could draw a million bathers to the public beach.

By the mid–1960s, rambling wooden hotels and attractions catering to the masses had been ravaged by spectacular fires, and the last of the amusement parks had closed. A decisive blow was delivered by Robert Moses, New York's urban renewal czar, who created thousands of units of grim public housing.

Real estate developer Fred Trump, father of Donald, acquired a good bit of deteriorating Coney Island property, anticipating zoning changes that would allow him to put up apartment buildings. He briefly owned the former Luna Park and Velodrome sites, losing both in 1955 when federal housing authorities blacklisted him for questionable financial statements. Less than a decade later, with public bonds and tax exemptions, he built a $70-million apartment complex north of the boardwalk, having collected relocation fees to move poor families from the construction site to dilapidated summer bungalows. Next, he managed to buy Coney Island's longest-lasting park, the defunct Steeplechase, before the city could declare it a landmark. Donald, at age 19, reportedly attended the secret signing of the sales contract. Fred then threw a demolition party, with champagne and bikini-clad models, but never got city approval to build apartments there, and resold the land.

My mother retains only faint memories of Coney Island, where her parents, Lazer and Ruthy, ran a cigar and candy store during the Depression. Even in the downturn, it remained a lively respite for city dwellers. After World War II, as the long slide began, the area attracted some adventuresome bohemians. Folk singer Woody Guthrie and his first wife, dancer Marjorie Mazia, raised four children in a home on Mermaid Avenue; in 2019, a section of that street was renamed Woody Guthrie Way. Marjorie still lived there when my father was making his winter forays, and he made her acquaintance, although he does not seem to have taken her picture. Nor did he depict Sophie Hoober, a longtime resident who did primitive paintings in her later years.

In fact, departing from his customary practice, Dad hardly seems to have sought out personal stories at all. Rather than putting people at the center of this project, he was

A riot of signage on Coney Island's Surf Avenue, 1965 (©Ted Polumbaum / Newseum collection).

conjuring up a place. Rather than seeing human beings exerting agency upon their surroundings, he saw an environment dictating human behavior. It was an upside-down, inside-out, backwards version of his usual approach.

His resulting photos of Coney Island at its chilly nadir convey a jumble of picturesque oddities; they are bleak, perplexing, playful, even hilarious, all at once.

An elderly lady bundled into a maroon coat and knit hat sits in her own private niche along the boardwalk—the concrete basin of a decommissioned water fountain. A street preacher rants into the air along Surf Avenue, where the Nathan's hot dogs sign proclaims world fame. Further back into the decaying neighborhoods, among the slum housing, an abandoned car rusting in an alley, kids amuse themselves by slinging sneakers over utility wires.

Freed from strictures, enthralled with fooling around, Ted sported with tricks of the trade. A filter over the lens deepens the sunset illuminating a near-deserted stretch of sand, coaxing what probably was pale pink into a wash of magenta, as a silhouetted figure gazes from the boardwalk upon a solitary beach stroller. An extended exposure blurs the only rider on a spinning whirligig, a little girl in a pastel party dress and beribboned hat.

My father was assiduous about noting down information for captions. But he didn't name his photographs. To my knowledge, in a career that produced thousands of memorable pictures, he bestowed titles on only two, both from his Coney Island expeditions.

One of these is nothing short of a compositional coup, a study in contrasting attire and demeanor that later earned Ted a prize in one of the few photo contests he ever entered.

Half a dozen sensibly dressed individuals are visible from the waist down, standing against the boardwalk rail, overlooking the beach, heavy woolen coats descending over five pairs of pants and one skirt. Four are aligned perfectly, center stage, while two are

"Six characters in search of a season"—Coney Island sunbathers in winter, 1965 (©Ted Polumbaum / Newseum collection).

"Dream and lie of the photographer"—Coney Island composition sets a cameraman against a dreamscape (©Ted Polumbaum / Newseum collection).

off to one side. In the distance behind them, against a small slice of sky, a few apartment high-rises jut up from the housing developments. At beach level below, alongside an older man relaxing on a lawn chair, an older woman on a stool, and a couple of younger women, all clothed to varying degrees, sit three male sun worshippers in bitsy swimsuits, baring bronze torsos, basking defiantly against foil reflectors.

Ted anoints the scenario "Six characters in search of a season," evoking Italian playwright Luigi Pirandello's *Six Characters in Search of an Author.*

The other titled photo is a composite—flaunting artistic license of the sort straight photojournalism frowns upon.

Through the viewfinder of his professional Nikon, Ted has fixed on a dapper-looking man, presumably a tourist, about to snap a picture of his own. My father records the man in profile, from head to toe, crisp black hair, prominent nose, knee-length black coat, dark pants and shoes, little point-and-shoot camera lifted to one eye. Elsewhere, in the detritus of bygone amusements, Dad finds a reclining mermaid, luxuriant red hair flowing around her bare breasts and over her hips, some sort of come-on to a shuttered show. He memorializes her presence, too.

He will sandwich those slides together, the picture-taking gentleman against the gauzy backdrop of a giant oceanic mirage, and name the double image "The dream and lie of the photographer." It's a twist on *The Dream and Lie of Franco,* Pablo Picasso's series of etchings mocking the Generalissimo's destruction of Spanish culture. I think Dad was mocking himself.

29

Grandpa Is a Stone Wall

Never dramatize a funeral or a trip to the cemetery. Too melodramatic, too obvious.
—Kevin Moffett, "Further interpretations of real-life events,"
McSweeney's, issue 30, March 2009

To Ted, the first sign something was off arose on the tennis court. He always said the key to the game was to "keep your eye on the ball." My brother absorbed that lesson, whereas I generally swatted air. My dad could still connect his racket with the ball, but suddenly he had no control over where the yellow orb went next. He'd hit the ball, some canny destination in mind, and it would veer off in wild directions. His tennis partners, including one of his former doctors in Lincoln, couldn't help noticing as well.

Ted's cherished sport; his failure to connect racket with ball presaged his final illness (Ian Polumbaum / family collection).

To me, the first sign came in mid–1999, when Dad and I drove my younger son, Gabriel, from my parents' home in Cambridge to camp in Vermont. Gabe and his brother already had spent many summers there; Nathaniel had moved on to jazz workshops. Counselors greeted us and carried Gabe's trunk down the trail to his cabin, perched on a wooded embankment overlooking the lake. Gabe and Dad and I traipsed behind. On the way back up, my father became winded. I was stunned; mild exertion had always been nothing to him.

Dad's mental and physical decline was rapid and dramatic. His spells of fatigue and dizziness became frequent and pronounced. He was forgetful and sometimes confused. His speech slowed. His walking grew unsteady.

His primary care physician's first response was to suggest an antidepressant. Dad said he wasn't depressed, and he needed a neurologist.

With a history of lifetime health and vigor up to this point, my father had never been a drag on my parents' cost-conscious HMO. Nevertheless, the internist procrastinated on the referral for a couple of months.

Finally, Dad saw a neurologist in the same system, who hypothesized that the patient had myasthenia gravis (the ailment that made Aristotle Onassis's eyelids droop). Tests ruled out this theory. An MRI revealed nothing. Neurologist number one was stumped.

On to neurologist number two, who speculated that Dad had inner ear deterioration, and said it would just get worse and there was nothing to be done—whereupon Dad dubbed him "Dr. Doom." Tests disproved his theory as well.

Neurologist number three was a bit more thorough, and more responsive about conveying results. A spinal tap revealed inflammation, so he ordered a five-day regimen of intravenous steroid treatment. Ted's coordination and concentration improved slightly. Number three also ordered a sleep study, which showed that my father was getting about two hours of real sleep a night. He investigated some far-fetched possibilities—kuru disease, mad cow disease, familial fatal insomnia, all rare, all ruled out. And he told my parents that he was leaving the HMO for a small practice elsewhere, so they'd have to find someone else.

Six months of getting passed around produced no clear verdict, no certain treatment, no stable care. As 1999 drew to a close, we identified a Boston neurologist who seemed better qualified to deal with the mystery, and finally got Dad past the boundaries of the ineffectual HMO network and into the specialist's office. Meanwhile, my mom planned an exfiltration from the HMO, finding a better insurance plan for the following year.

The new neurologist was appalled by the fanciful earlier diagnoses. He quickly determined that Ted had meningitis of unknown origin and assigned a battery of additional tests. Finally, Dad was getting a comprehensive workup and concerted, continuing attention.

For Hanukkah, I sent my father a new book by Antonio Damasio, *The Feeling of What Happens: Body and Emotion in the Making of Consciousness.* Damasio, a neuroscientist, was still at the University of Iowa; he later moved to the University of Southern California. Dad was delighted with the Damasio book, although he did have a quibble with the author's easy dismissal of Julian Jaynes. Curiously, while Dad struggled to stay alert when he was just sitting around, he evidently had no problems with heavy reading. He was juggling the new arrival along with a dense historical work on the Israeli-Arab conflict.

The year 2000 brought a succession of additional consultations, blood tests, EEGs, EKGs, balance and sleep tests, body part scans, lumbar punctures, and other invasions

and indignities, with periodic hospitalizations. Various pharmaceuticals and physical therapy seemed to help, and then Dad would backslide. The decision was made to cut into his brain and take out a slice for a biopsy.

Other than occasional visits during school breaks, I followed the situation mostly from afar, and for a while from abroad. I'd earned tenure at my university, with promotion to associate professor. My department head, seeing something in me of which I was unaware, was grooming me for administrative work. He put me in charge of undergraduate programs, course scheduling, and various other tasks. Making sure we were offering classes to fulfill requirements as well as electives that suited students' fancies, while also trying to satisfy faculty predilections, turned out to be a stressful juggling act. As a responsible campus citizen advancing through the professorial ranks, I also served on a batch of committees, which meant many meetings. Some of these duties produced useful and interesting results. Others were time-wasters. I personally plugged holes in the curriculum at the price of my own teaching preferences. I had less and less time for the research and writing I loved.

When matters under my purview went well, my work went unnoticed and unrewarded. That would have been fine, but for the problems and complaints that inevitably found their way to me. I started to loathe my job. I started to loathe prima donnas in the workplace. I even started to dislike colleagues I actually liked.

I realized I had no desire to be boss of anything or anybody but myself. Hardly more than a decade into my midlife detour into academia, I was burning out.

So I requested a semester of unpaid leave, and fled Iowa for China. I spent the first academic term of the new millennium, spring of 2000, teaching at Nanjing University. I jogged on the school track, lost myself in street crowds, and tried to forget about the stupid stuff that had bogged me down.

At the close of the term, I planned to take the train to Beijing to meet my dean, who was making her first visit to China. I would escort her around for a week before heading back to Iowa.

Instead, I got a rare long-distance phone call from my mom, summoning me to Boston as soon as possible. After his brain biopsy, Dad was more confused and incoherent than ever. If I didn't go now, Mom implied, I might never converse with him again.

A train took me to Shanghai, a long car ride to the new international airport in Pudong, then a plane to Boston, where my brother drove me right to the emergency department. Dad was having baffling seizures, spasms that rippled across his face from crown to chin, distorting his features into a grotesque Halloween mask.

Subsequent months brought more hospitalizations, more spinal taps, regimens of steroids and anticonvulsants, a couple of stints at grim rehabilitation facilities.

That summer, when Dad was very ill but still lucid, he told me on the phone about a dream in which he packed his camera bags and flew to San Francisco for an assignment. Inside the dream, he felt great, with no disorientation or dizziness or fatigue, ready to get back into the swing of things as if he'd never been sick. Suddenly, he realized he was so out of practice that he'd forgotten to pack his clothes! He had to call Mom to Fed-Ex them. His life partner and collaborator remained booster, taskmaster, and port of last resort.

Ted grew increasingly drowsy and disoriented. Definitive diagnosis continued to elude the doctors. The facial contortions could not be controlled. His physical and mental condition, vacillating by the day or week, plummeted over a year and a half.

My parents managed a visit to Iowa in October, where I'd arranged for Dad to see yet

another neurologist, an up-and-coming star with whom I'd shared reports from Boston. Upon thorough review of the records and the patient, this doctor said he had no further insights, nothing to suggest beyond what our eminent Boston neurologist already was trying—steroids, anti-seizure medication, watching and waiting.

The Christmas break before his death, Ted was doing worse. I flew from Iowa to Boston. My husband and our two sons followed a few days later. I led them into Dad's hospital room, sat them at the end of his bed, and asked if he knew who these three handsome fellows might be. My spouse offered his usual wry, diffident expression, the boys their sweetest adolescent smiles. Dad scrutinized their faces, obviously realizing he ought to know them, and then said, "A bunch of gangsters."

To the end, my father remained himself: a self-effacing wag, unwilling to admit he was foggy not out of pride, but because he didn't want to unsettle anybody, himself included. As always, Dad was most interested in the mundane: chatting with the lab tech drawing his blood, the service worker delivering a meal, the janitor mopping the floor, joking with the nurses, amiable toward the doctors, unimpressed by rank. He never complained; to the contrary, he found reason to praise. When an orderly walked him the few steps back to bed from the bathroom just as my brother arrived for a visit, Ted declared, "This guy is doing a great job!"

As I resumed teaching at the start of 2001, Dad was back in the hospital. Mom put him on the phone. He was hardly speaking, so mostly I talked. "I love you, Dad," I signed off. He replied with a semblance of "I love you, too," sounding like his tongue was swollen, his voice sluggish and slurred. Those were his last words to me.

I made contingency plans, with colleagues poised to take on my classes at a moment's notice. The moment arrived a couple of weeks into the new year. Dad was in intensive care again. "Just come," my brother said.

Again, Ian drove me straight from Logan Airport to the hospital.

During a final day and night in intensive care, my father faded peacefully as sepsis spread through his system. My mother was certain he wanted no heroic measures, and neither did she; along with the usual clutter of monitors, he had only an IV and an oxygen mask. Mom and I sat on either side of him and talked across his seemingly slumbering body until 2 a.m., when I noticed that the minimal rising and falling of his chest had ceased. A doctor with a stethoscope made the pronouncement.

Ian had left the hospital for home; we phoned to summon him back. My brother howled, my mom and I cried softly, and we held onto each other.

I don't remember how we told my sister. My father was always able to make Miki laugh. His decline left her wary and perturbed; even the idea of visiting him in the hospital upset her, so nobody pressed her. After his death, she seemed to watch the rest of us closely for clues as to how to behave. Ultimately, her own inner resources were the best guide. While my brother and sister-in-law and I took turns having little meltdowns, Miki remained solemn and dignified.

Hoping to forestall the inevitable, Nyna had not planned for the next steps. Longtime friends Louise and Bert Lown had more experience with mortality, via their own family history as well as Bert's medical expertise, so my mom called Louise for the name of a funeral home. We arranged for a pine box, unruly wildflowers, cremation, and a cemetery plot for the urn.

On a Sunday, an overnight snowstorm yielding to dazzling sun by midday, family and friends who were immediately available gathered for a small funeral.

We asked Lawrence Shubow, the attorney who represented my father and others before HUAC, to preside over this farewell. In the 1970s, Larry had taken up the cause of the Wampanoag Indians of Mashpee, Massachusetts, who were seeking certification as a tribe. My father helped out, photographing members fishing in creeks and firing up smokehouses to illustrate their traditional ways. The federal judge didn't buy it. Three decades later, however, the Wampanoags did win recognition, recovered some of their ancestral lands, and developed plans for a casino. By then, Larry had retired after serving fourteen years as a Massachusetts district court judge, the appointment some vindication for his being ahead of his times.

That Sunday of my father's funeral, despite the fortuitous weather reversal, the Shubows were snowbound on Cape Cod. At the last minute, I asked Bert Lown to emcee. Ordinarily, this accomplished physician and tireless peace activist was supremely self-assured, even imperious at times. Now he looked shaken to the core.

Our families had converged in the early 1950s, when Nyna and Louise connected through the Boston area women's peace movement. Bert was recently discharged from Army reserve duty, having been busted from captain to private for refusing to take a loyalty oath. Born a week after his youngest daughter, I had known him my entire life. Never before had I seen him hesitate. But he couldn't refuse and took the podium.

Ted and Bert had forged a friendship in the extreme. My father, polite with strangers, courteous toward people with outlooks different from his own, was notorious for arguing ferociously over politics with his best pals. The more closely aligned he and a friend were on fundamentals, the more outlandish these arguments got. To Ted, this was jocular mental exercise; he never lost his cool in the process, even if his sparring partners did. Yet he could inspire world-famous cardiologist Bernard Lown to world-class rage, teasing even more as his friend grew increasingly apoplectic. The thrill of these battles was the first thing that came to mind when Bert realized what he'd miss, and the good doctor said so.

From the funeral home, the closed pine casket bedecked with wildflowers rode off to the crematorium, and the condolences and reminiscences moved to my parents' Cambridge living room, over platters laden with appetizers from my parents' favorite Chinese eatery. The restaurant owner, who knew us from literally hundreds of meals at his place, refused to send my mother a bill. At Nyna's insistence, he accepted a huge photographic print, Ted's close-up of a Peking Opera actor's painted face. The image, handsomely framed, dominated the restaurant's back dining room for years, until high commercial rent charged by MIT forced our friend to sell the business.

Two months later, immediate family regrouped to carry the ashes to the cemetery plot, stuffing photos and letters and a tennis ball and a few other items into the hole before fitting in the urn. Then we had a big celebration back in Lincoln, complete with a Dixieland band, attended by hundreds who couldn't make it to the small funeral.

My mother had authorized an autopsy. When the report finally arrived, she fretted about it, returned it to the envelope it came in, and added it to a thick file of medical records and correspondence. When she and my brother's family moved from Cambridge to Brookline, the file went missing. For several years, I looked everywhere. I finally stumbled across it when I wasn't looking, in a carton of outdated documents in the basement of the Brookline house, squeezed between ancient bank statements and old utility bills. There was the trail, sheaves of papers recording the legions of doctor visits and hospital stays and procedures, the tests, referrals, trial diagnoses, prescribed drugs. There was the half-sized manila envelope with the postmortem.

To say this chronicle of Dad's decline and demise is clinical is a vast understatement. Medical records by definition are clinical. But to find his dynamic life and lustrous personality flattened into a paragraph or two of boilerplate, constantly repeated in almost the exact same words (76-year-old right-handed white man…), followed by unemotional recitation of observations and results, chock-a-bloc with impenetrable jargon and specialized terms, seems inhumanely reductive. I know, this is how professionals speak to professionals in the interests of practicality, precision, convenience. To the layperson, however, it's unwieldy, upsetting gobbledygook. These documents heighten my appreciation of compassionate physician-writers like the late neurologist Oliver Sacks, who animated people's struggles in all their quirky glory and tragedy so others could understand and empathize.

Yet the record of my father's illness and death is understandable enough to come across as highly speculative. Simply put, the professionals had no idea what was going on.

Even in retrospect, having weighed and measured and assessed his internal organs (the autopsy deemed almost everything "unremarkable"), the experts never figured it out. The best they could come up with was limbic encephalitis of idiopathic origin (translation: brain infection, affecting those areas concerned with emotions and instinct, cause unknown). It was a description, not an explanation.

For years after Ted died, Nyna second-guessed everything the doctors had thought and said and done and failed to do. It turns out that they had no basis for doing better: The scientific knowledge wasn't there.

The medical world long considered limbic encephalitis a "great unknown." Its manifestations often were confused with autism, schizophrenia, dementia, or other disorders. Only recently has that long history of error faced a reckoning. Although the origins and dynamics of the sort of affliction that killed my father remain elusive, much more is known about the syndrome today than at the time of his death.

There is no single complex; the malady takes different forms, varying to large degree by age group. The pathology may be viral, or infectious, or associated with cancer, or triggered by a virus or infection or cancerous condition, or a combination of these things, or by some other unknown factors. But the mental and physical turmoil that results has come to be recognized as an autoimmune reaction—essentially, the brain turning on itself. Moreover, while the syndrome is thought to involve an assortment of distinct mechanisms that may or may not occur in individual patients, many variants now can be specifically diagnosed through identification of antibodies, and treated with targeted immunotherapy. Instead of dying, sufferers live, and many recover completely.

A variant of the disorder that killed my father struck a young woman named Susannah Cahalan in 2009. She was diagnosed with anti–NMDA-receptor autoimmune encephalitis, made a full recovery, and chronicled her experience in the *New York Times* bestseller *Brain on Fire: My Month of Madness*, published in 2012. The book brought public attention to a hitherto unknown type of brain disease, and the cutting-edge work underway to address it—efforts that have given rise to an emerging medical specialty known as autoimmune neurology.

As a 2017 article puts it: "Encephalitis is a severe inflammatory disorder of the brain with many possible causes and a complex differential diagnosis. Advances in autoimmune encephalitis research in the past 10 years have led to the identification of new syndromes and biomarkers that have transformed the diagnostic approach to these disorders."

A 2018 review of the medical literature on limbic encephalitis says: "Awareness and

knowledge is emerging rapidly through clinicians, due to a large number of case reports, as well as the performance of retrospective data analysis. However, in many cases, the diagnosis and the treatment remain challenging." This article offers a chart with seventeen variants, distinguished by the different antibodies that can be identified in the lab. Five types occur mainly in elderly patients (median age from the 60s into the 70s or 80s), while other types afflict younger people (usually in their 20s) or children.

Ted had all the clinical symptoms of the senior versions: confusion, disorientation, memory loss, mood changes, language difficulties, abnormal movements and disrupted gait, sleep disorders, and often seizures. There's even a name for the scary spasms that distorted his face: "facial-brachial dystonic seizures."

Simply put, my father got sick too soon. He'd been gone five years when researchers and clinicians finally began to unravel some of the mysteries of brains gone haywire like his. If he'd fallen ill a decade later, his death might have been prevented, or at least postponed. The astounding breakthroughs on this biomedical frontier came too late for us.

Dad's ashes are interred beside a low stone wall bordering a pond in the heart of Mount Auburn Cemetery, a horticultural burial ground in Cambridge, Massachusetts. It's a peaceful place, graves and ghosts sheltered by botanical plentitude, an arboretum now accommodating more than 100,000 souls, including noted authors, politicians, business titans and philanthropists, scientists and philosophers. Museum founder Isabella Stuart Gardner, cookbook author Fannie Farmer, writer Bernard Malamud, composer Leon Kirchner, and Chinese restaurateur Joyce Chen rest in this cemetery. So does Mary Baker Eddy, founder of Christian Science, long rumored to have a telephone in her crypt, a tale that's been debunked. Visiting my father, we often stop on the way to the pond at a spot he would have appreciated, an obelisk marking the grave of an abolitionist who died in prison.

The stone wall, its flat sides rising from the grass, is inscribed with names and dates for the deceased. Not far from Ted Polumbaum's particulars (1924–2001) are those of blacklisted actress Anna Revere (1903–1990), descendant of Revolutionary War hero Paul Revere. She was openly and unabashedly a Communist Party member. Like my dad, she infuriated HUAC by taking the Fifth Amendment. With three dozen movie roles behind her—including as Elizabeth Taylor's mother in *National Velvet*, for which she won a best supporting actress Oscar—she gradually got work in television, but would not reappear in film for twenty years.

Further along the same section of wall are four Kazanoffs. Ted Kazanoff, Dad's friend since Tank Destroyer training, was an actor, director and educator, and longtime head of the Brandeis University theater arts department. After his death in 2012, his former student Tony Goldwyn, then appearing on the TV series *Scandal* as President Fitzgerald Grant, said Kazanoff's teachings were "the singular voice inside my head every day at work—whether on a film set or onstage."

When my dad died, two names already were engraved on the face of the Kazanoff stone: a daughter struck by a sudden fatal illness in her teens, and a son who lived only into young adulthood, with failing kidneys. Another son is a well-known saxophone player in Austin, Texas. Their patch of family ground by that stone wall is what gave us the idea. Lee and Ted Kazanoff followed my father to that place. Each plot can accommodate four urns. The Kazanoff plot is full—and a reminder that death doesn't always hew to the natural order of things.

When the time came to put the metal box of my father's cremains into the ground,

our tribe included three grandchildren. My two sons, the ones who got to know my father, were teenagers. My brother's son was four months old. In a hospital waiting room, we'd introduced him as a newborn to Dad's illustrious neurologist. Ordinarily a taciturn man, the doctor scooped up the tyke in a mischievous manner, swung him through the air in a long arc while watching his eyes, handed him back, and pronounced him fit. Dad himself was amused but a bit confused upon meeting his infant grandson. He repeated the name to himself a few times, let the baby grasp one long finger, then said, "You know what I like about Arun? He doesn't fight back."

So my nephew was too young to have any memory of the grandfather in the hospital bed. My niece, who arrived two years later, never met him at all, except metaphorically, on periodic pilgrimages to Mount Auburn. "They think Grandpa is a stone wall," Nyna would remark.

My dad had a knack for doggerel. One verse he produced for my sister and me is permanently lodged in my mind. Paying uncommon homage to our childhood expectations for Easter Sunday, my parents had hidden foil-wrapped chocolate eggs around the yard. Miki and I awoke to find a missive from the Easter Bunny on the dining room table, inscribed on a scrap of paper in block letters: "Where early morn sun first hits / on trees, bushes, grass, rocks / I have left behind tidbits / of small speckled egg-shaped blocks."

Ted also crafted more serious poetry, a penchant he later cultivated and refined through writing courses at the Cambridge Center for Adult Education. Shortly after his death, we came across what we believe is the last poem he ever wrote. When he was losing his powers of speech, Nyna would hand him pencil and paper and insist he compose something. Somehow, his crippled brain still conjured up inventive flights of words. Committed in his usual scrawl, this surfaced while we were straightening out the living room:

> Lumbering from his musty cave
> he waved a lordly
> wand over lively
> realm,
> where cranky woodchucks
> played hide and seek, and
> Jewish swans
> rendezvoused at Chelm.
> Small mammals then possessed
> the earth.

No way to know what was going on in Dad's head, but perhaps this was his way of coming to terms. The poem seemed to evoke a future world of tranquility, a world without blight or pestilence, a world blissfully free of *Homo sapiens*. We were especially amused at the reference to Chelm—not the real city in Poland, but Yiddish folklore's fictitious town, the place where God's angel, charged with distributing fools and sages equitably across the earth, accidently dropped all the stupid people. In Dad's vision, more reasonable creatures of fur and feathers held court.

30

The Mind's Eye

Smile sweetly and repeat three times with deep conviction, "The best kind of light for picture taking is the kind I happen to have at hand." Of course, this isn't necessarily true but, like the weather, there isn't a great deal you can do about it.

—*How to Make Good Pictures*, by the Editors of the Eastman Kodak Company

Bereavement is an ongoing state. I can hardly go a day, certainly not a week, without stumbling over something that begs for discussion with my father. And thus, occasion to mourn his absence anew. Luckily, the weight of loss fluctuates, from near-forgetting to crushing oppression. The grief washes up regularly, sloshing between these extremes, taking peculiar forms, making unseemly landings. More often than not, what wells up are chortles instead of tears.

Take, for instance, a recent scientific discovery about electric eels. Specifically, zoologists reported "unexpected species diversity" among the brand of fish first described by naturalist Linnaeus two and a half centuries ago. Examining 107 specimens of electric eel collected from across the Amazon region, researchers identified at least three species among creatures long believed to be a single species. Moreover, they recorded a discharge of 860 volts from one type, well above the previously cited maximum eel shock of 650 volts, making this the strongest known "bioelectricity generator" among life forms.

Their study, cited in news accounts, pops right up online. An article published in the journal *Nature Communications*, crediting two dozen coauthors, most Brazilian, and stunningly illustrated with maps, charts, and lateral views of eels, introduces the three species of *Electrophorus*—dubbed *E. electricus*, *E. varii*, and *E. voltaic*. These diverging lineages vary not only in shock power, but also in head shape, habitat, and genetics.

Much as claims about sacred relics or scrolls or sutras might call for Biblical or Talmudic or Buddhist interpretation, such findings cry out for Ted Polumbaum's exegesis. For they go to the electrifying essence of his longest-running bedtime saga, spun for my sister and me, revived for our little brother, resurrected intermittently for his first grandkids, my two sons, over months and years and decades: the heroic escapades of Icky the Electric Eel.

Icky was forever rescuing people and other creatures from danger—kidnapped children, stranded pets, passengers on a sinking ocean liner, occasionally the entire human race. Assisting our champion in his derring-do was a pair of intrepid siblings with forgettable names, something like Mary and Johnny. Our slithery savior (yes, that's how Dad narrated) inevitably resolved the evening's peril with a perfectly calibrated discharge of electricity. In the miracles of my father's storytelling, the jolts never harmed his trusty

sidekicks, nor anyone else who didn't deserve it—although Icky sometimes shocked himself into exhaustion, always recovering in time for the next installment. I can see my dad reading between the lines of this new study, dissecting the scientific verbiage for secret clues, finding support for the natural and physical improbabilities that drove his plots.

Or take happenstance of death and birth dates. In a spate of gloomy reading, focused on works by and about the author whose tormented literary output turned his name into a modifier, I learned that Franz Kafka had died in a sanatorium in Austria on June 3, 1924—the day before Ted Polumbaum's birth in Brooklyn Jewish Hospital on June 4, 1924. There's a discussion.

Dad and I would have dismissed the oh-so-logical conclusion of reincarnation, judging the soul departing earth as incommensurate with the one arriving. Dad would say Kafka possessed angst beyond his imaginings, and pessimism far outside his ambit, not to mention genius far surpassing his faculties. Then again, both were Jews with father issues, no? How Dad would have cackled when I pointed that out.

Furthermore, Kafka turns out to have been bewitched by my father's medium, the author's obsession finally noticed when German literary scholar Carolin Duttlinger reanalyzed his life and work to discover close engagement with photography. A competent amateur photographer himself, Kafka brought many of his fictitious characters into encounters with this fascination. A man of prodigious contradictions, he considered photography limited, superficial, deceptive, yet also with potential to enlighten. Dad surely would agree. More to discuss!

Above all, the cascade of political depredations since my father's death has generated countless talkfests in my head that will never take place outside it.

Three days after the 2000 presidential election, Dad left the Cambridge house for the last time, carried into an ambulance after he fell in the dining room and could not get up. For the next couple of months, he shuttled between hospital beds and rehab centers, with periodic detours from regular wards to intensive care.

During the controversy over the Florida ballot count, his mind was largely out of commission—but not completely. In mid–December, Ian broke the news to him that the Supreme Court had awarded the White House not to Al Gore, but to the son of Dad's old Yale classmate. The cryptic phrasing was intended to test our father's long-term memory. After a long pause, Dad rose to the challenge, and said, "Good God, George Bush is president? I'll stay in here." The inauguration followed Ted's death by two days.

When planes seized by terrorists crashed into the World Trade Towers, the Pentagon, and a field in Pennsylvania, Dad had been gone eight months. He would have been horrified by the attacks, but also chagrined by the ensuing War on Terror, with its wholesale assaults on American liberties in the name of national security. He would have championed Edward Snowden's disclosure of the latest installment in an old story: US government surveillance of its own citizens. With a favorite quip, he'd remind us that, "A paranoid person is someone in full command of the facts." He'd be saddened and appalled at the wasteful casualties, military and civilian, of the US wars in Iraq and Afghanistan.

Dad would be glum about America stealing Chile's claim to September 11 as a day of national tragedy, and apprehensive about Chile's prolonged agonies since the end of the dictatorship. Over time, even with democratic politics restored, Chile's middle and working classes saw standards of living decline. The tipping point came in the fall of 2019, when a subway fare hike of 30 pesos (about 4 cents US) set off mass protest. "We are at war," declared President Sebastián Piñera. Once again, troop-laden tanks rolled down the

boulevards of Santiago, reawakening bloody memories. The fare increase was rescinded, but the rebellion would not be stilled.

Had Ted lived into his 90s, he'd have viewed the renewed social activism with a mix of hope and anxiety, similar to the feelings that Allende's bold agenda inspired. Once again, cries of "The people united will never be defeated" rang in the streets—albeit without quite the same world-changing optimism of the Allende years. Ultimately, the government was forced into another plebiscite. The Chilean public voted overwhelmingly to scrap the flawed Constitution left over from the Pinochet years and craft a new one. The hard work of democratic change would continue.

My father would have felt uplifted by Barack Obama's election, yet skeptical that the first Black president could ever upset the status quo. The expansion of deportations, domestic surveillance, and drone warfare under Obama would have dismayed but not surprised him.

Nor would he have found Donald Trump's conquest of the White House so very surprising. Trump is no aberration, I can hear my father saying; he's just the most egregious expression of American insolence. He wouldn't fault Trump's followers for propelling a philistine to power; rather, he'd ascribe the mob mind that boosted Trump's rise to inherent human vulnerability. Trump, he would say, appeals to the reptilian brain. We're all susceptible.

Always perplexed by crude male behavior toward women, Dad would have cheered the #MeToo movement. At the same time, he would contrast the tidal developments at the celebrity level with the glacial pace of progress for ordinary working women. As Trump stacked the federal judiciary with right-wingers, he would bemoan Neanderthal inroads into the judicial branch. He would mourn for Ruth Bader Ginsburg.

He'd adore Swedish teen climate activist Greta Thunberg. And Elizabeth Warren. He'd concur with most of Bernie Sanders's analyses. He'd be pleased that, thanks largely to Bernie, young people don't find "socialist" a dirty word. He would praise Warren and Sanders for pushing progressive ideas into mainstream discussion. With Joe Biden the Democratic candidate for president, Dad would set aside revolutionary precepts and pledge jovial but genuine faith to the electoral process. When yet another white police officer killed yet another Black man, and Minneapolis erupted in outrage, and the entire country rose up, Dad would decry the persistence of pain, celebrate the activism, and imagine that a true turning point at last had arrived. Amidst the coronavirus pandemic, as a self-professed coward and bona fide senior, he might be persuaded to stay off the streets this time.

In the spring of 2020, our far-flung family members were variously sheltering in place, working or studying at home, and in a couple of instances, venturing out to perilous jobs as medical providers. The evening of March 28 (already March 29 in China), a batch of us converged in a Zoom videoconference to celebrate my mother's 96th birthday. Were my father alive, we surely would have reconvened on June 4 to mark his 96th.

Dad degenerated so quickly that we never really saw him grow old. I imagine him, like my mom, retaining his mental faculties far into his seniority. If he'd lasted to see coronavirus ravage the world, he surely would be more philosophical than ever, immersed in reading, probably revisiting Dostoyevsky, Tolstoy, Karl Marx, Julian Jaynes, James Baldwin, all those writing of a new world struggling to emerge from the wreckage of the old. He'd maintain his stubborn optimism, citing French economist Thomas Picketty: This public health crisis is rattling economic certainties, and capitalism will have to tolerate

some redistribution of wealth to survive. He'd write more poems, play with images on the computer, and hum to himself.

Dad's views, based on bedrock principles of conscience and an insistent faith in humanity, nevertheless were open-ended. He would have no definitive reading on the dire year of 2020. Once again, the promises of America had been severely tested, and had been found severely wanting. Donald Trump's reign had cast the nation's capacity for depravity into sharp relief. And even in defeat, his aggrieved constituency remained colossal, as his near-reelection showed. The ordeals of the Trump era had energized a new wave of democratic resistance. Yet, contrary to prognostications, Joe Biden did not sail to resounding victory; rather, he eked out his win. The forces of decency outvoted those of callousness, yet those who lost refused to concede. Biden's succession offered an opening, not a solution. The struggles against lies and perfidy, graft and profiteering, bigotry and brutality, inequity and injustice would continue. Transformational change was a long haul.

Despite all this, if only in tribute to my father's vision, I'm forever on the lookout for his forthright brand of truth.

The power of Ted's photography arises in part from its lack of melodrama. He avoided the mawkish and sentimental. Even amid adversity, he looked for dignity. Nyna was even more averse to bathos and pity. As for self-pity, not allowed.

These attitudes permeated their childrearing methods. At some level, the way I was raised makes grieving harder. Grief seems like an exercise in self-indulgence.

I know I was my father's favorite. I am ashamed of this, for him as well as for myself, because parents should not have favorites.

He confessed to it outright just once. In the grip of anorexia as a teen, locked into a surreal insistence on self-starvation, hollowed out and hardly speaking, I had withered to skeletal dimensions. My father could feel my jutting hip bones when he sat next to me. In a soft, strained voice, he told me that after trying to figure out the first child, the one who would not make eye contact, who went rigid and threw tantrums and seemed unreachable, after Miki and the autism diagnosis, my arrival seemed something like a miracle. "You saved my life," he said.

In his desperation, his fear that I might literally die, he unburdened himself, shifting to me what felt then, and still feels half a century later, like a huge burden. This is my guilty secret. Only now, twenty years beyond his death, do I find the strength to share it.

How can I not mourn the loss of such immense love? And everything else that is gone. I miss the zest with which my father plunged into the big issues of the day. I miss his droll, quizzical takes on the small and sublime. I miss his wordplay. I miss deconstructing pictures with him. I rue the nonexistence of all those conversations we never had.

I am thankful for the conversations we did have. I'm proud of the trove of remarkable images he left behind, illuminated, whenever possible, by available light. And I'm grateful for all that remains in the mind's eye.

During the early days of email, I once asked him: Dad, what's the first picture you remember taking?

He replied: Ahhh. First photo. I remember absolutely clearly. Even if the memory is filtered and distilled and distorted through the mists of time.

He was, he figured, about 8 years old. He had a 25-cent Univex camera made of black Bakelite, the earliest plastic compound, that took 126-millimeter Kodak orthochromatic film, with a frame size of about 1.3 by 2 inches.

Somehow, because his father Phil knew the drugstore owner, Ted got acquainted with the commercial photographer who processed pictures in the basement of the local pharmacy. He read some books to learn how to develop his own film, and set up a little darkroom in the family cellar. He snagged one of his mother Minnie's ruby-colored drinking glasses, fitting it over a low-wattage bulb to produce a dim safelight. From negatives, he made little black-and-white contact prints on a sheet of photo paper cinched between a wood base and spring-pressure glass plate.

His family hadn't yet moved to the grand Harrison homestead. They still lived on a big corner lot in Larchmont, a village in the town of Mamaroneck. Out in the yard, Ted took a picture of his mother engaged in her favorite enterprise, gardening.

The thrill was sliding that gardening negative into the holder of the commercial photographer's enlarger, and working with him to create what seemed like a gigantic five-by-seven-inch print.

Minnie was standing amidst her plants, wearing a neat apron and gloves, holding a small pair of shears in one hand. She'd turned to look smilingly at the camera.

It was a masterful picture, and brought accolades upon the fledgling photographer from all quarters, my dad recalled.

After that, Phil extended himself to find Ted a metal version of the Univex. Cost: 50 cents. On Ted's next birthday, Phil got him a used enlarger for his home darkroom. Cost: 12 dollars.

Once upon a time, a time fated to disintegrate into estrangement, my grandfather had been a sporadically doting parent, my father an appreciative kid.

My dad concluded his account: The print of that memorable picture was nowhere to be found. It existed, vividly, only in his memory.

I, likewise, retain an indelible mental image of a departed parent.

In one of my last conversations with my still-coherent dad, as he lay in a hospital bed, the topic of my mother's high-spirited father Lazer came up.

To Ted, Lazer was everything that his own father, Phil, was not—funny, demonstrative, politically radical, culturally rebellious. Long afterwards, there in my father's hospital room, that vivid presence flared up once more.

"Lazer was great," Dad said, his eyes dancing. "He had a great philosophy of life."

Just what was that philosophy? I inquired.

The response persists in uncanny splendor in my mind, a picture with a sound track:

Dad is ridiculously attired in a light cotton gown, its blue pattern faded from industrial washing. He stirs beneath the layers of blankets, then lifts himself up slightly from his sickbed, the covers slipping off his shoulders, the ridge of his collarbone protruding above the neckline of his skimpy hospital johnny. Grinning broadly, leaning into the imperative, he declares, "Live!"

Selected Sources

Over years of research, procrastination, and finally, writing and revising, I consulted many published, online, and archival resources that inform this book. This inventory, by no means complete, identifies some of my most useful and inspiring sources.

Essentials on photographers and photography include Henri Cartier-Bresson's *The Mind's Eye: Writings on Photography* (New York: Aperture, 1999) and pioneering photo editor John G. Morris's memoir *Get the Picture: A Personal History of Photojournalism* (New York: Random House, 1998). I frequently return to biographies of Ted's favorite photographer, especially *W. Eugene Smith: Shadow and Substance*, by Jim Hughes (New York: McGraw-Hill, 1989), and *Let Truth Be the Prejudice: W. Eugene Smith, His Life and Photographs*, by Ben Maddow (New York: Aperture, 1998). "The photojournalist," transcript of a WGBH-TV program in which Nieman Foundation curator Louis Lyons interviews photographers Smith and Dan Weiner, in the now-defunct ASMP magazine *Infinity* (v. 8 n. 5, 1959, pp. 20–23), also is useful. Photographer Art Shay's *Album for an Age: Unconventional Words and Pictures from the Twentieth Century* (Chicago: Ivan R. Dee, 2000) revisits the *LIFE* magazine of my father's era.

A key work on the tobacco industry is Elizabeth Ramsey's *The History of Tobacco Production in the Connecticut Valley* (Northampton, Massachusetts: Smith College Studies in History, Vol. 15, 1930). Carey McWilliams, later editor of the *Nation*, documented conditions of tobacco workers in *Ill Fares the Land: Migrants and Migratory Labor in the United States* (Boston: Little, Brown and Co., 1942). *Connecticut Valley Vernacular: The Vanishing Landscape and Architecture of the New England Tobacco Fields*, by James F. O'Gorman (Philadelphia: University of Pennsylvania Press, 2002), was helpful. *Cigars and Other Passions: The Biography of Edgar M. Cullman*, by Peter Hochstein (Bloomington, Indiana: Trafford Publishing, 2010) provided the view from one of Ted's father's main competitors.

Due to my own failure to make inquiries in time, perhaps the best account of Ted's experiences during World War II come from his responses to a questionnaire my older son administered as a sixth-grade assignment. Essential background readings on my father's military training and subsequent service in New Guinea and the Philippines include: Odie Faulk and Laura Faulk, *Fort Hood: The First Fifty Years* (Temple, Texas: Frank W. Mayborn Foundation, 1990); Harry Yeide, *The Tank Killers: A History of America's World War II Tank Destroyer Force* (Havertown, Pennsylvania: Casemate, 2004); Pat Robinson, *The Fight for New Guinea: General Douglas MacArthur's First Offensive* (New York: Random House, 1943); Floyd W. Radike, *Across the Dark Islands: The War in the Pacific* (New York: Ballantine Books, 2003); George Raynor Thompson, Dixie R. Harris, Pauline M. Oaks, and Dulany Terrett, *The Signal Corps: The Test (Dec. 1941–July 1943)* (Washington, D.C.: Office of the Chief of Military History, Department of the Army, 1957); and George Raynor Thompson and Dixie R. Harris, *The Signal Corps: The Outcome (mid–1943 through 1945)* (Washington, D.C.: Center of Military History, United States Army, 1966).

Samuel Goldberg's *Army Training of Illiterates in World War II* (New York: Teachers College, Columbia University, 1951), was uniquely useful. Bertha L. Ihnat, manuscripts curator at The Ohio State University archives, provided information on the Army Specialized Training Program my father attended between his martial assignments. Paul Fussell's *Wartime: Understanding and Behavior in the Second World War* (New York: Oxford University Press, 1989) is a powerful antidote to the romanticism surrounding that "good" war. So is *Hiroshima in America: A Half Century of Denial*, by Robert J. Lifton and Greg Mitchell (New York: Avon, 1995).

On the GI Bill and postwar education, I consulted Keith W. Olson, *The GI Bill, the Veterans, and the Colleges* (Lexington: University Press of

Kentucky, 1974); Glenn C. Altschuler and Stuart M. Blumin, *The GI Bill: A New Deal for Veterans* (New York: Oxford University Press, 2009); and Suzanne Mettler, *Soldiers to Citizens: The GI Bill and the Making of the Greatest Generation* (New York: Oxford University Press, 2007).

The pre- and post-war Yale scene are addressed in Brooks Mather Kelley, *Yale: A History* (New Haven: Yale University Press, 1974); Dan A. Oren, *Joining the Club: A History of Jews at Yale* (New Haven: Yale University Press, 1985); Jerome Karabel, *The Chosen: The Hidden History of Admission and Exclusion at Harvard, Yale, and Princeton* (New York: Houghton Mifflin Harcourt, 2005); Alexandra Robbins, *Secrets of the Tomb: Skull and Bones, the Ivy League, and the Hidden Paths of Power* (Boston: Little, Brown and Co., 2002); and Reuben A. Holden, *Profiles and Portraits of Yale University Presidents* (Freeport, Maine: Bond-Wheelwright Co., 1968). I also drew on the online archives of the *Yale Daily News*. For University of Michigan gleanings related to my aunt and uncle, I consulted the online archives of the *Michigan Daily*. For later chapters on Boston politics and antiwar activity, the *Harvard Crimson* proved helpful.

William F. Buckley's infamous *God and Man at Yale: The Superstitions of Academic Freedom* (Washington, D.C.: Henry Regnery, 1951) of course is a must. *My Harvard, My Yale*, edited by Diana Dubois (New York: Random House, 1982), offers several entries germane to this book. The most emblematic works of one of Ted's favorite professors, Ralph Turner, *The Great Cultural Traditions*—Vol. I: *The Ancient Cities* & Vol. II: *The Classical Empires* (New York and London: McGraw-Hill, 1941) are a treasure. Information about Ted's graduating class comes from *We Of '48: A Gathering Memoir of the Half Century of the Yale University Class of 1948*, edited by Emerson Law Stone (New York: Henry I. Burr, 1998). On much more recent matters, Anne Gardiner Perkins's *Yale Needs Women: How the First Group of Girls Rewrote the Rules of an Ivy League Giant* (Naperville, Illinois: Sourcebooks, 2019) provides a fascinating update.

Invaluable depictions of a fictional Yale are found in Owen Johnson's classic *Stover at Yale* (New York: Frederick A. Stokes,1912; first serialized in *McClure's*, 1911); John Leggett's *Who Took the Gold Away* (New York: Random House, 1969); and the first novel from Dad's roommate Bob Grant (aka Robert Granat), *The Important Thing* (New York: Random House, 1961).

Here, I cannot resist a contemporary shout-out to William Buckley's son Christopher Buckley; I know my father would enjoy his rollicking satirical novels, most recently his hilarious spoof of the Trump era, *Make Russia Great Again* (New York: Simon & Schuster, 2020). On the other hand, Brent Bozell, Jr.'s son, Brent Bozell III, known for his efforts to restore "decency" to the entertainment industry, his dire warnings against far-left extremism, and his promotion of voter suppression strategies and conservative judicial appointments, is extending his ultra-conservative lineage.

The McCarthy era, which in fact spanned many more years than those in which Joe McCarthy dominated the Red probes, has spawned a large literature. Highlights include: David Caute's *The Great Fear: The Anti-Communist Purge under Truman and Eisenhower* (New York: Simon and Schuseter, 1978); Frank J. Donner's *The Un-Americans* (New York: Ballantine Books, 1961); *Naming Names* (New York: Viking, 1980), by former *Nation* magazine editor and publisher Victor Navasky; and Ellen W. Schrecker's scholarship on inquisitions in the academy, *No Ivory Tower: McCarthyism & the Universities* (New York: Oxford University Press, 1986). Larry Tye's *Demagogue: The Life and Long Shadow of Senator Joe McCarthy* (Boston: Houghton Mifflin Harcourt, 2020) does great service in illuminating how McCarthy's ruthless tactics have continued to poison US politics—most obviously in the playbook of Donald Trump.

One of my favorite memoirs of those benighted times—in part because, unlike testimonials from certain onetime radicals who became smug conservatives, the author never disavows his progressive leanings—is screenwriter and film producer Walter Bernstein's *Inside Out: A Memoir of the Blacklist* (New York: Alfred A. Knopf, 1996). Journalist David Maraniss's reconstruction of McCarthyism's effects on his family, *A Good American Family: The Red Scare and My Father* (New York: Simon & Schuster, 2018), has chronological parallels with my father's experience, although the stories are very different in substance. J. Edgar Hoover's *Masters of Deceit: The Story of Communism in America and How to Fight it* (New York: Henry Holt, 1958) is good for its unintentional humor. Jessica Mitford pokes affectionately delightful fun at the CP in *A Fine Old Conflict* (New York: Alfred A. Knopf, 1977).

Edward Alwood's *Dark Days in the Newsroom: McCarthyism Aimed at the Press* (Philadelphia: Temple University Press, 2007) is a comprehensive account of the Red hunt's repercussions for journalists. See also works on the period by two friends of our family, James Aronson's *The Press and the Cold War* (New York: Monthly Review Press, 1970), and Cedric Belfrage's *The American*

Inquisition, 1945–1960 (Indianapolis and New York: Bobbs-Merrill, 1973). As cofounders of the left-wing weekly *National Guardian,* both men had personal experience with the dragnet. Aronson would become a distinguished journalism professor at Hunter College, with awards named after him. Cedric, a Brit, was deported; he and his second wife, Mary, ran a guest house in Cuernavaca, Mexico, patronized by progressive vacationers from all over the world.

The definitive volume on the great little newspaper where Ted worked after college is Mary A. Hamilton's *Rising from the Wilderness: J.W. Gitt and His Legendary Newspaper: The Gazette and Daily of York, Pa.* (York, Pennsylvania: York County Heritage Trust, 2007). The winding path of ownership changes may be found on today's *York Daily Record* website, at https://www.ydr.com/story/archives/2019/11/27/york-daily-record-timeline-ydr-history-ownership-key-events/4319510002/.

Among the many resources concerning the Time Inc. magazine empire, Alan Brinkley's biography of its founder, *The Publisher: Henry Luce and His American Century* (New York: Random House, 2010), stands out. A full archive of the old weekly *LIFE* is blessedly preserved on Google Books, at https://books.google.com/books/about/LIFE.html?id=N0EEAAAAMBAJ.

Michael MacCambridge's *The Franchise: A History of Sports Illustrated Magazine* (New York: Hyperion, 1997) is illuminating on past glories of a groundbreaking Luce publication. Recent articles detail sorrier developments at that magazine: see Ben Strauss, "*Sports Illustrated*'s new owners say they're saving the magazine. Staffers say it's in chaos," *Washington Post,* December 23, 2019, online at https://www.washingtonpost.com/sports/2019/12/23/sports-illustrateds-new-owners-say-theyre-saving-magazine-staffers-say-its-chaos/; and Laura Wagner, David Roth and Kelsey McKinney, "Inside TheMaven's plan to turn *Sports Illustrated* into a rickety content mill," from *Deadspin* of October 4, 2019, online at https://deadspin.com/inside-themavens-plan-to-turn-sports-illustrated-into-a-1838756286.

The joint memoir by the coeditors of *Ladies Home Journal,* Bruce Gould and Beatrice Blackmar Gould, *American Story* (New York: Harper & Row, 1968), is a revealing, if sentimental, insiders' account about that publication.

A dog-eared book for young readers that I found at a library sale, *Do You Belong in Journalism?* (New York: Appleton-Century-Crofts, 1959), edited by Henry Gemmill and Bernard Kilgore, makes for quaint reading on old-fashioned shoe-leather journalism.

When autism was little known among the general public, Dr. Jacques M. May, father of autistic twins and a friend of my parents, published a bold challenge to conventional wisdom: *A Physician Looks at Psychiatry* (New York: John Day Co., 1958). Nowadays, of course, both scholarly and popular works on autism abound.

Lincoln by Lincoln: Reflections on a Massachusetts Town at 250, edited by Mary Ann Hales (Lincoln Center, Massachusetts: Cottage Press, 2004), is a glorious compendium of history and observations from my hometown.

John Kenneth Galbraith, noted economist and envoy to India during the time my family lived there, offers recollections in *Ambassador's Journal: A Personal Account of the Kennedy Years* (New York: Houghton Mifflin, 1969). Also relevant to that postcolonial period is Jawaharlal Nehru's *The Discovery of India* (New York: Anchor Books, 1959).

For an expansive history of the presidency under which I was born, see William I. Hitchcock's *The Age of Eisenhower: America and the World in the 1950s* (New York: Simon & Schuster, 2018). My contemporary Jeff Porter's *Oppenheimer Is Watching Me: A Memoir* (Iowa City: University of Iowa Press, 2007) conveys baby boomer trepidations about threats of nuclear destruction.

From the vast literature of the Kennedy court, a minimalist selection: Sarah Bradford's *America's Queen: The Life of Jacqueline Kennedy Onassis* (New York: Viking, 2000), and Norman Mailer's classic articles about the Camelot era, collected in *The Presidential Papers* (New York: G.P. Putnam's Sons, 1963).

Ted Polumbaum's 1968 photographs of poetess Anne Sexton at home and work, part of the *Look* magazine collection at the Library of Congress, are catalogued at https://www.loc.gov/item/lmc1998005495/PP/.

The epigraph to the civil rights chapter is from the essay "Of our spiritual strivings" in W. E. B. DuBois, *The Souls of Black Folk* (Chicago: A. C. McClurg, 1903), available in full at https://www.gutenberg.org/files/408/408-h/408-h.htm.

Two indispensable works on Freedom Summer are *We Are Not Afraid: The Story of Goodman, Schwerner and Chaney and the Civil Rights Campaign for Mississippi,* by Seth Cagin and Philip Dray (New York: Macmillan, 1988), and Bruce Watson's *Freedom Summer: The Savage Season of 1964 That Made Mississippi Burn and Made America a Democracy* (New York: Viking, 2010), whose book jacket incorporates one of Ted's photographs. Cedric Belfrage's daughter Sally Belfrage, who died of cancer much too young, wrote

the beautiful memoir *Freedom Summer* (New York: Viking, 1965 / University of Virginia Press, 1990). My father contributed pictures to Shirley Tucker's compilation of news accounts and photographs, *Mississippi From Within* (New York: Arco Publishing, 1965). See also Gwendolyn Zoharah Simmons's lyrical entry in *Hands on the Freedom Plow: Personal Accounts by Women in SNCC*, edited by Faith S. Holsaert et al. (Urbana: University of Illinois Press, 2010).

Fifty years after that summer, retrospectives appeared, such as Eric Moskowitz's article "Summer of 1964: They heard the call of freedom, a summons that still haunts," in the *Boston Globe*, August 31, 2014; and Patsy Sims's "No Twang of Conscience Whatsoever," *Oxford American*, issue 86 (November 2014).

Thanks to the United States Department of Justice, harrowing details of the deaths of Goodman, Schwerner, and Chaney are accessible in the *Trial transcripts in the case United States v. Price et al. (also known as the "Mississippi Burning" incident) 1967*, online at https://www.justice.gov/crt/trial-transcripts-caseunited-states-v-price-et-al-also-known-mississippi-burning-incident-1967.

Elma Lewis's book of writings by the Norfolk Prison Brothers, with photo portraits by Ted Polumbaum, is *Who Took the Weight? Black Voices from Norfolk Prison* (Boston: Little, Brown, 1972). Roxbury activist Carnell Eaton's strange 1968 murder and the resulting 1969 trial were covered by Boston's *Bay State Banner* and the *Boston Globe*.

Among the voluminous documentation of the Vietnam War, Robert Mann's *A Grand Delusion: America's Descent Into Vietnam* (New York: Basic Books, 2001) is a straightforward, amply supported, history of folly. Also noteworthy are Andrew E. Hunt's *The Turning: A History of Vietnam Veterans Against the War* (New York: New York University Press, 1999) and Michael S. Foley's *Confronting the War Machine: Draft Resistance During the Vietnam War* (Chapel Hill: University of North Carolina Press, 2003).

Edward Pessen's *Losing Our Souls: The American Experience in the Cold War* (Chicago: Ivan R. Dee, 1993), chronicles the profound effects of anti-communism on US society. *The Short American Century*, edited by Andrew J. Bacevich (Cambridge, Massachusetts: Harvard University Press, 2012), gathers together thoughtful scholarly reassessments of the Cold War.

Certainly George Orwell's timeless essay, "Politics and the English language," originally published in the London magazine *Horizon* in 1946, has abiding relevance for the obfuscation of the truth—then and now.

My parents' book on Chile's Allende years and aftermath—which sold poorly, got effusive reviews, and stands the test of time—is the quintessential work on two decades of tribulation and resilience: Ted Polumbaum and Nyna Brael Polumbaum, *Today Is Not Like Yesterday: A Chilean Journey* (Cambridge, MA: Light & Shadow, 1992). Peter Kornbluh's astonishing *The Pinochet File: A Declassified Dossier on Atrocity and Accountability* (New York: New Press, 2003), a selection of documents and analysis of US complicity, is essential reading. The poetry of Pablo Neruda is a must; I draw on a collection edited by Luis Poirot, with translations by Alastair Reid, *Pablo Neruda: Absence and Presence* (New York: W.W. Norton, 1990), but there are many more.

Mao Zedong's pithy testimonial "In Memory of Norman Bethune," from December 21, 1939, appears in volume two of *Selected Works of Mao Tse-tung* (Beijing: Foreign Languages Press, 1965); during the Cultural Revolution, it was one of "Three constantly read articles" promoted nationwide.

In the burgeoning medical literature on autoimmune encephalitis, helpful articles include "Limbic Encephalitis: An Expanding Concept," by Francesc Graus and Albert Saiz, *Neurology*, v. 70 (February 2008); "A Clinical Approach to Diagnosis of Autoimmune Encephalitis," by Francesc Graus et al., *Lancet Neurology*, v. 15 n. 4 (April 2016); "Limbic Encephalitis: The Great Unknown," B. Sosa-Torres et al., *Medicina Intensiva*, v. 41 n. 5 (2017); and "Systematic Review: Syndromes, Early Diagnosis, and Treatment in Autoimmune Encephalitis," by Christina Hermetter, Franz Fazekas, and Sonja Hochmeister, *Frontiers in Neurology*, v. 9 (September 2018). Susannah Cahalan's brave *Brain on Fire: My Month of Madness* (New York: Free Press, 2012) introduced the public to an especially terrifying manifestation of the disorder as researchers were just beginning to understand it and develop treatments.

For inspiration, provocation, and ideas about both content and form, I must mention Franz Kafka's literary hallucinations, as well as his 1919 "Letter to his father," found in *I Am A Memory Come Alive: Autobiographical Writings by Franz Kafka*, edited by Nahum N. Glatzer (New York: Schocken Books, 1974). Gustav Janouch's *Conversations with Kafka*, 2nd ed. (New York: New Directions, 2012) is marvelous, quite apart from its questionable reliability; while Carolin Duttlinger's *Kafka and Photography* (New York: Oxford University Press, 2007) highlights a preoccupation that, metaphorically as well as literally, foreshadows my father's career.

Several books have deepened my understanding of how history and biography intertwine. *The Sociological Imagination*, by C. Wright Mills (New York: Oxford University Press, 1959, 2000), remains the best explanation I know of the dialectics of self and society. Elisabeth Asbrink's *1947: Where Now Begins*, translated from the Swedish by Fiona Graham (New York: Other Press, 2018), is a remarkable collage of the personal and the political, braiding quotidian matters with world events in the wake of the Holocaust. George Packer's *Our Man: Richard Holbrooke and the End of the American Century* (New York: Alfred A. Knopf, 2019) is a transcendent study of an individual wrestling with history while captive within history. Holbrooke was a man of ferocious appetites and beastly behavior, who relentlessly sought his spot in the Great Man pantheon. His earliest official posting, to South Vietnam in the early days of America's war there, would set the pattern for the contradictory impulses that resonated for the duration of his diplomatic career. A story and a person nothing like my father's story and persona. Yet analogous in that both men were embedded in, products of, and actors upon overlapping stretches of a momentous era. I read the biography of the famous statesman, mesmerized, as I was completing my manuscript about a modest journeyman photographer.

An assiduous reader of memoirs, I'm especially alert to memoirs by daughters about their fathers. More often than not, those fathers are luminaries, which my father decidedly was not. Three of these—Susan Cheever's *Home Before Dark* (New York: Houghton Mifflin, 1984), Honor Moore's *The Bishop's Daughter* (New York: W.W. Norton, 2008), and Jamie Bernstein's *Famous Father Girl: A Memoir of Growing Up Bernstein* (New York: Harper, 2018)—delve into deep closets: Author John Cheever, Paul Moore, longtime Episcopal bishop of New York City, and composer Leonard Bernstein all had secret, or semisecret, gay lives. All three works are riveting and gorgeously written. They also temper my impulse to glorify my father, who could shun the advantages of wealth, defy political orthodoxy, and embrace social change while retaining the privileges of the straight, white male. The dull, conventional aspects of his being were also, to a point, his protection.

I like Alexandra Styron's *Reading My Father: A Memoir* (New York: Scribner's, 2011), about novelist William Styron, whom Ted photographed for *LIFE;* and the impossibly sad, yet large-spirited, *Small Fry*, by Lisa Brennan-Jobs (New York: Grove Press, 2018), semi-abandoned by her father Steve Jobs. I appreciate a son's

intermittent takes on another famous father in *Just Like Someone Without Mental Illness Only More So* (New York: Delacorte Press, 2010), by physician Mark Vonnegut, eldest child of author Kurt Vonnegut, who partnered with Ted to cover a true-crime story of serial murder on Cape Cod for *LIFE*.

Other than progressive proclivities (Bernstein, Moore, Vonnegut) and World War II service (Moore, Styron, Vonnegut), none of these famous fathers' lives has the remotest resemblance to the life of my father, even as all these readings have infiltrated my process of reconstruction. Jane Lazarre's *The Communist and the Communist's Daughter: A Memoir* (Duke University Press, 2017) and Deborah Tannen's *Finding my Father: His Century-Long Journey from World War I Warsaw and my Quest to Follow* (New York: Ballantine Books, 2020), both marvelous books by daughters about progressive fathers, again with backgrounds and experiences very different from Ted's, nevertheless have helped me in my efforts to reconstruct character and era.

Rachel Cohen's *Austen Years: A Memoir in Five Novels* (New York: Farrar, Straus and Giroux, 2020), and Helen Macdonald's *H is for Hawk* (New York: Grove Press, 2015), whose stunning elegies for beloved fathers provide portals into other topics, have greatly influenced my thinking about love, grief, and mourning. *My Father's Ghost is Climbing in the Rain*, by Patricio Pron, translated from the Spanish by Mara Faye Lethem (New York: Alfred A. Knopf, 2013), and *Granta* magazine's theme issue on "Fathers" (issue 104, Winter 2008), also spurred my thinking about writing about fathers.

Amy Tan's *Where the Past Begins: A Writer's Memoir* (New York: Ecco, 2017), even further afield from my familial experience, is noteworthy for experimenting with varied formats. Kate Simon's *Bronx Primitive: Portraits in a Childhood* (New York: Viking, 1982) is probably my favorite memoir of childhood, more relevant to my mother's background than my father's. *The World's Largest Man* (New York: Harper, 2015), Harrison Scott Key's memoir of coming to terms with, and overcoming, his father's hunter-fighter machismo and engrained Southern bigotry, is one of the funniest serious books in any world, and admirable for its absence of self-pity. James McBride's *The Color of Water: A Black Man's Tribute to His White Mother* (New York: Riverhead Books, 1996), also innovative in form, may be my favorite memoir ever.

And of course, we have Julian Jaynes's masterwork, *The Origin of Consciousness in the*

Breakdown of the Bicameral Mind (New York: Houghton Mifflin, 1976, 1990).

The Trump years, for all their depredations, produced some marvelous, realistic yet hopeful works that fuel my continuing conversations with my long-gone dad. They include Ian Haney López's *Merge Left: Fusing Race and Class, Winning Elections, and Saving America* (New York: The New Press, 2019); and Eddie S. Glaude Jr.'s *Begin Again: James Baldwin's America and its Urgent Lessons for Our Own* (New York: Crown, 2020).

Other sources that I've drawn on for epigraphs at chapter beginnings include these works of fiction, poetry, drama and entertainment: Charles Bukowski's quasi-autobiographical howler *Ham on Rye* (Los Angeles: Black Sparrow Books, 1982); Claire LaZebnik's YA book *Epic Fail* (New York: HarperTeen, 2011); Ogden Nash verse at https://mypoeticside.com/poets/ogden-nash-poems; poem number 16, which begins "Kafka's Castle...," in Lawrence Ferlinghetti's *A Coney Island of the Mind* (New York: New Directions, 1958); the Greek tragedy *Agamemnon* by Aeschylus (458 BC); Tennessee Williams's *Camino Real* (New York: New Directions, 1953, premiered on Broadway April 1953); George Carlin's HBO stand-up comedy special *Playin' with Your Head* (recorded May 1986 in Los Angeles, released July 1976 on Eardrum/Atlantic); and Nathan Ausubel's *A Treasury of Jewish Folklore* (New York: Crown Publishers, 1948).

The epigraph about using the light at hand comes from *How to Make Good Pictures: A Guide for the Amateur Photographer* (Rochester, New York: Eastman Kodak Company, 1951, 29th edition).

Finally, some documentation particular to Ted Polumbaum:

United States House of Representatives, 83rd Congress, 1st session, Hearings before the Committee on Un-American Activities, *Communist Methods of Infiltration (Education—Part 3),* April 21–22, 1953 (Washington, D.C.: US Government Printing Office, 1953), also online at https://babel.hathitrust.org/cgi/pt?id=umn.31951d03564113z;view=1up;seq=283.

Lexington Oral History Project, interview with Ted Polumbaum, April 2, 1995, online at http://www.lexingtonbattlegreen1971.com/files/Polumbaum,%20Ted.pdf.

Index

Numbers in *bold italics* indicate pages with illustrations